THE CONTENT OF WATERCOLOR

REVISED AND EXPANDED

THE CONTENT
EDWARD REEP

OF WATERCOLOR

REVISED AND EXPANDED

VAN NOSTRAND REINHOLD COMPANY
NEW YORK CINCINNATI TORONTO LONDON MELBOURNE

To my wife, Pat,

to whom this book is dedicated,

my enduring gratitude not only for her valuable help

but for her patience, understanding, and encouragement.

The author is deeply indebted to the numerous artists, collectors, museums, and galleries without whose help this book would not have been possible. I wish to thank librarian Cal Davis and her staff at the Los Angeles County Art Museum, Richard Collins and his staff at the Chouinard Art School of the California Institute of the Arts, and, most particularly, Mrs. Diane Galli and Miss Blanche Nishimura for their assistance. My special thanks to Patricia Howard for her skillful research, Frederik Nieuwenhuijs for his translations, Ruth Marie Judge for her voluntary aid, and Donald Lent of the Noland Paper Corporation for his generous assistance.

Copyright © 1983 by Van Nostrand Reinhold Company Inc.
Library of Congress Catalog Card Number 83-1264
ISBN 0-442-27773-3

Printed in the United States of America
Designed by Myron Hall III

Published by Van Nostrand Reinhold Company Inc.
135 West 50th Street
New York, New York 10020

Van Nostrand Reinhold Company Limited
Molly Millars Lane
Wokingham, Berkshire, RG 11 2 PY England

Van Nostrand Reinhold
480 LaTrobe Street
Melbourne, Victoria 3000, Australia

Macmillan of Canada
Division of Gage Publishing Limited
164 Commander Boulevard
Agincourt, Ontario M1S 3C7 Canada

16 15 14 13 12 11 10 9 8 7 6 5 4 3 2 1

Library of Congress Cataloging in Publication Data

Reep, Edward, 1918-
 The content of watercolor.

 Bibliography: p.
 Includes index.
 1. Water-color painting—Study and teaching.
 2. Water-color painting—Technique. I. Title.
ND2110.R35 1983 751.42'2 83-1264
ISBN 0-442-27773-3 (pbk.)

CONTENTS

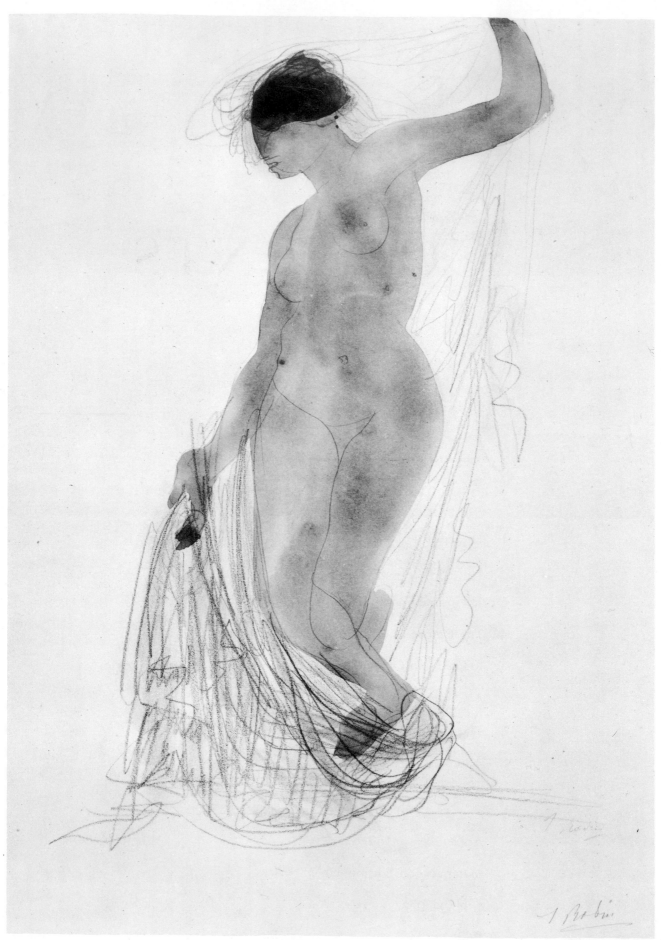

FOREWORD

Despite the acknowledged fact that important painters throughout history deemed their efforts in watercolor to be their finest work, their watercolors were relegated to a *second class* status. This was lamented by both Winslow Homer and J.M.W. Turner. Major art exhibitions were, for the most part, devoted to oil paintings; watercolors were placed in back galleries—a virtual *salon de refuses*. Books on painting more often than not classified watercolors with drawings.

Recently, the publishers expressed a desire to produce a revised and expanded edition of the original book, suggesting that a portion might be devoted to basic instruction. At one time, for inexplicable reasons, I would have considered that task impossible. I have since concluded that there ought to be some way to set something down that smacked of my work in the classroom. Why not try to convey that same spirit of investigation, practice, or learning—call it what you will—to those in need of a syllabus or guide for study.

With intense enthusiasm, a virtual autopsy of my classes was undertaken in order to convert the lessons to text. I soon discovered that to do this with *clarity, purpose,* and *integrity* would not prove a simple task—and I was right. The omnipresent gimmicks and formless effects lurked and tempted, much as the Sirens beckoned Ulysses.

So it is that two sections of text evolved and are now a part of this work. If adhered to with reasonable patience, the diligent student should be able to gain a rudimentary control of the watercolor medium. Over the years my students found the work exciting and have prospered; what is infinitely more satisfying to me is that they have used their classroom experience as a base to launch extremely personal directions.

In the first edition of *The Content of Watercolor,* the foreword resolutely stated that this is not a "how-to-do-it" or "how-I-do-it" book. Max Doerner is quoted also: "It is no more possible to learn to paint from books, than to learn to swim on a sofa." My attitude has not changed since then. The initial section of added text material is devoted to a fundamental use of materials and equipment; the latter section goes on to underscore my belief that there can be no single way to paint in watercolor.

Teachers and books get you going but *activity* is the thing that counts.

Standing Nude by Auguste Rodin. Watercolor and pencil. 17½ x 12⅜ inches.

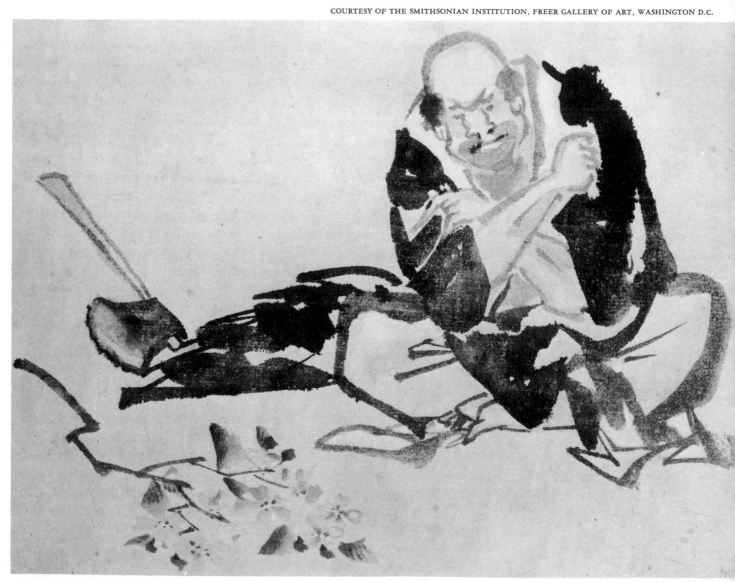

A Theatrical Character by Katsushika Hokusai. Watercolor and ink on paper. 7⁷⁄₁₆ x 10⁹⁄₁₆ inches.

INTRODUCTION

To be free in the sense of being able to make independent choices means that the free person must know a great deal, must be sensitive to a wide variety of experiences, and must have enough confidence in his own judgment to assert it and to learn how to correct it through further experience. It also means that he must have learned to respond to other people and other ideas different from his own, rather than reacting against them, and that he has learned to accept differences as natural rather than as a threat to himself and his whole style of life.

(From "Moral Values and the Experience of Art," in Art and the Intellect *by Harold Taylor,* © *1952 and 1960 by The Museum of Modern Art, New York)*

To reach the individual, bring out of him what he already knows, that is the trick! To develop sensitivities, to be aware, informed, and alert, and to persevere — from these experiences the true artist develops. Only the hapless dilettante, the sycophant or the frustrated student will ape his teacher beyond the point at which learning from another's experience is relevant. One must not force-feed one's own limitations upon others.

My purpose is to place before the reader, in word and picture, the singular beauty of the watercolor medium. It is not only vital to explain how and why watercolor is technically unique while possessing obvious limitations, but to underscore its true gift of intimate, spontaneous expression. And while it is possible to abuse a medium or tool, we encourage everyone to strain against all boundaries in the search for new and rewarding events.

Through long experience in this field as both artist and teacher, I have become increasingly aware over the years that craftsmanship is a simple result of practice. Nicolaides speaks of craftsmanship in painting as mere virtuosity and calls it a skill that may hide lack of real perception. He suggests that in the end there can be only expression. Most painters will rate content, subject matter, and technique in that order of importance. In all portions of this book you will find repeated emphasis upon these beliefs, almost to the point of redundancy; yet it is important that we take that risk.

The elaborate world of sophisticated materials will not be dealt with in the sense that there are special effects to be achieved. Nor will equipment be discussed beyond the advantage which may be gained by using versatile, quality products or by avoiding others. Here, too, we will stress *why* and not *what*. There have been too many diagrams, suggestions, and far too many rules laid down already.

Watercolor has played an enormous role in the history of art, especially in the Oriental world. This long legacy is traced in Section 1, beginning in the prehistoric era with the art of the Stone Age. These ancient cave and rock paintings were of necessity executed with a very liquid paint, and the results often resemble those of the contemporary artist at work with turpentine, acrylic or watercolor wash. For this reason alone the history of watercolor begins with extraordinary drama.

The development that follows maintains a startling pace. Cave walls and rock surfaces give way to the more refined plastered walls of the Egyptians, Greeks, Etruscans, and Romans. Egyptian scribes applied watercolor to rolls of papyrus, and the Orientals employed rice papers with unusual effect. With the Renaissance, the penmanship of the painter begins to take hold, to ultimately dominate the medium. Tonality insinuates itself and eliminates the chromatic beauty contained in the flat, bright colors of the ancients. The critics alertly label such work as "watercolor-drawing," and innocently proclaim that the medium is extremely difficult to manage. Watercolor is dubbed "the medium of the masters."

In the early 19th century the British schools virtually suffocate the medium in overemphasizing a strict methodology more closely bound to documentation than artistic expression. It remained for Turner almost single-handedly to rescue watercolor from this fate with his outpouring of vital and spontaneous work. Turner gives us our first glimpse of things to come. Toward the end of the 19th century, the French Impressionists add sparkling color-and-light experiences. Then, soon after the turn of the century, the German Expressionists and an awakening American school completely restore the status of watercolor with dynamic energy and dramatic innovation.

In Section 2, we take a brief but hard look at the artist's background, the things he painstakingly explores and the enormousness of his task. The background outlined herein is but a sample of the vast world that serious young painters explore during their years of training. We could not begin to encompass all of the areas of interest and study that concern him — studies both formal and private. With this in mind, no longer may we regard artists as merely gifted or skilled workmen, nor can the amateur, neophyte or dilettante honestly call himself a painter.

The contemporary artist is treated in a very personal way in Section 3. The text traces the contemporary school to its origins in Impressionism and Expressionism, while simultaneously looking upon the total movement as a revolt against the long tradition of Renaissance thinking. The interim schools are noted carefully, with Dada singled out as an important predecessor of contemporary art. For the most part, aside from the historical survey, living artists supply us with personal commentaries through their work and word. There has been no attempt to guide or in any way control this commentary. Understandably, this becomes the most enticing section for the author, since he too is invigorated by the persuasions of other painters.

Perhaps there is more visual excitement in Sections 4 and 6 than in the others. Wherever possible, there has been an attempt to accompany the work reproduced with an enlarged detail of the painting. This provides a most unusual optical journey for the viewer, although some of the enlargements are

more revealing than others. By way of explanation, the difficulty of getting these details has been fearsome. It entailed selecting from available work, noting the section, returning the work, and praying that good results would be forthcoming. Several selections had to be abandoned simply because the negatives were no longer available, while in some instances the enlargements were sacrificed as they were thought to be unnecessary.

The preliminary text of Section 4, which is devoted to the dynamics of watercolor, pecks away at the ludicrous formula-oriented artist and offers a visual autopsy of pictorial content. There is humor involved in the text, based mostly upon the author's misfortunes as a student, when technique was demanded as an end in itself. The dynamics of watercolor are carefully explored in order to afford liberation and full expression through intelligent analysis. The desire is to breed confidence, not futility.

Moving into the media related to watercolor, such as acrylic, tempera, etc., enlargements are again employed in Section 5, with startling effect. Here, collage and impasto thicknesses appear along with the more opaque paints and suggest further dimensions. For example, it is captivating to watch Morris Louis transform an essentially opaque acrylic into a translucent symphony, or to observe the infinite variations that occur when paint and support are altered. In addition to a survey of works in the related fields of water-base paint, we are afforded a dramatic view of the artist straining against traditional barriers.

The sensitive reader will undoubtedly understand the author's concern in Section 6, the area devoted to his own paintings. All artists would like their work to speak for itself whenever possible. In this treatise, however, the text explanations help provide a far more revealing essay, and they are straightforward. In my opinion, such a written analysis can only be attempted with one's own efforts and not otherwise. Apropos, and in retrospect, some of the early work is admittedly based more upon enthusiasm than knowledge or insight. However, the chronology of work should prove illuminating and the lessons, it is hoped, clear.

Sections 7 and 8 make their entrance into this revised and expanded edition of *The Content of Watercolor* offering practical guidance for student and teacher alike. Because the foreword deals with an explanation of purpose relative to the new sections, there is little need for further description here.

If rules and regulations are ultimately to be denied and if method-approaches are deemed futile, then how might this particular book be most helpful? While the answer to such a question would prove as complex as the question itself, the following is submitted: Like most treatises, it should not be read from cover to cover and then abandoned forever. It is not an examination to be taken one day and forgotten the next. It ought to be explored with discrimination; that is to say, one thing may be used and the next spurned. Everything in this book cannot possibly help you, nor can it always be useful to you at a given time. Returning later to the very thesis that was once cast aside may prove to be most helpful. This is a source book of information that has been drawn from inspiration, and this knowledge hopefully will provide rare and exciting new painting experiences. There is so much that remains untapped and awaiting release deep within each of us that it would be lamentable not to investigate these individual worlds of discovery.

THE LEGACY

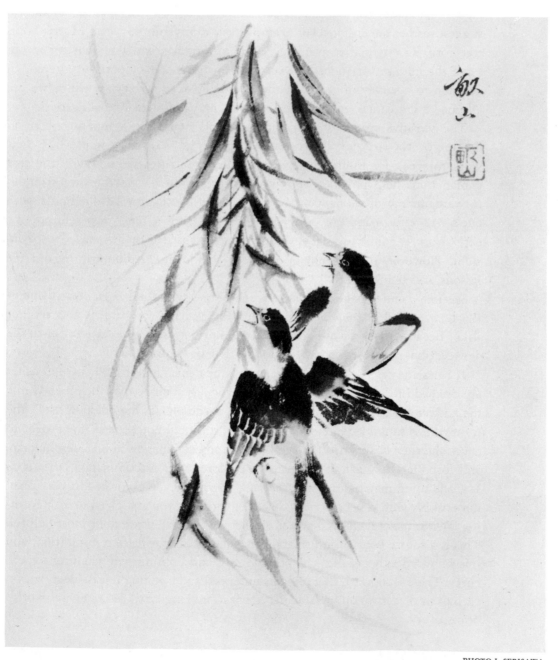

OF WATERCOLOR

In order to fully appreciate the nature of watercolor today it will serve us well to examine briefly some of its origins. While it is impossible to present a complete document of so vast a subject, we may attempt to highlight the most significant contributions and at the same time relate them to the purposes of this book.

The monumentality of this task grows when one realizes that the earliest known paintings, dating roughly 20,000 B.C., were no doubt executed in a water-base medium. Of greater import, these works look more like contemporary painting than do the efforts of the more "advanced" schools to follow, such as Chinese, Persian, or Renaissance. One has only to examine the cave-wall art of Altamira, Spain, or of Lascaux, France, to witness this astonishing revelation. By careful examination of the Bushman paintings of South Africa, and the work of the North Australian Aborigines, one gains even further reassurance. This latter work of cave-wall, rock, or bark painting will appear remarkably contemporary, almost identical to many of today's efforts.

The hunting and animal motifs which dominated early art are clearly understandable, since survival was of primary importance.

Whether these scenes had further and specific meanings is debatable, but I am inclined to agree with those scholars of paleolithic art who believe they did. For example, it appears reasonably certain that there were utilitarian demands for the numerous single animal paintings found on cave walls. Wall scars in strategic areas and other clues indicate that they were used as part of a training program for the hunter. For example, working from the single animal paintings, the young hunter could be shown where the vital striking areas existed, and evidence suggests that spears were actually driven into the paintings in practicing the kill.

Of greater pertinence for us is the fact that these works reveal a softness and spontaneity that are bound to emotion. Undoubtedly the roughness of the walls demanded a very aqueous paint in order to cover the surface, and this in turn lent itself to the artist's excitement and intensity in executing the work. The magic of this performance was quite obviously shared by both the artist and the spectator.

The greatest contributions in the history of watercolor come from the Far Eastern schools of painting. As early as the Nara Period in the eighth century,

Sumi-e painting (opposite)
by Ken Wakeshima.
Sumi ink on rice paper.
10 x 12 inches.

the Japanese executed scrolls, mainly in ink on paper, which remain extremely vibrant and spontaneous to this day. Japanese culture was strongly influenced by T'ang China at the time, and painting styles in particular were taken from Indian prototypes carried eastward through Central Asia, China, and Korea.

Whether secular or religious, Oriental art is superb in concept and execution and has remained unexcelled. Watercolor is its natural medium, for not only did the Oriental child develop exceptional dexterity through the delicate manipulation of his chopsticks, but he was virtually weaned with a brush in his hands. While it may seem incongruous, since there are 72 important laws that govern Japanese painting, the Japanese artists were masters of the subjective attitude. The viewer of the Oriental landscape senses at once that he is a part of it, or is in it and surrounded by it. It suffuses him with its overpowering sense of scale and depth. It is aromatic, mysterious, and adventuresome. The sheer beauty of the work gives the viewer a heady experience. Contrast this with the traditional European concept in which the viewer stands apart from the painting. It was something to be viewed, to witness, as if it were some sort of occurrence participated in by others. Not until the French Impressionists was there a major change in this point of view, and with it a recognition of the true contribution of Eastern art. For along with it came an understanding of the flattened patterns, the chroma, and the use of graphic symbols, plus the art of selection, elimination, or the *unsaid*.

Nowhere in the history of painting has the medium of pure, essentially transparent watercolor been relied upon more exclusively than in Oriental art. The school of *Sumi e* (black picture), while limited to black and white, depends entirely upon the subtle nuances of tonal wash gradations. These tones are produced from a cake of black color, which resembles the hard-pan watercolors used in our elementary schools. The results are exceptionally spontaneous since overworking is frowned upon.

The laws that govern *Sumi e* painting are far too numerous to recount here, but one may not take the name of the *Sumi* master until all the strict teachings have been absorbed. One such law is called *fude no chikara*, which means "the strength of the brush stroke." While the contemporary painter might feel limited working under imposed restrictions and rules, this is not so with *fude no chikara*. Conversely, under this law, at the precise moment of paint application to surface, the artist's sentiment or feeling must be transmitted from within, through his arm and hand, through the brush, and onto the painting surface. His sense of the vital forces of power, restraint, fragility, softness, or harshness continues to pour steadily into his work until completion.

We may compare the results of *fude no chikara* with those of the contemporary action painter, or find a strong resemblance to the older school of *alla prima* painting. *Alla prima* painting, popularly known as wet-into-wet or to-be-completed-at-one-sitting, I prefer to explain as "that which begins with emotion and ends with emotion." The lessons contained in *fude no chikara* were so completely lacking in the work of the English, French, Italian, and American painters (especially those working in watercolor), that their paintings were often tired, worn, and limp by comparison. We find to this day this saccharine and flabby work being produced and espoused.

Tempera painting dominated the world of the ancients and may be classified technically as a form of watercolor. But there is far deeper meaning to be found

here than in mere definition, despite the fact that free-flowing line and an abundance of glazing were prevalent. For example, the artists of Egypt, or scribes as they were called, were required in apprenticeship to execute their work on papyrus rolls, which encouraged quickness and fluidity. This influence is readily noted in their wall paintings (usually in tombs), for despite the specific demands of a craft handed down from one generation to another, individual and expressive characteristics are felt. It must be kept in mind that the art of the scribe was primarily concerned with death. Tomb decorations were dominated by the need to provide for the life after death of important or wealthy persons. His subjects were ritualistic, biographical, or mythological, and included graphic symbols and hieroglyphics. There was no attempt to portray literally nature or people, yet the results were extremely realistic. This delicate paradox is readily understood when one recognizes the mastery of expression, pattern, and flat, bright color that dominates Egyptian painting and produces an inimitable time-lessness.

The Etruscans, on the other hand, being highly influenced by the Orientals, presented an even livelier version of tomb paintings. They decorated their walls, ceilings, terra-cotta slabs, urns and sarcophagi with scenes of people, animals, and plants. All of this, as in Egyptian art, was prepared mainly to document the life of the deceased and/or to record his funerary rites. Although the Etruscans were strong admirers of the Greeks, they were unable to compete with the Greek mastery of draftsmanship.

A later record of Italian painting is to be found in the art of the Romans, which has endured remarkably well. Relying essentially on tempera along with very careful preparation of the ground support, the Roman artist-craftsman became even more sophisticated by adding a wax-encaustic element to his paint when exposure problems were present. It is small wonder that Roman art has remained in excellent condition to this day, for those two concerns of ground and pigment are of prime import to all artists.

The Roman artist was involved with the recording of historical events, military conquests, and honorific rites. He presented them in amazingly illusionistic landscape settings, in addition to producing isolated landscapes, garden scenes, and even still-lifes. Modest and elaborate homes alike were profusely decorated, as evidenced by the excavations of Pompeii. Walls, ceilings, floors, furniture — indeed everything was painted with color that served to provide spiritual and emotional meanings in addition to decorative values. *Brushless* areas were played against translucent line on pale off-white surfaces that produced delicate sensations. Then, too, a precise *absence of color* was employed for similar purposes of achieving special meaning. For example, a room might be done in a startling black and white theme, which is a most contemporary attitude. While there was a very definite striving for form through the use of light and shade, it is noteworthy that this period produced innovations through analysis of light that suggest future impressionistic thinking.

So when we think of the legacy of watercolor we are irresistibly directed to the magnificence of Ancient and Eastern art, for these worlds of art, while highly developed for their time, were not concerned with labels of media. Yet with all of the restrictions of technique and style, plus utilitarian demands, there remains a strong flavor of magic and discovery, remarkably direct.

Turning to the Middle Ages, watercolor as such, with the possible exception

of some fantastically rewarding frescoes, was ignored. Stones and metals invaded the art form, and decoration became a chief concern. The Byzantines stunned the world of art with overpowering mosaics, and the superb stained-glass windows of the Middle Ages played a vital role in influencing the general art mold. Manuscripts, tapestries, and miniatures (notably Persian), preoccupied artists, and produced lasting influences. Religious themes dominated the masterworks of Giotto, Duccio, and Lorenzetti; while Bosch and Van Eyck dazzled all with incredible fantasies.

However, it remained for the artists of the Renaissance to revive watercolor and establish a sound base for its future role as a major painting medium. For here, primarily through preliminary sketches, we sense the awakening of the intimate world of the artist through his penmanship.

Watercolor became an inexorable part of drawing, and was to become classified as such. This regrettable and somewhat naive pattern is still held to faithfully by various critics and art historians who either cannot detect differences or who enjoy artistic snobbery. For to refer to an oil painting as painting, and to a watercolor painting as a drawing is pure foolishness. Yet in all fairness there was cause for this attitude during the Renaissance period.

Dürer brought watercolor to a new plateau, and the works of Rembrandt and Tiepolo were destined to reacquaint artists with the singular beauty of the spontaneous statement. Through watercolor, painters were struck with the rare opportunity to gain freedom and achieve rapidly. Their preparation work alone displayed emotional involvement heretofore unknown, except perhaps in the aforementioned Oriental world.

Until we come to the English school, headed by Blake and Turner, there is little to note. This may seem paradoxical, for surely here lay the very foundation of contemporary watercolor as a major medium. But this was due to a host of reasons, not the least of which was the enormous interest in watercolor and the copious amount of work devoted exclusively to the medium. It is unfortunate that while the artists working with watercolor at that time were dedicated and excited about their efforts, retrospection offers up little more than ennui.

It is noteworthy that the beginning of the "watercolor society" or "club" as we know it today, dates back to this precise era, as these early 19th century English artists reacted to the snubbing of their work in watercolor. They felt that their watercolors were being given second-class consideration, and they had the evidence to support their claims. The best oil paintings were always hung in the main gallery of an exhibition, whereas the watercolors were automatically lumped together with the inferior oils in adjoining rooms. This prompted them to form societies for the exclusive exhibition of watercolors. This practice not only spread but has continued to this day.

The singular contributions of Turner have proved meaningful and enduring; yet it is odd that the bulk of his watercolors were painted on landscape locations as a preparation for later and more ambitious oils. While Turner's oils were greatly enhanced by this procedure, it remained for his sketches in watercolor to capture an essence and brilliance which placed him far beyond his contemporaries. When we contrast his work with that of Paul Sandby, a mannerist, romantic painter of the eighteenth century, we clearly feel the tedious preoccupation with overembellishment, so popular at the time.

In America, during the latter half of the nineteenth century, Winslow Homer

brought a new meaning to the medium. His now classic Bahamian series stood apart as the epitome of freshness and vitality. His work offers a wide sensory appeal as one inhales sea air, stands against the wind, or cuts through tropical flora. Prendergast and Demuth added new dimensions to Homer's work; while their work was of a less rugged nature, both men were superb composers and draftsmen. Now, into the twentieth century, Davies, Feininger, and a whole new school including Marin and Burchfield brought watercolor in America to a resplendent level.

It is amusing and significant to note that Homer attached far more importance to his watercolors than to his oils. At the Pan American Exposition Exhibition in Buffalo at the turn of the century, Homer insisted that his watercolors, not his oils, represented him. Time has given generous support to Homer's wisdom.

The French Impressionists and German Expressionists concurrently were creating separate and dramatic paintings of their own with watercolor. Reacting with vigor against tradition in general and the Renaissance in particular, it is obvious that their efforts remain largely responsible for the complexion of today's art scene. Caught up in the excitement and discoveries of the day, watercolor emerged not only as a spontaneous medium, but as in the work of Paul Cézanne, an enigmatic, solidly structured, yet transparent medium as well. Through Cézanne's dedication to the re-creation of light, plus the requirement that the viewer *reassemble* the work, he became known as the "great innovator." If ever there was a need to support the old cliche that "watercolor is the medium of the masters," we need only point to Cézanne and his genius in composition.

The Expressionists brought a new color dimension to all of painting, including watercolor. Their efforts simply exploded from the walls and poured forth dazzling groupings of colors. Totally subjective, and purposely ignoring all past lessons of light and shade, their work hinted of things to come. The theory of kinetic or *inner* energy was exploited, and art horizons immediately widened. Paul Klee and Wassily Kandinsky brought enormous intellect and wit to their art, while Nolde followed with an outpouring of small, brilliantly colored works.

The lessons had been learned, and now they were being abandoned. The cave-wall paintings formed a beginning, the Renaissance a high point, and Cézanne's impressionism heralded a counter-reaction to all that had gone before. The horizons of painting widened to establish a broader plateau that would, hopefully, support the imminent creative explosion to follow. There would be newer lessons but they were not yet clearly in view; however, what of the old? In the next section we will carefully examine the fundamental needs of the contemporary painter, which are based in great part upon his monumental legacy.

Lascaux Cave (below). The great frieze on the left wall of the "Hall of Bulls."

Large Eland and Human Figures (opposite). Rock painting from Khotsa Cave, Basutoland, South African Union.

This extraordinary wall painting from the Lascaux Caves begins our pictorial survey of the legacy of watercolor. It is unquestionably a remarkable work from the standpoint of durability alone; but in view of the technical restrictions imposed by surface and materials, it becomes a staggering accomplishment.

Both the Lascaux frieze and the South African rock painting opposite set the stage for our exploration of the fluid characteristic of all water-base media. The precise components of primitive painting media are of little concern to us, but we do wish to impress upon the reader the cave painter's fundamental need for an extremely liquid paint, a need dictated by the porosity of his stone and wall surfaces.

The total effect of this Paleolithic work is strikingly similar to that of the great Oriental schools to follow. Even more surprising is the marked resemblance to many contemporary works. The softness of mass, the crispness of calligraphy, the glazing of color over color and color over raw surface are methods found in today's painting. Furthermore, we may observe in "Hall of Bulls" a most impressive example of the use of the convolutions of the natural rock surface to enhance or achieve a goal. This may be likened to the inventiveness of the contemporary artist in preparing varieties of grounds and supports.

In the later Paleolithic period, or the last Ice Age, prehistoric art came into being. The rock painting shown here, from the South African Union, is the product of a culture with a highly sophisticated tradition in art. This superb example of animal and human figures, rarely superimposed, is typical of the work which was usually done in polychrome layers. Again we discover a compatibility with the historical schools or watercolor to follow.

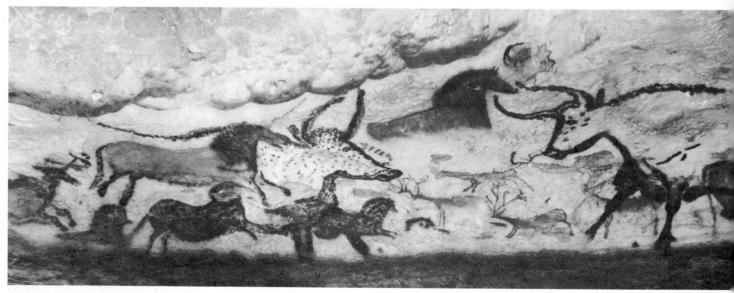

18

While all primitive art is representational, it by no means could be termed realistic. Animals dominated painting, since hunting was a chief concern, but there were paintings of processionals, rituals, and dances in which human figures would appear with animal heads. Of more pertinence to us is the rare compositional gesture and draftsmanship seen here. Scale and buoyancy are handled with such distinction that one must assume that esthetic goals were uppermost in the mind of the artist. There can be little doubt that early art was highly sophisticated.

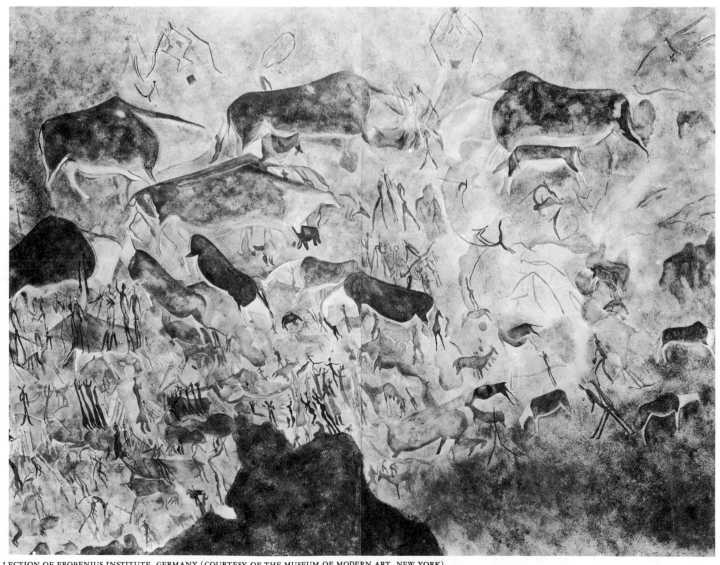

COLLECTION OF FROBENIUS INSTITUTE, GERMANY (COURTESY OF THE MUSEUM OF MODERN ART, NEW YORK).

Fowling Scene, from a Theban tomb. 1570-1349 B.C.

This exquisite example of Egyptian painting comes from the "Empire" period of her history and is significant for several reasons. Until this dynasty (XVIII), painting had been primarily a means of decorating the stone relief of architecture and sculpture; rarely did it exist as an independent art. Because of the difficulty of carving on very coarse walls, Egyptian painters were called upon to produce prolific tomb paintings.

Still reflecting such conventions as profiling the human figure, *Fowling Scene* exhibits masterly draftsmanship and sense of design in the birds, hunting cat, and papyrus. Flat colors were mixed with gum and applied to dry plaster or stucco surfaces. Gum arabic is used to this day in confecting watercolor. In this painting, an Egyptian noble, his wife, and his daughter are depicted ridding their papyrus swamp of birds. Despite its age of well over 3,000 years, the painting still shows a most delicate application of soft glaze at work in the papyrus, birds, cat, and fish.

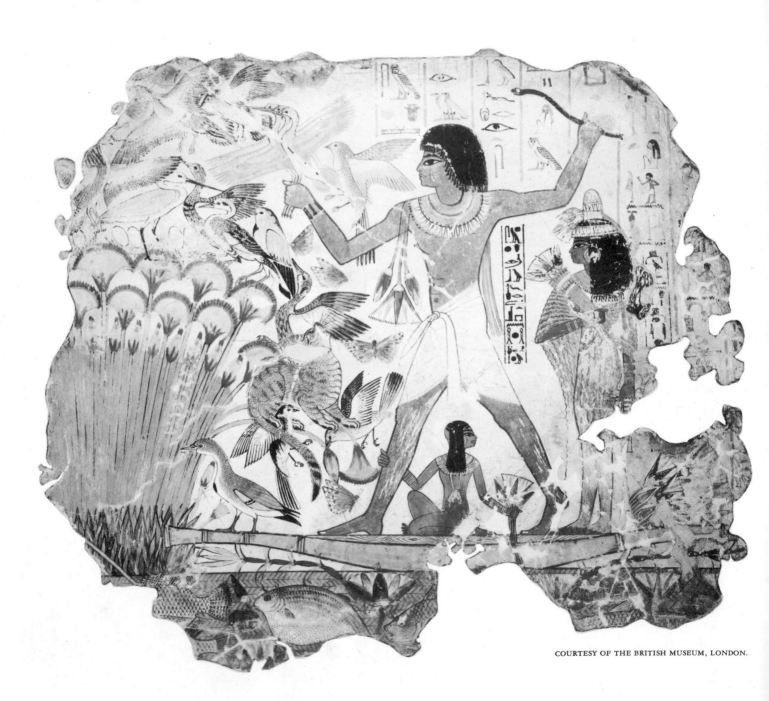

Danzatore, detail from the Tomb of the Old Man, Tarquinia, Italy. VI century B.C.

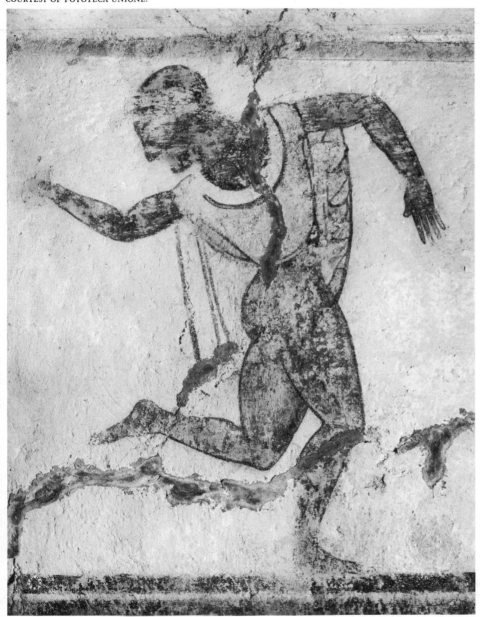

While volumes have been devoted to Etruscan Art, we are concerned only with a sample of the era in order to touch on an important step of our legacy. The remarkable Etruscan tomb frescoes not only afford us an opportunity to observe Etruscan culture and daily life, but allow us a further examination of their art itself. The Etruscan dancer shown here has been selected primarily to give an intimate view of surface and paint application.

In the main text we referred to Etruscan tomb paintings as the liveliest version of that ancient art. This was obviously due to the distracting and constant civil wars during this period, which undoubtedly arrested cultural development. The result was a bolder and less sophisticated draftsmanship applied to a cruder working surface; and the scenes reflected the Etruscans' violent preoccupation with forceful animation. The Etruscan artist plunged fearlessly into his work, decorated virtually every surface in sight, and in great measure paved the way for much of the splendid Roman art to follow.

In *Danzatore,* we note the profiling seen in the three Egyptian figures on the opposite page; yet the action is far more vigorous and there is less of a reliance upon symbolism. This comparison holds true not only with these examples, but with most Etruscan and Egyptian works. The deterioration shows clearly how the wall surface was prepared, and gives us a glimpse of the rough surface and its subsequent paint layers. We may also compare the bold Etruscan line with its careful Egyptian counterpart. From a purely technical standpoint, a rougher surface would demand a more liquid paint, or the result would be a skipping, drier wash or line. Furthermore, in fresco painting, because the artist works on fresh plaster, control is a vital factor. A mistake often demands removal of the old plaster and re-surfacing. This alone makes such early art all the more impressive and relates it to the expanded world of watercolor to follow, in which mistakes are obviously more difficult to deal with than in traditional opaque media.

Clear Weather in the Valley. Landscape scroll (section) by Tung Yüan. Sung Dynasty (XII century?). Ink and slight color on paper.

This handsome section of a very early Chinese handscroll is attributed to the Sung Dynasty, although there has been much debate among historians in attempting to identify accurately both artist and school. Our purposes may happily ignore this controversy, and instead look to the superb performance of ink monochrome, subtlety of color gradation, and richness of total orchestration.

The origin of the watercolor medium is felt here. The inimitable qualities of the controlled accident, so vital in many phases of contemporary expression, combines with the wondrous calligraphy of the Oriental artist, the virtual innovator of the landscape painting. We are invited to explore valleys and coves, walk down mysterious pathways, and peer into detailed clusters of plant and rock formation. The magnitude and quality of early Oriental painting is a direct result of thorough training and subjective analysis.

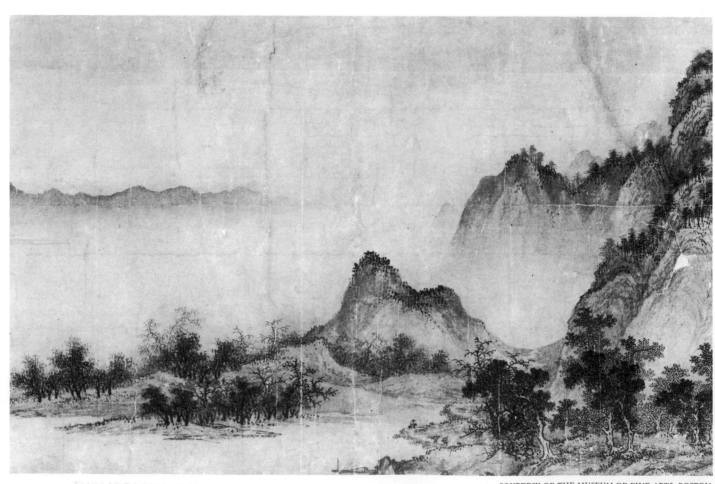

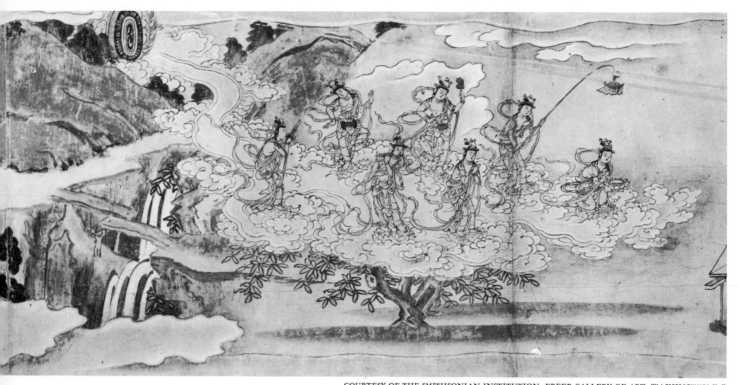

Handscroll (detail). Yūzū Nembutsu Engi. Kamakura period, Yamatoe school. 1329. Ink, color, and gold on paper. $11\frac{7}{16}$ x $5\frac{5}{8}$ inches.

The exquisite handscroll shown here is one of countless works produced during the twelfth to fourteenth centuries in Japan which display superb draftsmanship and compositional control. The great tradition of drawing excellence established by the Yamatoe school is clearly evident here. These artists placed so much emphasis upon drawing that their work was often outlined first, and later filled in with color.

While this approach would be frowned upon by contemporary artists as seeming to deny all spontaneity, it is surprising how much flow and movement have been maintained. Executed in ink, color, and gold on paper, this handscroll, like others of the Yūzū Nembutsu belief, illustrates stories and incidents related to their sect. Despite the strong demands of method and subject, if one examines the line, the trees in the upper portion, and the soft gradations of color throughout, he will become aware of an amazing freedom within the self-imposed limitations.

View of Arco by Albrecht Dürer (1471-1528). 1495. Watercolor and gouache. 8⅞ x 8⅞ inches.

At the age of 24, Albrecht Dürer painted several landscapes in watercolor which were revolutionary in scope. Nature never had been presented with such a peculiar blending of sharp detail and atmospheric grandeur. While the Orientals were masters of the subjective landscape, it took Dürer to free European painting from ancient religious dogma and build new foundations for contemporary thinking.

This was not a new experience for Albrecht Dürer, for when only 13 he was producing self-portraits, a rare subject for any artist at the time. He later turned to animals, portraits, landscapes, and altar pieces; he worked with oil, watercolor, and pen and ink, and produced magnificent woodcuts and engravings. At the dawn of the Renaissance in Germany, Dürer unquestionably laid cornerstones for the great schools to follow.

View of Arco was painted on his return trip from Italy in 1495. It appears to capture an infinite distance that plays against the closeness of forbidding cliffs. It lives as the very essence of the ancient Italian landscape. Its awesome sense of scale is given emphasis by the nestling of walls, fortresses, and other smaller structures against the majestic mountain.

Dürer's accomplishments cannot be summed up in a single painting or even in an entire volume. His prodigious accomplishment went far beyond art; he wrote treatises on many subjects, including fortifications, proportions, and measurement. Although his greatest influence has been felt in the field of graphic art, we cannot overlook his monumental gift to the watercolor painter.

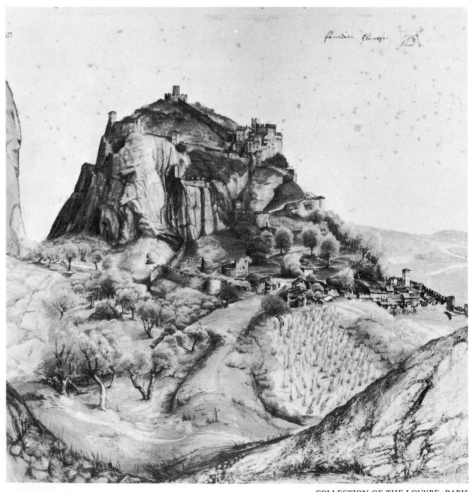

COLLECTION OF THE LOUVRE, PARIS.

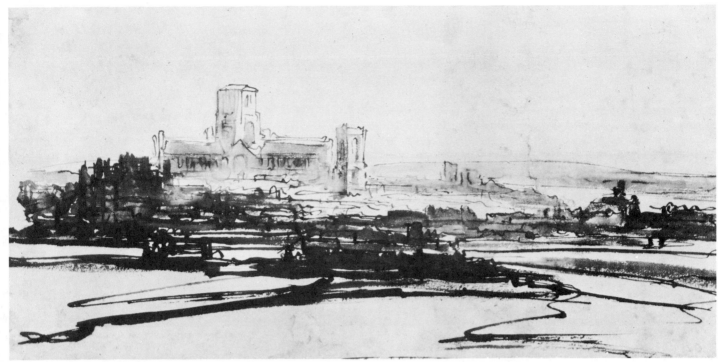

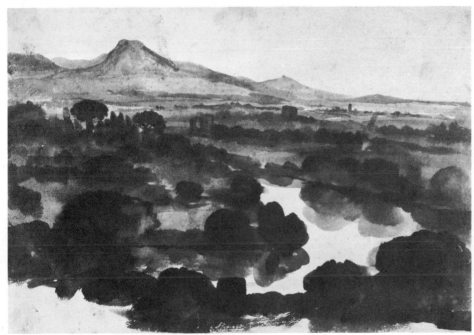

View of London by Rembrandt van Ryn (1606-1669). 1640. Pen, bistre, and wash. 6½ x 12½ inches.

Le Tibre en Amont de Rome by Claude Lorrain (1600-1682). Brush and bistre wash on white paper. 4¼ x 10⅝ inches.

These two significant paintings by Rembrandt and Claude Lorrain are similar in that they are both panoramic; but they are quite different in treatment. For one thing, Rembrandt's view of the London countryside, with St. Paul's in the distance, is a spontaneous, flattened, and linear experience. Executed in pen and bistre (a brown pigment made from charred wood), it deals magnificently with light and haze in essentially a monochromatic key. Lorrain, on the other hand, presents a fullness of wash and suggests an intense color contrast and reflection of light off the Tiber.

So much has been written of these famous painters, and most especially of Rembrandt, that this brief commentary could add little biographically. My purpose in showing these two works together is not only to encourage comparative viewing, but to set the stage for the unusual development of the British school which follows. Keep in mind that we have now reached a high point of spontaneous expression, and that watercolor was curiously referred to as the medium of the masters.

25

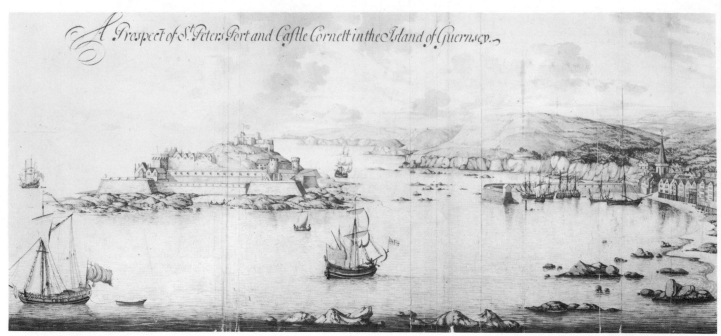

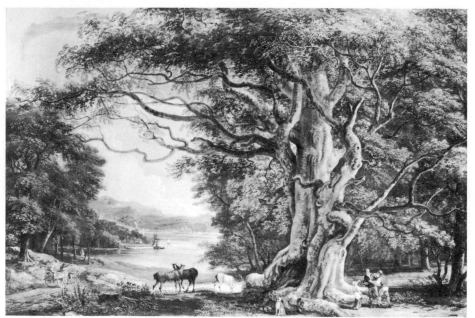

St. Peter's Port and Castle Cornett by Thomas Phillips (1635?-1693). 1680. Ink line and watercolor. 17⅞ x 41⅛ inches.

An Ancient Beech Tree by Paul Sandby (1725-1809). 1794. Body colors (watercolor gouache). 27⅝ x 41⅝ inches.

No survey would be complete without touching upon the odd turning of the English school. For here, well over a century after the expressive vitality of Rembrandt and the chiaroscuro of Lorrain, we sink back into a world inundated with genre painting. Phillips' work is hardly classifiable as a painting. It is truly the forerunner of the architectural rendering as we know it today, and was referred to then as a platte painting. These plattes, or plot-plans, were normally drawn out in monochrome, but with the tremendous interest in watercolor at that time, Phillips added transparent color washes to his platte to increase its effectiveness.

Meanwhile, Sandby and others were contributing little more than enormous portfolios of highly romantic, idealistic and mannered works. Interest in the medium was so high at this time that clubs and societies were formed for the sole purpose of exhibiting watercolor paintings.

Ship and Cutter by J. M. W. Turner (1775-1851). Watercolor and pencil on paper. 9⅜ x 11⅜ inches.

A simple comparison of this painting with those on the opposite page will accomplish more than these words. For Joseph Mallord William Turner gave the English school a needed transfusion of vitality. *Ship and Cutter,* as a single statement, can hardly be expected to display the fullness of his total contribution, but there can be no questioning its message.

Turner's watercolors are essentially studies for his oils or mezzotints, but they are obviously filled with more emotional content than the more elaborate works to follow. He peered long and hard into nature, searching for an internal truth rather than the customary outer veneer. His early training as a draftsman — he was selling his drawings at the age of 12 — no doubt endowed him with the necessary confidence to work with rare enthusiasm in the outdoor world he loved.

It is not difficult to understand that this brash upstart was not readily accepted by his fellow members of the Royal Academy, for his innovations posed a serious challenge to their traditions. Nor is it surprising to note that Turner's idol, the man he tried to emulate, was Claude Lorrain. We have seen the drama of Lorrain, which must have moved Turner; but never before had the painting world experienced such a dynamic and tempestuous brush as that wielded by Turner. While others were relying upon subject matter alone, Turner displays in *Ship and Cutter* an innovative spirit that provides ammunition for those who contend that he was the father of the contemporary school. He lets slashing brush strokes, spattered paint, and unfinished wash support his perilous theme. He controls conflicting diagonals masterfully with a superb disorder of things coming undone, in motion and transit, all struggling for survival.

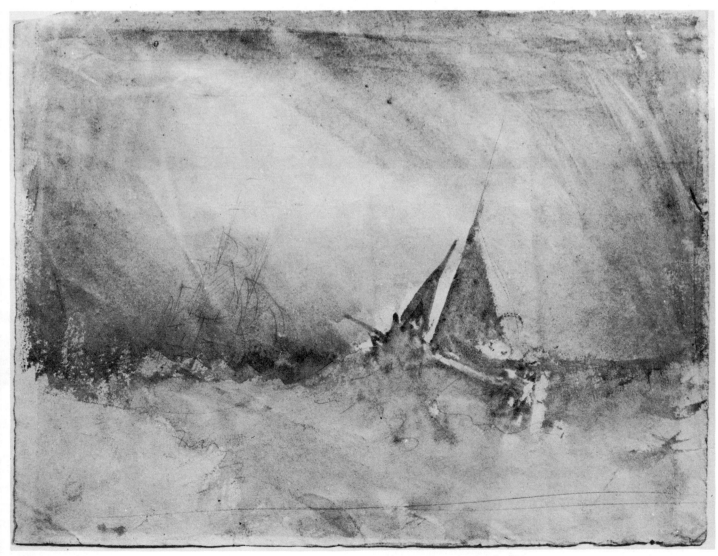

The Whirlwind of Lovers (Hell, Canto 5) by William Blake (1757-1827). Ink line and watercolor. 14½ x 20½ inches.

Because of Turner's enormous impact upon the art world, we have purposely placed him before William Blake in order to play Turner against his flaccid predecessors. It is of little consequence that our chronology suffers a slight shock, for at best Blake can hardly be placed into any normal sequence of art events.

William Blake was unique: there will never be another like him. He was hardly a painter in the accepted sense, although he used watercolor almost exclusively to carry out his visionary works. These were often illustrations for his own poetic writings and those of the Bible. He composed with his imagination, ignored convention, and held fast to his own subjective goals.

The Whirlwind of Lovers is but one of a prolific outpouring of magnetic works which powerfully attest to this great man's burning personality. We look for no technical guidance or classic draftsmanship here, yet William Blake, by virtue of his imagination and vision, is one of the great painters of all time.

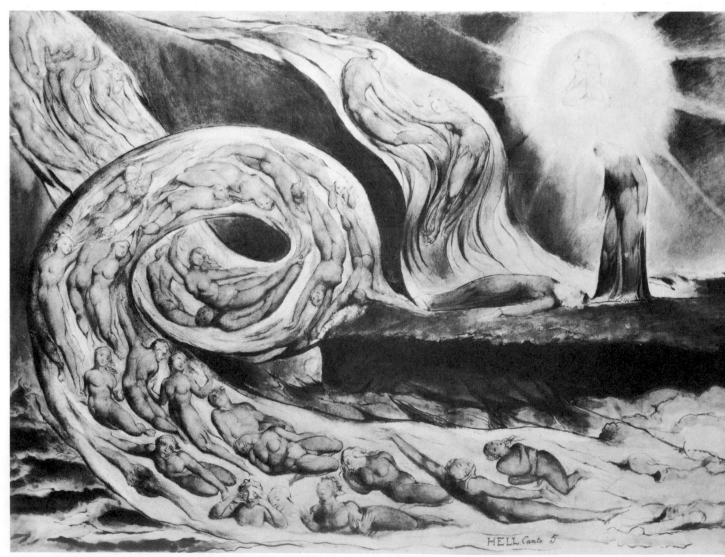

HELL Canto 5

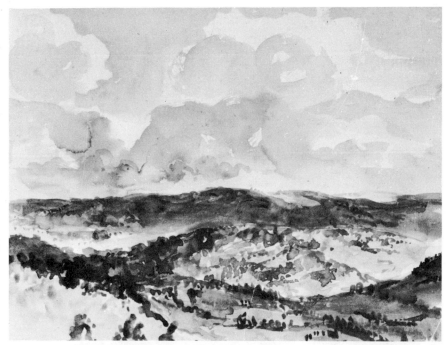

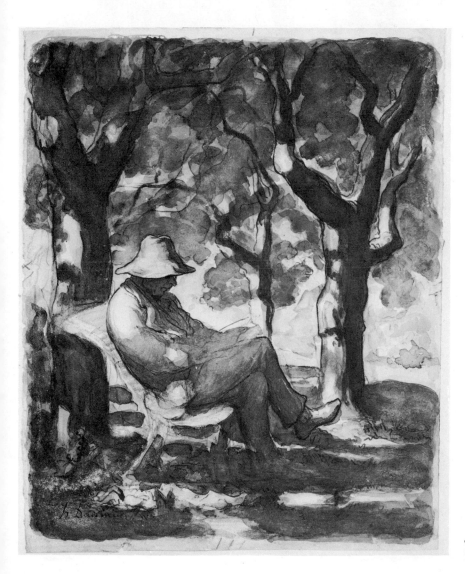

Slope of a Hill by Eugene Delacroix (1798-1863). Watercolor on paper.

The most notable painter and the leading figure of the romantic movement in France, Delacroix presents us with the antithesis of the Blake on the opposite page. Fresh, spontaneous, and spatial, brilliant in panoramic scale, *Slope of a Hill* is unlike even Delacroix's own carefully planned oils. But despite this sparkling, breezy jacket, there is a careful transposing of light and dark masses in the lower portion of the painting. This must be the result of Delacroix's studies under Gros and his admiration for Gericault, Rubens, and Veronese, all classically involved with subject and form.

While his output was prodigious, his most satisfying works remain his colorful sketches, drawings, and watercolor paintings.

Man Reading in a Garden by Honoré Daumier (1808-1879). 1854-56. Wash drawing on paper. $13\frac{15}{16}$ x $10\frac{5}{8}$ inches.

Once again we witness a classic control of form and structure in this amazingly solid performance by Daumier. Still, there is a premonition in this work of impressionist things to come. The loose brush and line, and the patient love for intense contrasts that characterize Daumier's work, are clearly evident. Originally a cartoonist, he eventually completed over 4,000 lithographs which, for the most part, furiously attack corruption and evil. His satirical and often bitter commentaries aimed at the French society around him are without parallel.

The Shell Heap by Winslow Homer (1836-1910.) 1904. Watercolor. 19$^{11}/_{16}$ x 14 inches.

Nassau by Winslow Homer. 1899. Watercolor. 15 x 21$^{3}/_{8}$ inches.

Winslow Homer was the first in a long line of American artists to receive wide acclaim for his watercolor efforts. Yet only recently have critics hopped on his bandwagon to speak of his modernity. They now proffer reasons why his tightly formed oils present "minimal" experiences of deepest and most profound implication. But the truth is that Homer was an illustrator, self-taught, and was happiest when cutting away from the shackles of his past. He openly felt that his watercolors were far more meaningful than his oils.

In both of the paintings shown here we share Homer's love for the open, windswept Bahama coast. His superb control of draftsmanship and structure understandably echoes his disciplined past, but there is ease and assurance in his adroit handling of the medium as well. Unquestionably Homer is the bellwether of American watercolor enthusiasts; but it is unfortunate that his work is more often emulated in method than in subjective spirit.

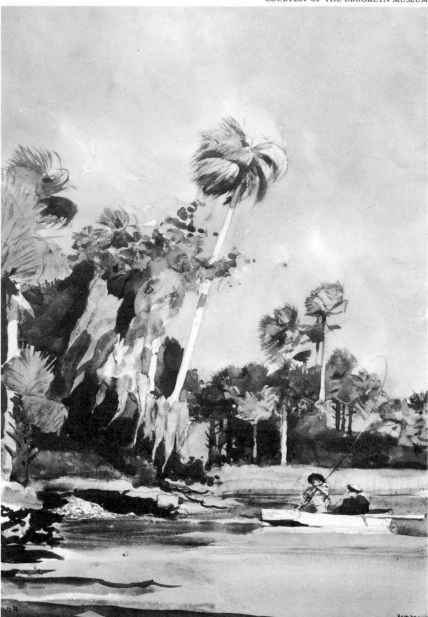

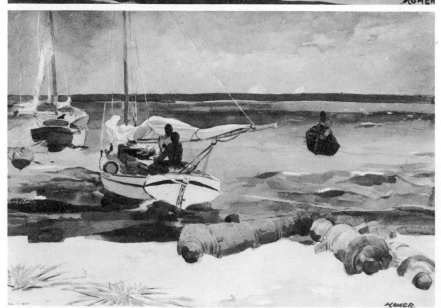

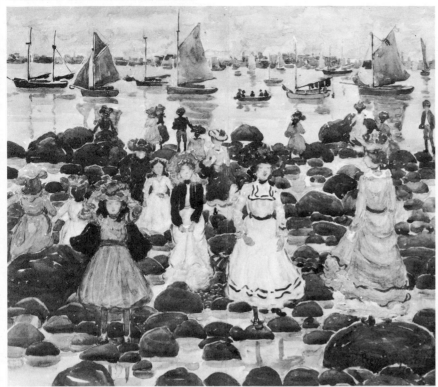

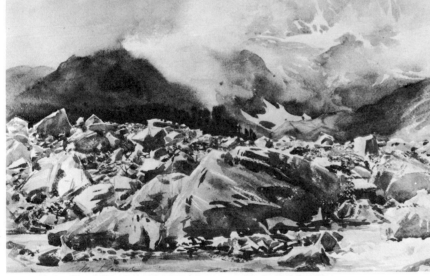

Low Tide, Beachmont by Maurice Brazil Prendergast (1859-1924). 1897. Pencil and watercolor on paper. 19½ x 22⅛ inches.

Simplon Pass, Avalanche Track by John Singer Sargent (1856-1925). 1911. Watercolor. 13 x 20½ inches.

The comparative essay of Prendergast and Sargent serves us with moving clarity, for time has reversed the positions of each painter. The struggling Prendergast paint-ed with little acceptance, yet is now ac-knowledged to be America's first modern painter, 50 years ahead of his time. On the other hand, Sargent's every effort was eagerly snapped up as he gained notoriety and fortune. He was a master of the ac-cepted style, a virtual pedaling-backwards when you think of Turner or Delacroix. While his virtuosity was conspicuous and unexcelled, he had little to say.

Maurice Prendergast once noted, "The love you liberate in your work is the only love you keep." His paintings gave full affirmation to his words. Watercolor for Prendergast was only a means to an end, as all media should be. He wove a pattern of beautiful people, gaily attired, happy at play; and his patchwork of color was de-voted to the re-establishment of nature as he saw and loved it. He dabbed at his sur-face with an awkward, halting brush, and made convenient rules as he went. No-where do paintings more richly endorse the content of watercolor.

31

Two Prostitutes by Georges Rouault (1871-1958). 1906. Watercolor. 26½ x 22¼ inches.

An overpowering statement, *Two Prostitutes* stands as a giant step forward in the history of watercolor painting. Rouault unleashes all of his disgust for vice and corruption in depicting these pitiful, grotesque creatures; and yet he does so with an underlying empathy of majestic proportion.

A student of Gustave Moreau, Rouault had already completed his apprenticeship to a stained-glass window maker when he enrolled at the Ecole des Beaux-Arts. Here he met Matisse, and by 1902 was associated with the Fauves. The point of this brief biographical examination is that his later work was to be greatly affected by these early events.

A deeply religious man, Rouault's initial efforts took deadly aim at a complacent, hypocritical society, largely through his commentaries on clowns, judges, and the prostitutes shown here. *Two Prostitutes* illustrates the spontaneous potential of watercolor when employed by a powerful draftsman of profound belief. Later in life he turned directly to Biblical subject matter in order to further express his devout attitudes; and only on rare occasion did he stray from the themes of religion, landscape, and the flower still-life. Regardless of subject, Georges Rouault brought a new dimension to painting, one that fused a classic background with Fauvist overtones and the simplicity of stained glass.

Bathing Women by Raoul Dufy (1877-1953). 1920. Watercolor gouache.

Dufy, like Rouault, was classically trained, influenced to an even greater extent by the Fauvist movement and Matisse; but, additionally, he felt a kinship with Japanese draftsmanship and concepts. He abandoned all attempts at imitation at the very outset of his career and sought to express himself with bright color masses held within a design format. He gave a new life to each element, whether object or person, that entered his work. Each element found its own place in a color tempo that was singularly Dufy's. As with Prendergast, Dufy's world abounded with a *joie de vivre* that included the recording of regattas, symphonies, and the pageantry of historical events.

Whether one believes that Dufy had more philosophical goals in mind or not, we are assured that he was drawn to the abundant life. *Bathing Women* may be nothing more than three opulent ladies languidly posing for us, or it might be symbolic of far deeper meaning and implication. While all this is highly debatable, there is no question as to his devices. When Dufy paints a shape, color, or tone, he does so with resolution. He relinquishes traditional draftsmanship and reconstructs with a flowing line that animates his forms. He delights us with his innovations, and again, not unlike Prendergast, makes watercolor traditions submit to his personal goals.

Twittering Machine by Paul Klee (1879-1940). 1922. Watercolor, pen and ink. 16¼ x 12 inches.

The vital contribution of Paul Klee to contemporary art is almost as well documented as that of Cézanne and Picasso. His influence is felt through both his paintings and philosophical essays. Klee's *Pedagogical Sketchbook,* which was actually a plan for theoretical instruction at the Bauhaus, is still a most deserved best-seller. In essence, it contains his inductive exploration of proportionate line and structure, dimension and balance, gravitational curve, and kinetic and chromatic energy.

Klee felt it essential that the artist communicate with nature, and that, indeed, he was a part of nature. Along with his Bauhaus colleague, Wassily Kandinsky, he was dedicated to the exploration of spiritual realities rather than to the traditional, analytical approach. *Twittering Machine* is a superb example of such thinking, for there never were living birds that resembled Klee's. Yet we cannot dispute the fact that they are birds, for we are even allowed to listen to their music. If we really care to hear more, we simply turn the crank, and who knows what further songs they will sing!

Klee rarely worked large; anything over 30 inches is considered unusual. Coupled with the fact that much of his work was executed in transparent watercolor, de-

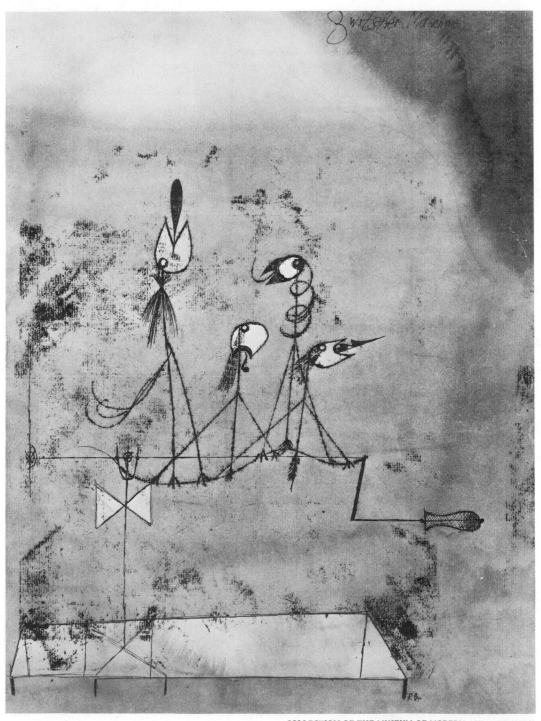

COLLECTION OF THE MUSEUM OF MODERN ART, NEW YORK.

tractors allude to the slightness of his efforts. This simply brings into clear focus the utter nonsense of such empirical criticism, for if ever there was an artist in full control of his work, it was Paul Klee. He dominated his painting completely and was unerring in his choice of sign or symbol language. He intuitively depended upon the controlled accident, so generously available with watercolor, in order to disguise his preciseness and to lend counterpoise. Klee's oils, by comparison, often self-consciously struggle to attain this quality.

Twittering Machine dramatically underscores for us the formation of the contemporary school. It symbolizes the fusing of myriad heroic but scattered attempts to break away from Renaissance thinking, and presages a future art world full of new expression, invention, and discovery.

Nude Female Reclining by Egon Schiele (1890-1918). 1917. Pencil and watercolor. 11⅞ x 18⅜ inches.

A contemporary of Kokoschka and Gustav Klimt (his teacher), Schiele is regarded today as a charter member of Austrian expressionism. His work reflects a brief, turbulent life. Quitting school, he was later imprisoned on charges of producing pornographic paintings. Days after his marriage, he was conscripted for military service; and three years later he and his wife died of Spanish influenza.

Schiele's prowess as a draftsman remains unexcelled. *Nude Female Reclining* characterizes the compassion he held for the female form; it is not as violent or distorted as many of his other works. He compressed, distended, and foreshortened the figure at will, exposed joints, and developed his own symbolism. His color was off-beat, as his unruly brush scumbled its way over a tortured surface. Painted almost exclusively in watercolor, Schiele's soulful outpourings are totally dependent upon his peerless draftsmanship.

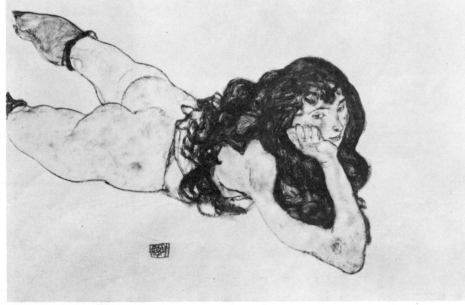

COURTESY OF THE VIENNA ALBERTINA.

Sun Storm by Oscar Florianus Bluemner (1867-1938). 1927. Watercolor. 10 x 13¼ inches.

Relatively little is known of Oscar Bluemner, yet his wondrous *Sun Storm*, painted in 1927, will live forever. It is a most inventive, personal expression of celestial energy, one that bares a mysterious, kinetic happening.

For 16 years, before turning to painting, Bluemner worked as an architect. Trained in Germany at the Academy of Fine Arts in Berlin, he came to America in 1892, where he became a pioneer of the modern art movement.

Sun Storm is typical of Bluemner's ability to simplify form and eliminate the unessential. Of special meaning to us is the manner in which he has ordered transparent glazes of watercolor to carry out his explosive message. All too often we hear empirical utterances that insist upon spontaneity in watercolor, yet neither Egon Schiele nor Bluemner seem to heed this advice. Antithetically, the crux of Bluemner's individuality rests largely upon his determination to solidify form and structure and ignore technical considerations.

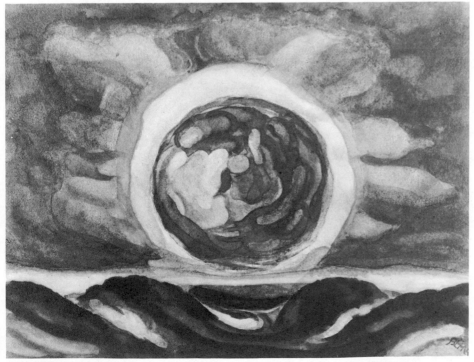

COLLECTION OF THE MUSEUM OF MODERN ART, NEW YORK. GIFT OF JAMES GRAHAM AND SONS.

Seascape by John Marin (1870-1953). 1914. Watercolor on paper. 14 x 16 inches.

Since we rely upon John Marin's dynamic orchestration in the following section, this eloquent statement is offered more as a commitment to our chronology than to his importance in American painting. *Seascape* is a relatively serene example of the rugged genius of Marin; in 1914, when it was painted, he had not yet been moved by the Armory Show, which was to have a great effect upon him. But there is evidence in the lower portion of *Seascape* of bolder things to come. Unquestionably the name of John Marin and American watercolor painting are synonymous.

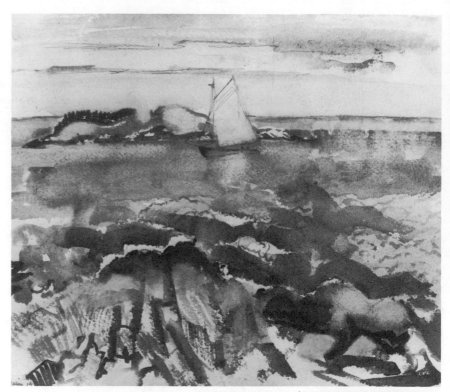

Mid-Manhattan by Lyonel Feininger (1871-1956). Pen and ink and watercolor. 40 x 56 inches.

In this single distinctive work we are immediately impressed by Feininger's passion for space and dimension. Everything he touched was fully orchestrated into a geometric network of shapes and planes: ships, buildings, people, land, and sea. Cartoonist, composer, Bauhaus professor, and an original member of the "Blue Four," Feininger's individuality and broad scope leave to us an unparalleled document.

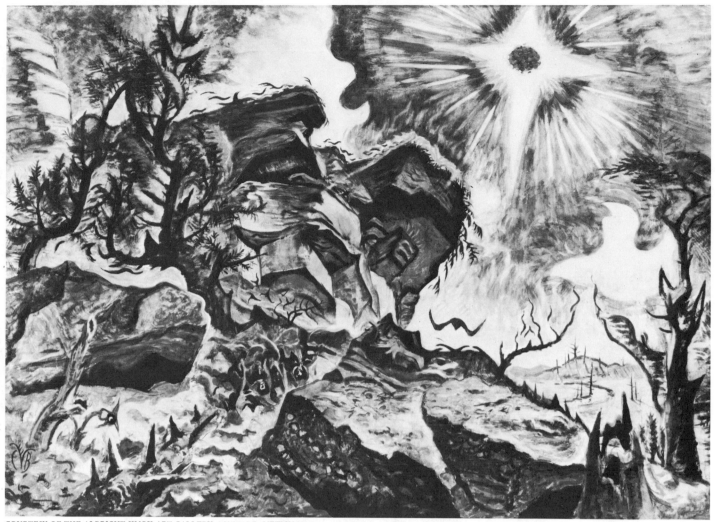

Sun and Rocks by Charles Burchfield (1893-1967). 1950. Watercolor. 40 x 56 inches.

If Marin and American watercolor are synonymous, then Charles Burchfield and American watercolor are almost equally so. His early paintings of the sound and smell of nature are deeply moving works endowed with mystical grandeur. He loved the world of growing things, of radiant light and murky depths, which fill his work with impelling mystery. In *Sun and Rocks* we are transfixed by the mighty sun-star, as the earth submits to its furious power. Burchfield tells us of swollen, gaping, reaching, and broken forms of living and dead things, and he does this with a powerful brush that defies convention. Perhaps Charles Burchfield's secret was revealed when he noted, "I do not wander the woods free of superstition any more."

37

THE BACKGROUND

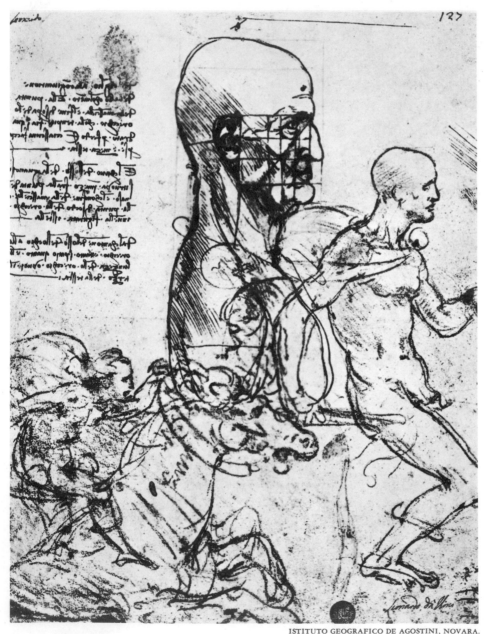

Studio per la Battaglia di Anghiari, Venice Academy, from the volume *Leonardo da Vinci.*

OF THE ARTIST

A "primitive" artist in today's society has to be either one of two things: naive or insane — unless, of course, he were to be found in some remote, secluded area. A so-called primitive living in an urban area is a pathetic figure, since he is surrounded by libraries, schools, art galleries, museums, and other artists.

In other words, there are things to be learned. How deeply involved an individual artist becomes in this learning process is a very personal matter, and where it may lead him is highly unpredictable. It may safely be said that an artist will learn in order to discard or avoid. For example, mastering perspective (a relatively simple matter) is necessary in order either to capitalize upon it or avoid it.

Several years ago a former student of mine went off to a summer of study with a renowned artist-teacher. When he returned, highly enthusiastic and bubbling over, I asked him what he had learned. "It was wonderful," he replied. "The first thing my professor told me to do was to forget about perspective!" In this instance the professor's advice was sound, as the student was well trained. But could we advise all students to do the same? Or, to rephrase it, how do you forget something you don't know?

Perspective is hardly a major course of study in any school of art today, yet the above may well be applied to all of the learning areas. The mastery of draftsmanship, picture structure, and color, plus a working knowledge of the properties of paint and support, can be no less vital to the serious painter. Nor can we begin to list the myriad explorations and penetrating studies which can prove deeply personal.

The purpose in outlining this background is not to frighten off the aspiring painter, but rather to lay it out clearly for those who are interested in painting or in becoming artists. It is essential to do this, for there are no shortcuts and there is no magic formula. Furthermore, painting is more than a craft or a skill, and it is high time to underscore this obvious truth in the area of watercolor study.

There are still other requirements apart from the formal study areas. Awareness, empathy, and integrity must play a vital role in the life of the artist; yet it is doubtful if these things can be taught beyond a point. To learn to paint is time-consuming, and one must not only persevere but learn to cope with dis-

aster. Self-discipline is a basic requirement and must be cultivated if it is not already a part of the aspiring painter. Eventually, through the development of work habits, the tedious and strenuous task can become joyful. I stress *strenuous* because, unbeknownst to many, painting is a tremendously enervating experience.

So many of today's young artists are in search of "instant" art or "instant" success; they are of the *now* generation. Yet Joyce Cary states that "Without education, it is not possible for a man even to appreciate any art." Kandinsky, among other things, was an attorney and had a thorough education before enrolling in art school, while Giacometti was well into his thirties before holding his first one-man show.

Only when the experience of learning finally awakens, strengthens, and frees the student will he become aware of the value of his labors. The subtle indications of growing competency or sureness achieved largely through repetition and practice are reassuring and beckon one toward that golden moment when he will paint without being conscious of the act itself.

In Henri Matisse's letter to Henry Clifford, Curator of Paintings of the Philadelphia Museum, he very eloquently states the following:

I have always tried to hide my own efforts and wished my work to have the lightness and joyousness of a springtime which never lets anyone suspect the labors it has cost. So I am afraid the young, seeing in my work only the *apparent* facility and negligence in drawing, will use this as an excuse for dispensing with certain efforts which I believe necessary. The few exhibitions I have had the opportunity of seeing during these last years make me fear that young painters are avoiding the *slow* and *painful preparation* which is necessary for the education of any contemporary painter who claims to construct by color alone.

While any course of study may look naked and exposed when it is examined in its written form, I believe that so much misinformation has been offered in the world of watercolor with respect to what constitutes study, that I have gone to great lengths here to present meaningful material.

Typical diagrams and analyses have been avoided, as well as various exercises that are altogether unnecessary. No advice will be given on how to paint a leaf or a tree, a clever little figure, or an industrial sky at twilight. Nor will aid be offered in the area of thatched roofs, stormy seas, stone walls, dogs, cats, horses, and birds. In my estimation, simple answers do not exist.

Nowhere in the world of art education has technique been so foolishly substituted for true meaning, self-expression, and knowledge as in the field of watercolor.

The following are examples of areas of study that are fundamental in the curricula of most top-flight art schools and colleges. It must be noted that in such a book as this, perhaps in any book, one cannot be taught *how to do*; but the following outline may well suggest *what must be done.* And while oversimplification is a deadly enemy, it is my belief that we may divide the major study areas of the painter into *composition, draftsmanship, color,* and *materials.* These four subjects are very complex in nature, and most artists become deeply involved in all at one time or another. Apropos, one may examine the work of a great painter and virtually pin-point the period when his preoccupation with one phase or another was evident. It is doubtful to me that a creative statement could be produced without the artist's being aware of all four of these subjects.

COMPOSITION

Perhaps composition, or picture structure, is the most difficult and complex of all the categories to explain, for there is little doubt that solutions to problems of composition are highly occult. By virtue of their structure alone, pictures may evoke meanings to the sensitive eye that read as legibly as realistic subject matter. Even to stand before a blank surface is to feel an intense clarity, immaculateness, and serenity. The absurdity of presenting a blank canvas for exhibition (it has been done) becomes less irrational when one contemplates the juxtaposition of emptiness next to clutter.

To digress for a moment, a painter's work may well be a daring new adventure, a reaction against other artist's efforts, past and present. His most recent paintings may take issue with his earlier work, as they strain against mannerisms, limitations, and prejudices. Composition is inexorably bound up in a reacting of one thing to another, whether or not that reaction takes place within the confines of a single painting.

Emerson once stated that "An inevitable dualism bisects nature, so that each thing is a half, and suggests another thing to make it whole; as, spirit, matter; man, woman; odd, even; subjective, objective; in, out; upper, under; motion, rest; yea, nay."

Thus, a diagonal line amidst the relative calm of perpendiculars and parallels produces activity and commotion. Large next to small, whether in color, form, mass or line, creates contrasts that are immediately felt. If a large red shape is placed next to a small green shape, we are treated simultaneously to contrasts of size and color. When two similar objects are placed side by side, one may appear to advance and the other to recede due to a simple alteration of color, tone or texture. Such investigation is so fundamental to the artist that it commences without the concerns of content and subject.

Wassily Kandinsky became so incensed with imitators (comparing them with apes) that his own approach to art remained in the area of the spiritual. A leader of the abstract movement which began in Paris at the start of the century, Kandinsky in his paintings and writings dealt not only with the basic contrasts alluded to herein, but moved on to far more esoteric areas, such as abstract "art of internal necessity."

In examining the picture plane, or surface of a painting, we find that it plays a dramatic role in how we interpret special meanings. The picture plane may invite us to look into a painting to an infinite horizon or eternity, or it may foster the illusion that objects are advancing toward us. The picture plane can support weighty architectural or geometric forms, or, conversely, the atmospheric and ethereal. Diagonal planes or planes parallel to the picture's surface may be utilized, each with different messages. The use of perspective devices, or their negation, such as the Cubist's *inversion* of perspective, is effective. We are all aware of railroad tracks appearing to converge at a distant horizon. When we upset this natural phenomenon by not allowing the tracks to converge or by widening them as they move to the horizon, we reverse order and cause the distance to advance. In essence we are dealing with distortion, a twisting or deviation from a natural shape. In further manipulating the picture plane, we use such things as surface patterns and symbols. Generally speaking, complex patterns recede as we associate smallness with distance, while the re-

verse is true with large patterns. Symbols such as letters of the alphabet, numbers, arrows, or other familiar shapes, also play an important role in juggling the picture plane.

The artist-composer is a keen observer of natural, architectural, and animal forms and may depend entirely upon their evolution as a source for his imagery. Or he may rely upon the imagery, subconscious, and the unpredictable (accidental). There are methods of weaving shapes to create patterns, to induce movement and produce stronger impact. Line, pattern, color, contrast, and texture support, define, and control these shapes. The very heart of a painting may reside in the fine balance of positive and negative shapes, or, to put it another way, areas that appear as weight-forms as opposed to air-spaces.

Nothing could be more appropriate today than to emphasize space, yet the artist has been dependent upon the implications and uses of space since the Stone Age. The classic use of space in Oriental and Renaissance art is illuminating, but no more so than the use of space in the contemporary works of the Surrealist, Abstract Expressionist, or Reductive painter. The control of space, whether shallow or deep, is of inestimable worth to the artist.

Lastly, a working knowledge of the traditional classic structures and controls, such as the Golden Section and/or Dynamic Symmetry, is rewarding. The Golden Section is essentially a geometrical proportion, dating back to Euclid, which governs the harmony of proportionate relationships both in art and nature. There are actually two propositions set down in Books II and VI of Euclid, but the common formula is "To cut a finite line so that the shorter part is to the longer part as the longer part is to the whole." Dynamic Symmetry is also highly geometrical. It proposes methods of establishing a series of *root rectangles* possessing perfect order comparable to that found in the Golden Section. Then, through a strict method of establishing diagonals, followed by horizontal and vertical divisions within the original shape, an endless series of lines, angles, and smaller shapes may be constructed, all in perfect proportion to one another as well as to the original shape.

One must be careful with such rigid teachings, since there is a temptation to adopt them as a crutch; but in a sense this may be said about all advice given in life. There was a time in my own career when the study of Dynamic Symmetry was an invaluable aid and comfort to me, and while my efforts at that time were self-consciously stiff and geometric, the experience was necessary.

DRAFTSMANSHIP

When one thinks of draftsmanship, perhaps the first subjects that come to mind are people, animals, and other recognizable objects. While these subjects will always be valid, there are, in addition, vast areas of expressive draftsmanship that are devoted to drawing those shapes and forms that reside only in the artist's mind. Even to play an ovoid body in tangent to a simple oblong and to do it with complete control and conviction is still draftsmanship. To carry a thrust to its wanted terminus requires not only the facility of hand, but, of far more import, the knowledge of *when* the precise goal has been reached. In painting, as with so many other things in life, the simple and direct statement can be far more difficult to achieve than the complex.

If we were to examine drawing only as drawing, that is, not as an inseparable element found in fine painting, then we might appreciate the importance that

schools of art place upon good draftsmanship. For drawing is the penmanship of the artist, his very heartbeat and soul. So much is revealed in the artist's ability to draw (or his lack of it) that many great painters are truly draftsmen in color. Leonardo da Vinci, for example, was a far more exceptional draftsman than painter. It may be equally shown that a great colorist is rarely a brilliant draftsman. Bonnard and Vuillard, who without question rank among the noted colorists of our time, could hardly be classified as magnificent draftsmen.

It is vital that the painter have a working knowledge of the human form. There are countless arguments posed today, convincing enough on the surface, that take issue with this idea. We cannot deny, however, that a study of human anatomy and its function is a most revealing exposé of the ultimate in mechanical engineering. While a knowledge of all animal forms is worthwhile, and sometimes imperative, the human form remains most important for the artist.

To have a knowledge of the human form is to understand one of the most ingenious apparatuses ever designed. It would be pure folly to ignore the opportunity and need to comprehend the function of bone and muscle, or the system of joints, shock absorbers, and protective devices that make up the human anatomy. How rewarding to investigate the interior regions and become involved with the phenomena of man's physiology. Indeed, how do we understand anything until first we understand ourselves? Furthermore, how can we expect to proceed with a visual commentary involving man without clearly understanding such things? It is often stated that if you can draw the human form well, you can then draw anything well. To a large extent I believe this to be true.

There is much to be gained from the study of man's inventions and constructions. How things work together, assist or oppose one another, and hence serve as lessons in functional analysis, is of great concern. Careful exploration of architectural form, past and present, is an exciting course of study for the draftsman. The most important lesson to be gained from this area is the full appreciation of soundness in structure. The budding artist will profit from a careful inspection of machines and tools, roads and waterways, and dams and bridges, and from this study he will develop a vital awareness of force, leverage, tension, compression, and power. It is fundamentally necessary for the artist to thoroughly comprehend gravity and balance, and it is additionally rewarding for him to investigate flight, motion, and animation. He will continually draw from the vast reservoir of nature study, geography, and ultimately the new geography of other planets.

Some of his drawings may spring directly from a subconscious image, while others may ramble on to exquisite, unpredictable conclusions without apparent direction or motivation. We could not begin to account for this immense variation in detail. It is reasonable to conclude that all artists, and most especially the young so rightfully engaged in new experiences, would profit from *early* study of the foregoing outline.

When we attempt to interpret a city, a girl, or a machine through our affection or knowledge of form, depth, shape or image, tone, space, color, texture, pattern, line, mass, void, and transition, we are simply staggered by how much there is to learn. Knowledge or information comes to us in many ways, but for the artist there is nothing superior as a learning process to careful investigative drawing. The artist whose background includes such a program of study develops a deep and lasting curiosity about all that surrounds him.

COLOR

It is easy to understand that many of today's painters find color to be the most fascinating part of their work. There is so much to be known about color and its effects upon man that one can hardly limit this enormous investigation to the artist alone. It is significant too that our broad knowledge of color is relatively new. Not only does the artist continue to make startling discoveries, but men of science and medicine contribute as well.

A painter may achieve overwhelming effects through nothing more than playful experimentation with color, whereas this is not likely to occur with draftsmanship or picture structure. Therefore, color becomes a tantalizing and delicious morsel, beckoning all and seemingly within the grasp of the novice painter. One must keep in mind the admonition and gentle warning of Matisse to those who would claim to "construct by color alone" (see page 40).

For our purposes we may think of color in the area of *color physics* or *color pigment.* Most painters agree that there is a need to gain a working knowledge of both subjects, although there are those artists who carry the study of color to complex and mysterious scientific goals. Rarely do these men continue to produce creative paintings, although we find an exception to be the renowned Josef Albers.

In color physics, we are primarily concerned with colors produced by refraction, although there are other ways of generating color. The simplest demonstration of color refraction is the Newtonian experiment of directing white light through a prism, which in turn disperses the ray and produces the color spectrum. Using this as a base, the eager young artist plunges into the study of light rays and wavelengths, why objects appear to be a specific color (through the rules of color subtraction), and on into the world of psychophysiological color. For color must be a *seen* thing, requiring not only the optical but the cerebral participation of the viewer. When color experiments are conducted with such goals as the phenomena of afterimage, illusion, etc., they are usually reliant upon the comparison and contrast of color.

How chromatic or intense one color may be when played next to another, or how dark or light a tone, or how warm or cool one color may appear through various juxtapositions offer endless and exciting challenges to the serious art student. A former teacher of mine, a noted color authority, has successfully identified color while blindfolded by placing his fingertips over multi-hued surfaces exposed to heat. Since it is basic knowledge that black absorbs and white refracts heat, it would not be too difficult for anyone to succeed with a very simple experiment of his own.

The painter and his pigment, in contrast to the color scientist, works in many other areas. He begins with a very basic use of color spirituality; in other words, he uses color to evoke emotional conditions within the viewer. For example, we all react to blues and greens, or the *cooler* spectrum, quite differently from reds and oranges, or the *warmer* spectrum. Color combinations may easily provide for us any number of harmonious or dissonant reactions. Color symbology, elaborated upon below, is especially significant to the artist in attaining more esoteric, precise meanings. Color impressionism is undoubtedly the most widely accepted area (although not easily understood) to be explored by the artist; this is largely due to the popularity of the Impressionist painters. Color groupings

that provide the viewer with sensations of humidity and temperature, as suggested by the terms *warmer* and *cooler* noted above, prove to be invaluable to the painter. Lastly, artists will explore the areas of precise color construction, which are often extremely mathematical. Apropos, there are methods and theories to be dissected. The Munsell system presents strict measurements for all color with respect to hue, value, and chroma. The Ostwald color system classifies all colors as either achromatic or chromatic, with a peculiar and complicated method of descriptions such as *full-clear colors*, *light-clear colors*, and *tones*. The great men of color are to be sought out; in particular Goethe, Bezold, Chevreul (who influenced the Impressionists), Holzel, Itten, and Albers.

When we think of the symbolic meanings of color, we automatically visualize red and green as stop and go. Red, white, and blue may hold deep implication for the American or the Englishman, but what kind of meaning does it hold for the Mexican? In America the color black is a funeral symbol, while in China it is white. Religion is filled with color symbolism: specific colors are associated with various rites and feasts. We need look no further than the red and green of Christmas and the blue and white of Hanukkah. White was once believed to be hygienically advantageous and was considered necessary in hospitals, especially operating rooms. Yet we now know that white contributes to eye fatigue, due to the intensity of light refraction of a white surface.

So, whether we are deeply or superficially involved with color, we recognize that the chemist, the physicist, the physiologist, and the psychologist contribute constantly to our growing store of color information. And while the artist has explored in the past, and will continue to explore and discover, he, along with the architect, designer, city planner and others interested in color from every esthetic attitude, will depend upon such sources for new information.

MATERIALS

The last broad category that must concern every artist at one time or another deals with materials and equipment. Since in Sections 4 and 6 the dynamics of watercolor and related media are fully covered, and there is a section in the Appendix entitled Materials and Equipment, this account will be brief.

The artist has to be aware of his materials, the nature of his pigment, of ground and support, adhering factors, permanency, and use. He must be cognizant of known limitations of media in order to be prepared to move on to new achievements. He cannot carry out experimentation successfully without a thorough understanding of his tools and materials, nor can he reconstruct desired qualities that are gained through accident alone. He will benefit in other ways that will save him both time and expense, for there are high roads and low roads to all destinations. Apropos, to see an artist use a large brush for a minute notation, or dry paint on a porous surface, or apply sensitive tonal nuances to a buckled or warped support, or simply paint *lean over fat* seems incredible to me, especially when he does not do so through selection, for special effect.

Still we must remember that artists are not chemists or scientists, and that there is a decided limit to the emphasis placed upon technological attitudes or theories. In the long analysis, as stated elsewhere, there is only expression. Only in rare instances would the esthetic viewpoint fail to suffuse and dominate the work.

While we cannot prescribe exactly what should constitute an artist's back-

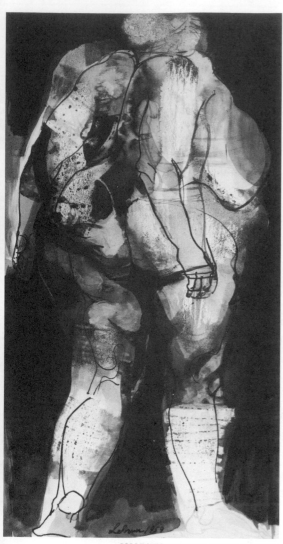

Figure with Bandaged Legs by Rico Lebrun (1900-1964). 1959. Ink wash and wax. 30 x 15¾ inches.

The power of the draftsman — what revelation, what singular beauty! The work of Lebrun needs no accolade, for it speaks its own mind. One has only to glance at *Figure with Bandaged Legs* to be swept into the world of mass and weight and of chiaroscuro and counterpoise. What a propitious moment to dwell upon the dividends of drawing knowledge. And what good fortune that the artist uses wash and line to record the moment. But here, from the magnificent volume *Rico Lebrun, Drawings* (University of California Press), the artist speaks for himself:

I shun drawing which is too easily formulated. It does not seem fertilized enough to produce consequences, and a drawing should be a provoker of consequences. It should be, above all, not a thing of art but a tool for understanding. I wish my drawing to get richer by consulting the tangible world. I am just beginning to see how even the most static form is bounded by profiles so constantly changing that the form itself is in movement. This inherent animation which has nothing to do with action offers me a chance to select and transfer to the paper those contours which most fully describe that movement and that life. When I become arbitrary in my selection, the drawing weakens; it is at this point that elegance, spontaneity, and freshness often take over and essentially destroy meaning.

The fine edge between the pertinent and the brilliant can be maintained only with the greatest effort. On the other hand, the deceptively simple means of line can lead time and again to half-truths. Seemingly the most easy of all crafts, drawing is the one which reveals most tellingly our incapacity to sustain true vision and our acquiescence to the ready-made. This baffling fact has haunted the work of even some of the greatest master draftsmen. And the nature of the task has all along been so strenuous that it is easy to see why drawing in our own time has moved violently away from the contest with the ascertainable world. Not only did it not want to repeat the results of the masters of the past (a moral resolution to be fully endorsed), but it could not find symbols of its own potent enough to equal in validity what tradition had already achieved. And in trying to find a new world of its own, the line — living into itself, disengaging itself more and more — finally achieved an ironical independence which is fine to see but not nourishing to the soul.

ground of study, it would be well if he could look back upon such exposure as is outlined above. Even then it is doubtful if anything more than a small progress would have been made in any direction. The true artist never really terminates the study program, for he is constantly searching and uncovering. This is part of his nature. Picasso states that he does not search any longer, but instead discovers, and this may very well be valid. Artists may play with semantics a bit, especially when paraphrasing Picasso; but all great artists learn and grow until stripped of the ability to work.

Whether an artist *searches* or *discovers* seems irrelevant to me at this point. What is important is that through intensive and thorough training, the young or beginning artist is led toward that golden moment when he will feel released from all bonds and fully prepared to begin. What precise order his training takes is continually debated by artists and educators, since needs vary with the individual student. Training, whether gained in formal institutions or otherwise, breeds discipline, and all great artists possessed some form of discipline. How else might one discard or violate rules, unless they have been learned; for to deny or *non-conform*, one must be intimate with the facts of one's rebellion, and anything less is deceptive or juvenile.

COLLECTION OF THE ARTIST.

Sleeping Women (page from Shelter Sketchbook), by Henry Moore (b. 1898). 1941. Watercolor, ink, and gouache.

Undoubtedly the most renowned sculptor of the 20th century, Henry Moore is noted for his poignant draftsmanship, particularly his epic drawings of sleepers in the underground shelters of London during the Second World War. The name and work of Moore will invariably be included in any discussion of art today, but why, you may ask, is it deemed particularly necessary in a book which is devoted primarily to watercolor? The answer is extremely simple: Henry Moore employs watercolor in its purest and noblest form; that is to say, one is hardly aware of its presence. Its place has been subordinated to a supporting role, with the result that all emphasis is given to meaning.

We turn to Moore for yet another reason: his is a unique force and direction that broadens the horizon of watercolor. He does not overwhelm or shout as does the magnificent Lebrun on the opposite page; but instead he gnaws at your soul and conscience. The work shown here is typical of that distinctive power, as it plays upon us with an incisive and tender message. One runs the emotional gamut, sensing courage and fatigue, and feeling guilt or shame. The attack is persistent; there is no relief. The artist's compassion is overwhelming.

Henry Moore was born at Castleford, England, of a family of miners. Today he works in an ancient farmhouse near Hertfordshire, a rural community just north of London. The monumentality of his sculpture is known to all, but an equally impressive attribute of Moore is his personal integrity and character. This always seemed so to me in his interviews and writings; it was also quite evident in our brief correspondence.

While of secondary importance, it should be noted that the trying conditions under which Mr. Moore worked during the brutal bombing of London compelled him to rely upon the special advantages of watercolor.

Group of Three Girls by Egon Schiele
(1890-1918). 1911. Pencil and watercolor.
12¼ x 17¾ inches.

Nowhere can there be found a more sig-
nificant contribution to the world of
watercolor than the work of Egon Schiele.
And yet the wedding of medium and art-
ist is far removed from the mastery of
Lebrun or the calm of Henry Moore. In-
stead, we are confronted with torture and
struggle, along with constant argument
and futility. No less compassionate than
the others, and unquestionably a brilliant
draftsman, Schiele stood apart as a young
genius on the prowl, searching and de-
manding as he went.

Egon Schiele died in 1918 at the tender
age of 28, thus terminating a most promis-
ing career (see page 35). A dedicated stu-
dent of Gustav Klimt, he was well on his
way toward the development of a highly
inquisitive, peculiar approach without
precedent. While *Group of Three Girls* is
relatively serene, there remains an under-
lying feeling of deep concern for the girls,
perhaps even of impending tragedy. This
characteristic is not foreign to Schiele's
work, whether it is still life, landscape or
the figure. While Schiele did some work
in oil, most of his efforts were executed
in watercolor and, to great extent, con-
cerned themselves with portraiture or atti-
tudes of the human body.

The intriguing analogy to be found
here is that the manner in which Schiele
abuses the medium fits neatly into the
content-message he offers. One is com-
pelled to accept the fact that this is not
purely accidental, indeed it remains at
the very core of his work; but there is a
lingering impression that this was also the
way it had to be, that there was no choice.
He was an intense young man who had
little use for convention. His work sought
out the truth as he saw it, concealed noth-
ing, and avoided the accepted genre of the
day.

Over and over again we are made aware
of the union of drawing knowledge and
personal concept. One could hardly point
to a mastery of the medium in the con-
ventional sense, or begin to instruct in
Schiele's style; it would prove fruitless.
Egon Schiele not only assaults accepted
notions of how one ought to draw, but
utterly ignores all technical painting ad-
vice as well.

48

The City (Man and Woman) by George Grosz (1893-1959). 1930-31. Watercolor. 25½ x 18½ inches.

We have examined the work of three brilliant draftsmen working with watercolor, Rico Lebrun, Henry Moore, and Egon Schiele. The fourth, George Grosz, though equally competent, is unique. The Grosz legacy is filled with an unparalleled bitterness. The nature of his enemies demanded savage reaction, and George Grosz met the challenge head-on. He lashed out at war profiteers, their promoters, and the establishment with a hatred that was born of deep belief. He dealt with sexual perversion, greed, lust, and crime with an eye to awakening the working class to all that was around them. He was utterly fearless and spared no one. Hitler and Nazi Germany ultimately became one of his chief targets; it finally became necessary for him to flee his country and seek refuge in the United States.

The satirical genius of Grosz has been so well established that few are aware of his other qualities as a painter. Subject matter or message alone does not automatically will greatness to a work of art, nor does the mere facility scorned by Nicolaides. The fact that the thoroughly trained Grosz saw and felt an enormous human injustice truly allowed him wider latitude and gives our thesis deeper meaning.

This relatively passive example of his work begins with the enigmatic double title, *The City (Man and Woman)*. It is as if Grosz wanted much more to be perceived than just an affluent couple out for a stroll. Their fashionable attire, and the suggestion of a wintry night in the lighted city, summon subjective responses,

as does the brisk action of the massive man pulling along with giant strides his more delicate companion.

As *The City* attests, Grosz is at ease with subject and media. He controls fluid wash and line with less concern for method than for his esthetic goal. In his widely known *Ecce Homo* series, he is far more caustic and violent in his attack upon a depraved society but, oddly, not as spontaneous as in *The City*. Whatever his direction, Grosz was a brilliant draftsman whose limitations knew no boundaries.

No artist may be adjudged by a single work; in Grosz's case such an attempt would be pure folly. Throughout his turbulent life, his work reflected one eventful turning after another. Court-martialed and saved from the death penalty, fined again and again for "insulting" works aimed at the army and public morality, he nevertheless continued to produce throughout his life. Although he became an American citizen, George Grosz was ultimately accepted and honored by his native Germany.

COLLECTION OF THE LOS ANGELES COUNTY MUSEUM.

River at the Bridge of Trois Sautets by Paul Cézanne (1839-1906). 1906. Watercolor on paper.

On Morse Mountain, Small Point, Maine by John Marin (1870-1953). 1928. Watercolor. 21 x 16½ inches.

How frustrating only to mention Cézanne and Marin. To expect single paintings to represent their massive contributions to art is unthinkable. Their contributions cannot be summed up by their works alone, but must be reflected against their roles as leaders of great art movements in Europe and America.

Since so much has been written about these two painters, we need not delve too deeply into folklore, but instead come directly to the point. We are examining their work with a single thought in mind: to uncover evidence of master composers at work.

It is by careful intent that we pose Cézanne's tranquility against the blast of Marin; yet one painting complements the other, and neither suffers by comparison because each artist remains in full control of total orchestration. Cézanne thought *River at the Bridge of Trois Sautets* to be one of his most harmonious efforts, achieving the utmost possible relationships. Every element in this sensitively structured painting seems indispensable. The rhythms, movements, films of iridescent color, and soft staccato line summon forth

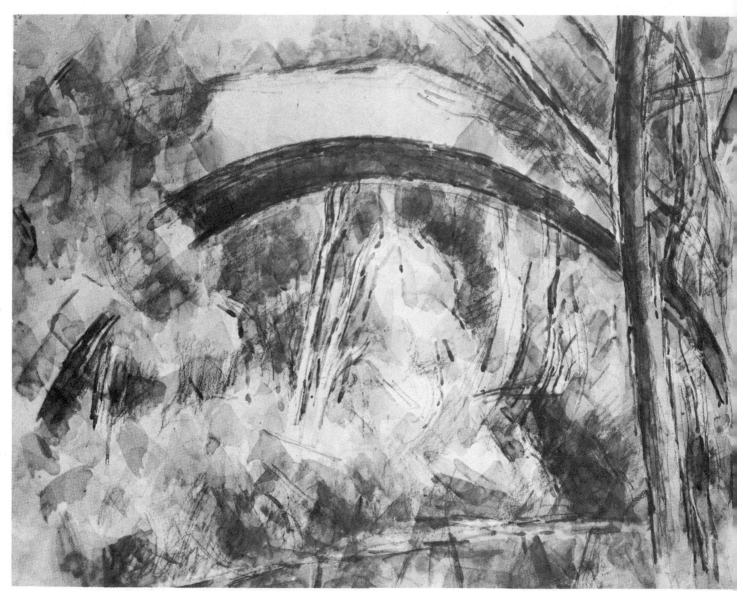

a vibrant melody. There is supreme order and ceaseless enjoyment to be found in repeated viewing. It is a magic blending of invitation and distant recollection, unquestionably the stamp of Cézanne. Painted during the last summer of his life, it survives as a dividend of his enormous dedication.

At first glance, *On Morse Mountain* seems quite different from Cézanne's painting; yet, when carefully analyzed, it is quite similar. Despite his more rugged approach, John Marin was as deeply concerned as Cézanne with the total statement and picture plane. Marin was a crusty, outdoor soul who abhorred convention, and his work reflected this character. Imbued with a love of nature, he was dedicated to a perception built upon a full use of the senses. He leaned into the wind and filled his lungs with the salt air; he meant his work to lure the viewer into this world. His enthusiasm caused him to paint over margins and onto the frame, at the same time dividing, cutting, and creating new planes within the painting's surface wherever needed.

In both of these notable statements concerning nature, there is no need for more horizon. Each painter says what he must and is done, and neither work pretends to be more through embellishment or geographical identification. Cézanne gives us a tender word, a quatrain; Marin grabs and sweeps us out to sea; but the compositional genius of both artists is omnipresent.

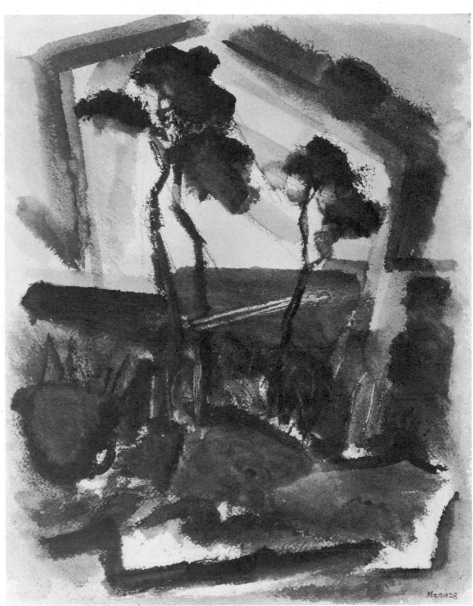

COLLECTION OF MR. H. SAGE GOODWIN. PHOTO PETER A. JULEY & SON.

51

Flowers Cyclamen by Charles Demuth (1883-1935). 1920. Watercolor on paper. 11¾ x 13¾ inches.

Whatever Demuth painted was done with extreme care, as is evident in this meticulous study of flowers. Whether working from vaudeville entertainers, flowers, or factories, his patient attitude robbed nothing from the effectiveness of his paintings.

Charles Demuth was an excellent draftsman and an even more remarkable composer. His illustrations of the works of Poe, Zola, and Henry James rank high as collector's items, while his paintings of acrobats are sought after by museum curators everywhere. But the relatively serene painting of cyclamens reveals more for our purposes than do his other works. Here Demuth exposes a penchant for control which faintly echoes the Cubist manner,

an influence he openly admitted and which was even more evident in his paintings of architecture. Demuth's control of space and form, along with his ability to transpose dark and light, invests his paintings with imminent drama bordering on the sinister. While it may seem far-fetched to those who are not aware of Charles Demuth's full range, he was considered to be a modernist crusader and is now acknowledged to be a forerunner of Pop art.

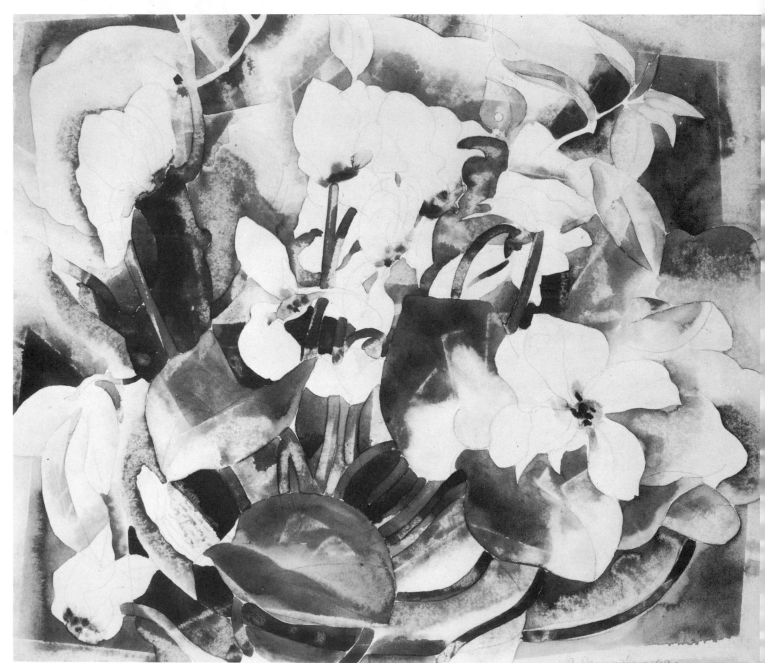

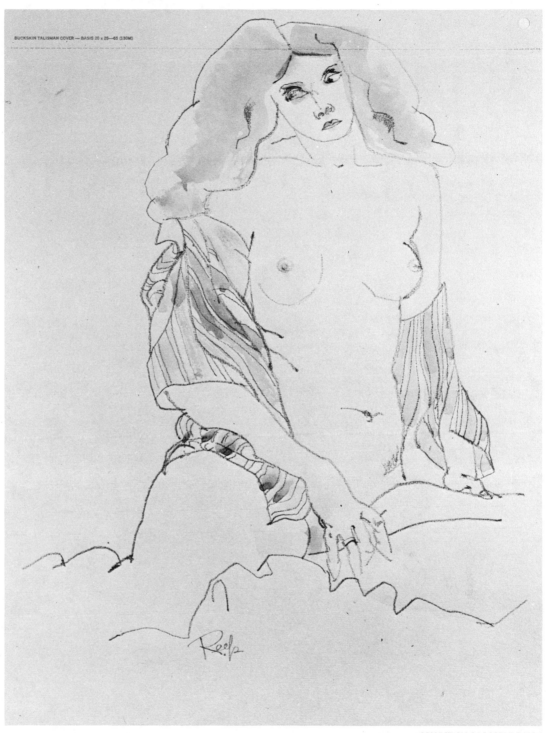

Miss M by Edward Reep. 1974. Pencil and wash drawing. 12 × 20 inches.

THE CONTEMPORARY

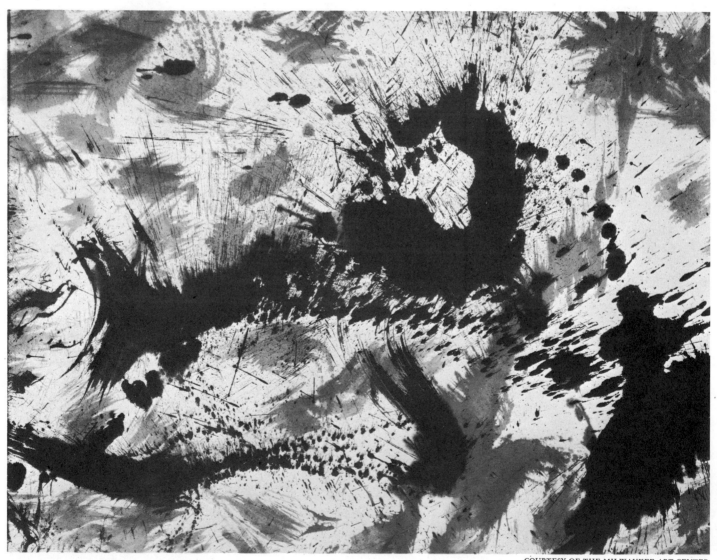

Dragonade by Mark Tobey (b. 1890).
1957. Sumi ink and rice paper. 24⅝ x
34⅛ inches.

SCHOOL

Defining precisely who or what is the "contemporary school" is so difficult and subjective a task that it might very well prove an impossibility. Nothing of this nature will be attempted here, save to chronicle in part some of the work that is being executed with watercolor today. Perhaps it should be further noted that while we are fully aware of much of the art of the day, we are certainly in no way able to account for all of it. Since most artists and critics agree that *art is a very secret thing* (created by one person, usually working alone, and not always able or willing to describe his work), there is a gnawing possibility that even the galleries and museums do not contain examples of the most significant contemporary paintings. As we all know, this condition is not peculiar to the present era alone. While we know that many contemporary painters of note have been duly recognized, and their works may be seen continually in galleries, museums, or reproduced in periodicals and books, we must also surmise that there will be numerous others appearing later who will take their rightful places as important members of our contemporary school. And we can only conjecture when we attempt to appraise any of today's work in the light of its meaningful endurance.

There was a time when it seemed painfully clear that watercolor painters produced more trivia than any other group of artists. In America and England, in particular, this condition existed, for painting in watercolor was a pastime or hobby, and was even taught as such in stylish girls' schools. Or it was nothing more than a sketching device, and the results, although stimulating, were dismissed as incomplete works. Clubs, groups, or societies were formed and unwittingly fostered one approach or another, usually with a local hero and his sycophants leading the way. But even as these dilettantish adventures were taking place (and they still are in many places), solid painting in watercolor was also being produced. In America, for example, if Homer was largely responsible for elevating watercolor to a major role, then we must assume that Prendergast kept it there, and Marin gave it liberation.

In the first section we traced briefly the origin and development of painting, with special attention to the important role played by watercolor. Throughout, painting has served the purposes of documentation and decoration. There were very few deviations from the accepted premise that a painting must communicate readily to the viewer, and that subject matter should of necessity consist of

recognizable objects. This was true even with Bosch's *Garden of Worldly Delights* (a precursor of surrealism), in which a most unlikely fantasy unfolds, employing carefully realized human and animal forms.

However, in the contemporary world of painting there are no such boundaries with which to contend. Over and over again we face difficulty in determining whether a painting is an oil, acrylic, or casein; or if it has been executed with transparent washes of turpentine or water bases, on canvas or paper. And this is as it should be, for the choice of medium is arrived at by a number of factors that have very little to do with predetermined limitations or restrictions.

It does not seem strange to me to note that Paul Cézanne, working in both watercolor and oil, began the great movement away from Renaissance thinking. Most scholars agree that Cézanne, at the head of the Post-Impressionist Movement, founded the modern school. There were others, too, such as Monet with his preoccupation with light, color, and their effects; but his was an unordered contribution that truly achieved full realization only with the lily-pond paintings near the end of his life. And while it was not Cézanne's desire to form a school or develop disciples (for he believed in an "individual intuition, fundamental, free from all preconceived academic ideas"), his followers were legion.

Cézanne's preoccupation with order through "concentric focusing" was not adhered to by Seurat, Pissarro, or the Pointillists. Men such as Bonnard and Vuillard seized upon a theme of dazzling quiltworks of color, while Van Gogh's concern was dynamic energy, and Gauguin's a pattern-tapestry of highly personal color. Others, such as Rouault, Picabia, Delaunay, and Leger strayed even further; yet in their work one could easily identify Cézanne's influence.

Now that Impressionism was a reality, it had to follow that there would be a continuing chain of rebellious reaction. So it was that the Fauves, or wild beasts, with Matisse as their leader, rose up to denounce Impressionism in general, and Seurat's mechanical approach in particular. In attacking "Divisionism," Matisse claimed that "The splitting of color brought the splitting up of form and contour."

Meanwhile, from Germany came Expressionism, with the two groups Die Brücke and Der Blaue Reiter spearheading the movement. Modersohn-Becker, Mueller, Pechstein, and later Nolde, Munch and Ensor, among others, were leading artists in this movement. Here was a vital, restless, and frenzied art that may well reflect the introspective, self-examining, and sometimes morbid temperament of the northern European mind. A sense of fear, imminence, fantasy, and mystery are inescapable throughout the Expressionists' work. In addition, we continually see Gauguin's strong influence; he, in turn, was greatly motivated by the printmakers of Japan. But if such imbrication in those days seems startling to some, think how prevalent it is today with supersonic travel and instant communication at our disposal. "Schools," as we have so conveniently labeled them in the past, no longer reflect provincial points of view but are now of necessity international in style.

To return to the events leading up to the present school of painting, it remained for the Cubists to create the most remarkable turn of all. Not only did their art influence the world of painting then and now, but it spilled over into architecture and design as well. The grandeur and elegance of Cubist paintings, at first colorless, fragmented and geometrically shaped, remains to this day. Later, as the work became more colorful and prismatic, it developed such a

dominantly scientific nature that it was likened to the work of Seurat. While it is sometimes impossible to pin-point a precise origin, it is generally conceded that two of contemporary art's strongest tendencies sprang from the work of the Cubists. One is the lesson of simultaneity, in which, as an example, one sees the interior of a vessel as well as its profile at the same time. The other is inverted perspective, in which lines, instead of converging as they move away from the viewer, grow farther apart. One may witness these devices at work throughout Cubist work, and most especially in the paintings of Juan Gris.

Futurism, while not of Cubist import, nonetheless contributed immensely to the artist's development of motion symbols: time and speed. Undoubtedly everyone concerned with art knows of the outrageous reaction to Duchamp's *Nude Descending a Staircase*. After its appearance at the Armory Exhibition in New York in 1913, Duchamp and *Nude* were household words in America. Less well known is the manifesto of the Futurists, speaking out against virtually everything and anything, including imitation, the masters, harmony, and good taste.

There is little doubt that the Dadaists had the most profound and lasting effect upon the trends that are current in our time. While the hub of this movement lay in Europe, as did all of the other schools noted herein, Dada quickly took on an international flavor. Major cities in Germany, Italy, Spain, Switzerland, and France formed Dada groups, and proceeded to hold festivals and fairs, to publish and exhibit. In New York, Alfred Stieglitz and his gallery became the center of the modern movement, displaying works of both European and American artists. It is of special interest to us that John Marin was a charter member of the Stieglitz stable, for this pioneer of the American moderns worked almost exclusively in watercolor.

Dadaism was in essence a denouncement of naturalism, realism, and idealism; in other words, imitation of nature was a lie! It dealt a death blow to those who were tenaciously guarding traditional ideas, and at the same time created a wedge into the future. And the Dada Movement was not to be confined to painting alone. It was a source of inspiration for poets, writers, and architects of the era. It became a symbol of freedom to men such as Schwitters, whose work made out of junk and rubbish was intended to shock the bourgeoisie. It is not surprising to find an even stronger bond between the Dada artists and those of today, when one realizes that there is a continuing protest against a society that embraces warfare. And because of a deepened sense of outrage and disgust, it is understandable, if not reasonable, that much of today's art is absurd, self-devouring, or *anti-art*.

Surrealism, the last movement of note that we shall concern ourselves with in this brief résumé, was soon to follow the Dadaists. But it is debatable if the Surrealists did more than bring attention to an art form that may well enjoy immortality. The ubiquitous nature of an artist's intimate fantasy world is made of such revealing stuff that it could never be denied. This is not to say that the Surrealist vision is universally accepted as the epitome of expression; incongruously, it is viewed with disgust by hordes of artists. The major source of resentment might well be the tedious use of photo-reality, despite the bizarre or dreamlike content couched in pronounced psychological overtones. But my point is, at the risk of oversimplification, that we have noted the works of Bosch, Arcimboldo, and Jamnitzer from as far back as the 15th Century, which appear

as contemporary as many modern Surrealist attempts. Dali, who is considered by some to be the leading exponent of Surrealist thinking (this view is not shared by all artists or critics), has virtually repeated examples of both Arcimboldo and Larmessin. The contributions of Ernst, Arp, Masson, Miró, Magritte, and Tanguy, among others, live on as far more distinguished Surrealist works.

While there have been numerous other influences felt since the advent of Surrealism, it does not appear that any clearly defined "school" of great import has been established. Nor does it suit our purposes to even presume evaluation or identification of such recent art. We cannot neglect reference to Action Painting and its marriage to emotion, vitality, and intoxicating drives. In this area alone, Jackson Pollock led the way toward international recognition of the contemporary American painter. And while Pollock was not the sole originator of action painting as such, he was immensely successful and well accepted at the time of his unfortunate death, and left a scintillating bequest to the contemporary world of art.

Today there are newer and newer turnings. Pop and Op art have been on the scene for some time. At the moment, there are eventful things being done in the realm of Psychedelic and Reductive art, both with paint and light. Happenings, boxes, traps, found objects, assemblage, frottage, and numerous other names, descriptions, and manifestos inundate us. Some directions are real, meaningful, and durable, if not much more than a repetition or extension of the earlier movements chronicled here.

To resume our discussion of the contemporary school, or (a) that part of it working in watercolor, and (b) artists who work in watercolor now and then, let me make the following clear. There is convincing proof that the versatility of watercolor is well established. Additionally, there is a long record of artists from every school and era who have felt compelled to employ watercolor for one reason or another. But nowhere is there to be found any work of lasting import that is referred to by medium over content. If it be said "the etchings of Rembrandt" or "the watercolors of Turner," it most assuredly is not the method or technique that is uppermost in mind (save perhaps for pedantic discussion), but rather the content-meaning of great artistic accomplishment.

Nor can watercolor be dismissed to a minor role, for quantity will never equal quality. It is enervating to read essays and theories espousing naive reasons for watercolor ever to have existed. The last such diagnosis to come my way binds American watercolor securely to "luminism," as if this were the major goal of Marin, Burchfield, Tobey, O'Keeffe, or Francis, to name but a few American artists of stature whose work in watercolor is well known to us.

The following pages devoted to paintings by artists working in watercolor is by no means a complete register of all such contemporary work of note. It is work that is either known to me by my association with the artist, knowledge of his work, and/or its availability for this purpose. Furthermore, I feel compelled to offer my deepest apologies to the numerous artists whose work would merit inclusion, but, by the very nature of physical limitations, has been omitted. Since the paintings have been selected to present as comprehensive a viewpoint as possible, without attempting a complete bibliography, each artist has been asked to present a written statement concerning his attitudes, concerns, and beliefs. In this way we may gain further insight into the unique autobiographical nature of watercolor and its content.

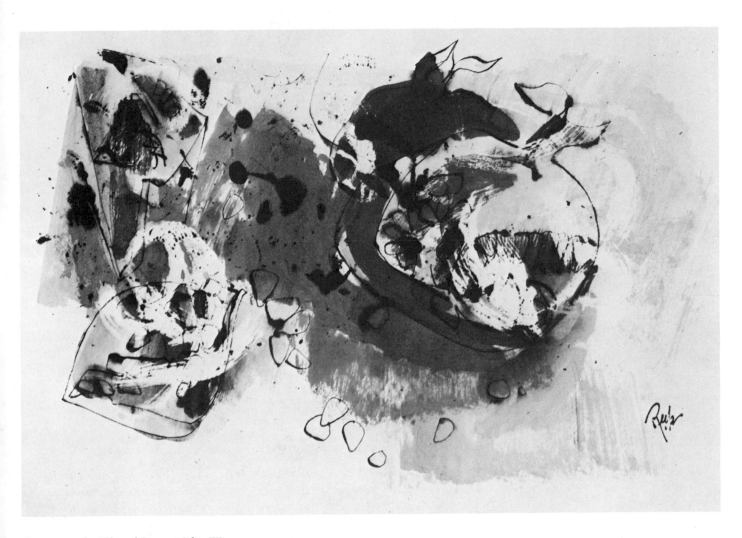

Pomegranate by Edward Reep. 1967. Water-
color and ink on rice paper. 11 × 17 inches.

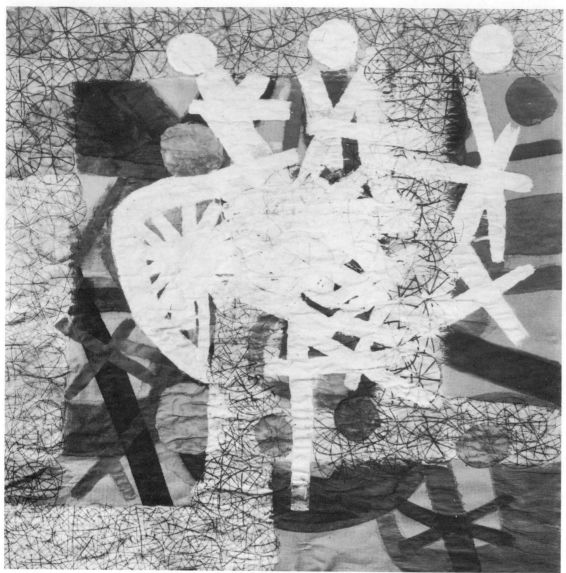

Fugue in the Silence #15 by Hilda Levy. 1963. Watercolor on "hospital paper." 19½ x 19½ inches.

In talking about painting, words may become a trap! The trap springs from man's need for reference to the known, the familiar — a sense of security. In seeking to hold on to these bases, one may fail to keep his emotional and mental passages open for the unfamiliar. The finality of the word is a deadening thing!

The visual arts offer the possibility to keep open these channels for true experience through revelation. This involves a process of becoming. The process of continuous change, or metamorphosis, is truly man's link with the Universe. This vision being metamorphic, how can the artist define his art? The nature of the creative self is so illusive, unknowable! The truth of the now stands by the side of a further revealment of the tomorrow.

A painting is telling of a creative act or of a non-creative act.

The process of life experience moves toward extraction of essences. Extraction follows destruction of elements made unnecessary for the moment present. So, too, in the painting — the process of destruction moves to preserve the necessary only.

The painting presents in itself the full gamut of an all-inclusive experience, and through its metamorphic existence continues to a composite of essentials. This final abstraction brings forth a new truth.

An attempt at explanation of a painting begins its dissolution. It will, however, reveal of its own accord its mystery to the beholder patiently seeking to fathom its meaning.

The fulfillment of the painting is the sensing of its particular flow as a truth. Only this experience can give the work a life of its own.

(Hilda Levy)

60

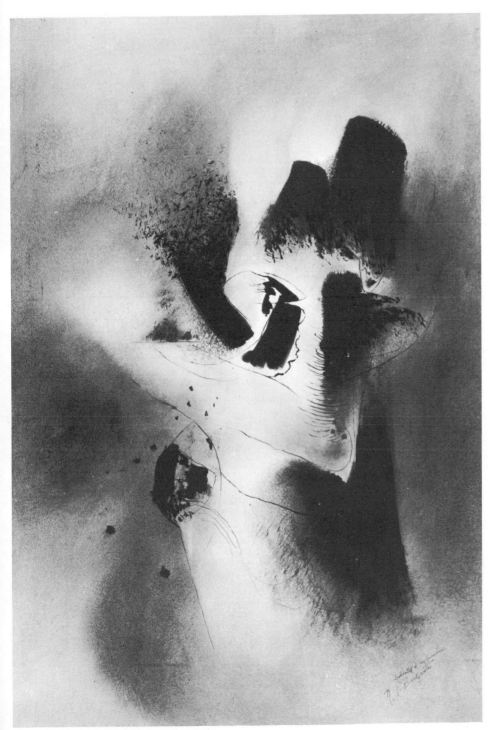

Three P.M. Fog by N. P. Brigante (b. 1895). 1962. Watercolor and ink on paper. 24 x 36 inches.

The artist must have absolute control from start to completion over all forces that engender the creative effort. This includes control over craftsmanship and materials, the entire surface and the spaces confronting him, the elements which suggest movement and dynamic, kinetic energy (Yang, active, male), and those which promote tranquility, with the rest and repose that follow (Yin, passive, female).

The artist synchronizes ends and means as well as heart and brain.

The natural world remains as always the common basis for all inspiration and research, even though it has changed from the world of our fathers and of antiquity. New images are constantly discovered and revealed, and appear in ever-changing forms for both our pleasure and enjoyment. We are also inundated with new sights, sounds, tastes, textures, and smells. To understand this new development, we must re-make and re-orient our vision with these new images, in order to direct these new elements into concrete, permanent, and expressive art forms. They possess shapes and are confined within limits, and they are microscopically small as well as enormous . . . Furthermore, these many images may reveal themselves to us but for a fleeting moment.

This nature touches and immerses us in a moving sea of atmosphere, heat, dampness, and cold. We are awed by the mystery contained within the volume of its depth and space.

(From *The Artist's Approach to the New Nature* by Nick Brigante.)

Composition by Ernst Wilhelm Nay (b. 1902). 1964. Watercolor. 16½ x 23¾ inches.

The notable simplicity of Nay's spontaneous and melodious paintings, would at first seem to contradict his elaborate philosophical premises. But quite the opposite is true, for he is totally reliant upon his personal investigations as source material for his efforts.

Nay is imbued with "the loneliness of man," and alludes to this in his writings. Initially I considered translating his statements verbatim, but all of my efforts proved meaningless. As his erudite wife Elisabeth has written to me (in English), ". . . But Nay's language is the language of an artist, and is sometimes not logical."

It is logical enough for us to determine that there is a brilliant and sensitive mind at work when Nay paints. "Nature," he states, "is not only visual, but has mathematical form." He draws from nature experiences which allow his work to speak of these experiences rather than of nature itself. He speaks of time, space, mathematics, physics, and cosmology as prime sources for new thoughts. He writes with abstract precision of ascending and diminishing scales of color and movement motifs. His treatises include the analysis of the number as a symbol, posing value against its imminent value.

Nay's paintings project an eternal quality that extends beyond the borders of the frame. He feels that his work is nonvisual at first viewing, but that it becomes more and more visual as we reach the center of each painting, where the visual quality disappears again. He likens this phenomenon to "a wave flowing over the painting in a very poetic way." This continual movement in each painting establishes the basis for a genesis; that is, the energy of one work flows into or demands another, until an ultimate cycle is completed. In his numerous exhibitions, Nay very positively wants each painting to be in contact with the next, in order to form this *zyklus,* or cycle.

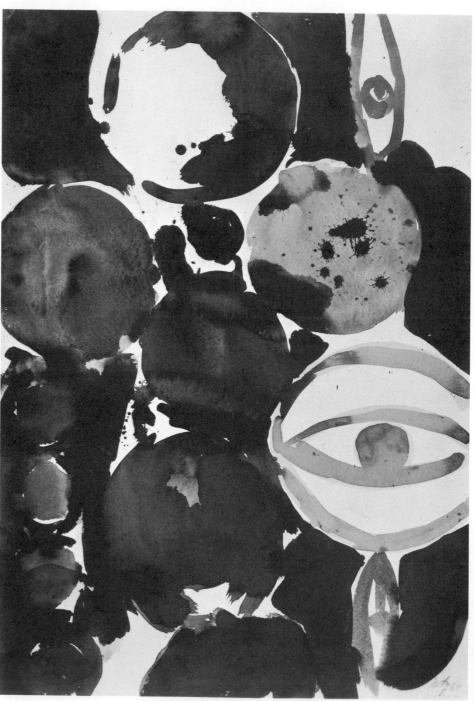

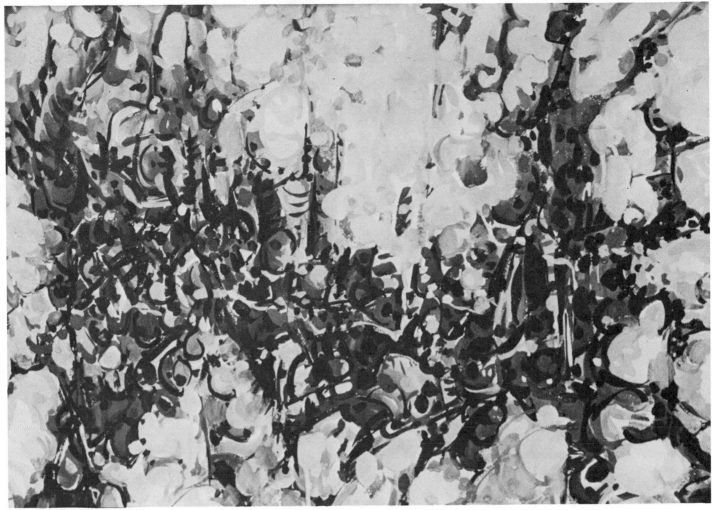

Untitled by Watson Cross (b. 1918). 1965. Casein watercolor. 19 x 28 inches.

As an artist-teacher I find many direct parallels in my approach to art and to my classes. There must be an opening of oneself, a freeing of one's tensions, prejudices, and predetermined techniques, to make contact, whether it be with a canvas or a student. Contact is the precise word. One must strip away one's surface self or front, one's respectability, in a sense, and say, "This is me! Take me, or reject me, but by God, this is me! This is my painting, this is my line!"

This sounds egotistical. What presumption to say, "I'm an artist," and, even more, "I'm a teacher of art." The brief history of watercolor painting included in this book can make one feel mighty humble. What a colossal act of egotism, then, to paint yet another picture! This is a part of the "hang-up" that must be stripped away if we are to make contact anew, to again be Adam before the Fall, or the child-artist before school.

As existential as the above may sound, we need not separate ourselves from the world of everyday experiences. In fact, these very experiences can enrich and mature us if we give ourselves to them.

Contact with new materials as well as with vital new people can bring creative action and touch new facets of the inner self. Knowing these inner resources and not undervaluing them in the slightest, we should prepare our physical self with the skills, crafts, and mechanics that seem continuingly relevant to our field. If we are unprepared technically, this too can limit our freedom and creativity.

When your precious moment of contact comes, prepared or not, it's your picture, or thing, happening then and for the first time.

(Watson Cross)

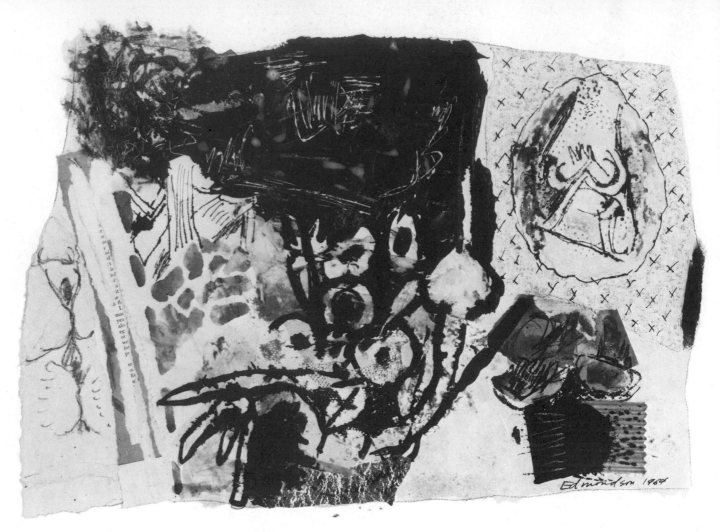

Dream by Leonard Edmondson (b. 1916). 1964. Watercolor collage. 19½ x 28½ inches.

Each artist creates out of an environment. His environment is physical, emotional, and intellectual — and he is imprisoned by it. What the artist receives (perceives) and how he responds (re-creates) are two faces which peer over his shoulder as he works. He may glorify his environment or curse it, embrace it or flee from it, make it a tomb or make it a garden, but he cannot turn away from the reality of it. This environment is made up of the major philosophical and social trends of his day on the one hand, and the most trivial, fragmentary, and peripheral episodes on the other.

The environment in which I work is dominated by science and technology. The machine has taken over and is my teacher. Science has created the specters of over-population and annihilation. An industrialized urban society has destroyed the old myths, scattered the family, and alienated man from nature, from his work, and from his fellow man. In the face of this environment that is shaping my art, I have responded in two ways. My first response is to assume an anti-traditional attitude — one that turns away from the familiar, the ingratiating, the appealing; one that defies limitations of artistic vocabulary (concepts, attitudes, purposes). My second response is to identify with the existentialists' "absurd man," who prefers to live with his courage and his reasoning, to live without appeal within the span of his life-time — the artist who does not concern himself with creating for posterity, but only with those creative acts which fulfill his existence.

My creative acts are intellectually conceived and pursued, with little reliance on gesture and still less on informality. The technique is impersonal (not the handwriting of the artist). The painting solutions are based on a predetermined structure (primarily of space, but also of arrangement). Space is sometimes used like an atmosphere which surrounds shapes and objects; sometimes like a web on which shapes cling. The arrangements can become either active (swift, moving, dynamic) or static (slow-moving or even inanimate). I would like my work to engage the viewer, to provoke him, to leave him free. My work is not didactic. It does not teach; it shares. It is its own metaphor. Its roots are buried in the environment from which it springs.

(Leonard Edmondson)

64

Oracle by Leonard Cutrow (b. 1911). 1962. Watercolor and ink on cloth. 14½ x 15½ inches.

It is difficult to write about one's own painting, since it must speak for itself; therefore, I will comment on painting in general. By painting I mean the artist's constant search for new symbols and ways to communicate.

The artist, from long, striving study, becomes keenly attuned to form; attuned to so great a degree that on rare occasions he develops new symbols and new ways of using this broad language. He applies these symbols in his own particular way of seeing and executing; he manipulates his vast energies to make use of all directions and accidents. He pushes and seeks because of a momentary mood. He gam-

bles and sometimes succeeds, then judges the work and in retrospect justifies the logic — a logic that does not necessarily come from the status quo.

Therefore, the artist with all of his concepts encompasses a broad range of human acts in the creation of a work of art.

(Leonard Cutrow)

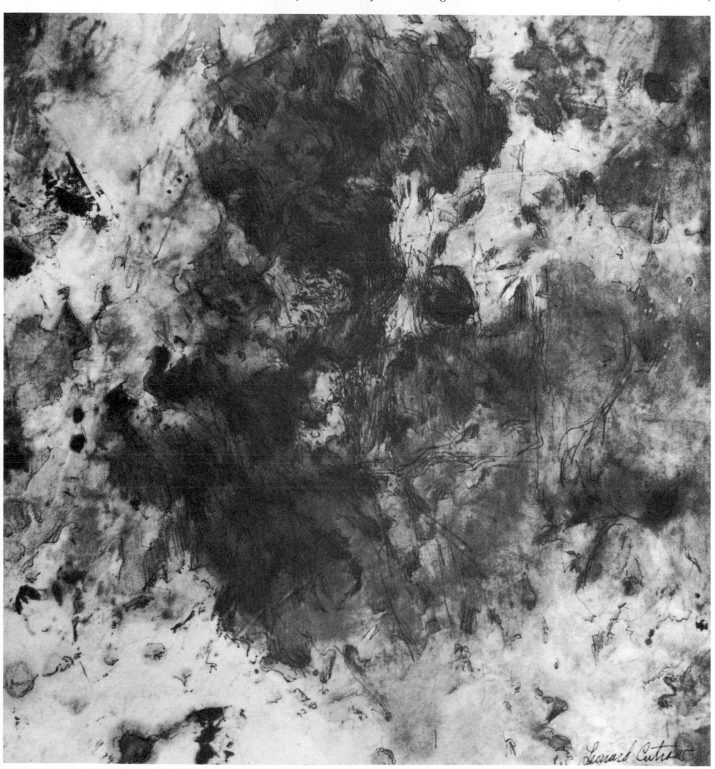

Malibu Series by Jack Kling (b. 1929). 1967. Ink on rice paper. 20 x 30 inches.

Ink drop falls, splashes, spreads; another follows, and another, and still more. From somewhere a line appears; it is intersected by another, and soon, as if by magic, shapes take form and meaning.

In a few seconds the intensity of feeling dissipates and is lost forever.

I try again and again, finding new wonders in each work, but always there is something missing, something overlooked or scorned. It is this something that drives me on to continue the search. Giacometti once described it thusly: "In search of the impossible."

(Jack Kling)

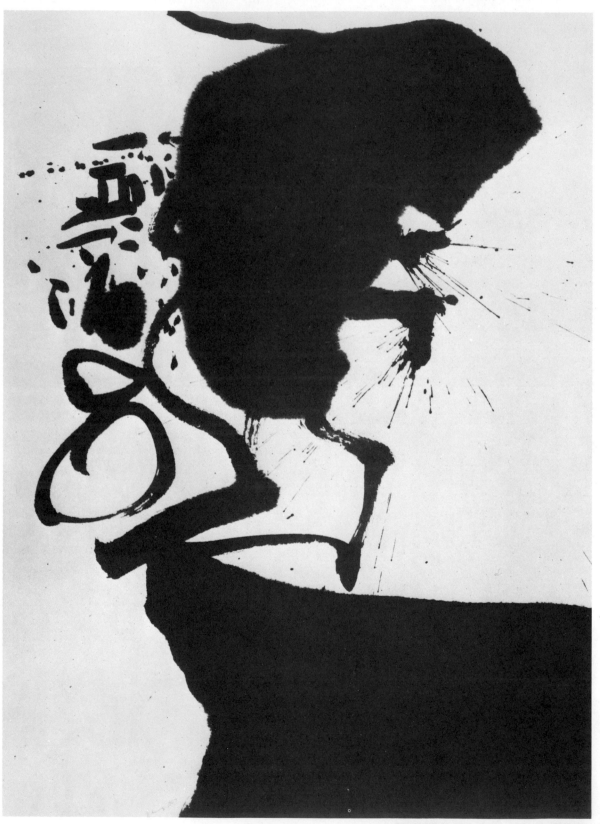

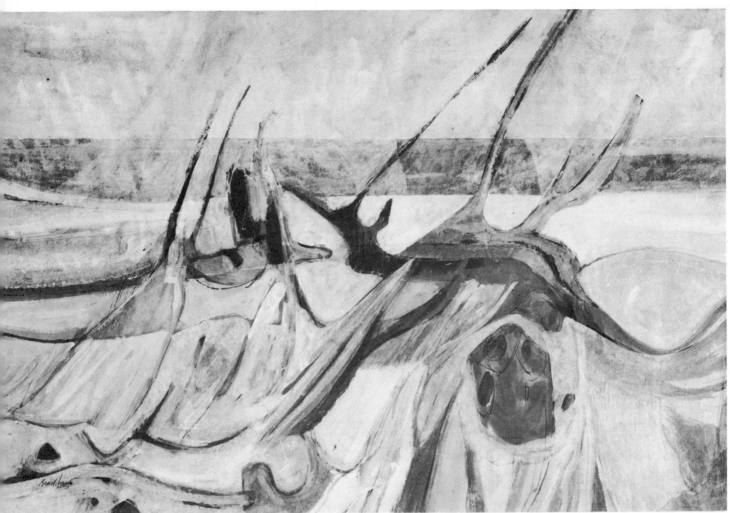

Mantled Shore by Glen R. Bradshaw (b. 1922). 1959. Casein wash on rice paper.

Writing about my own painting always creates some uneasiness for me because my primary means of communication is visual rather than verbal. It is possible to write about work methods and overemphasize the "nuts and bolts" side of art, and it is just as easy to go to the other extreme and pay lip service to ideas that I think that I believe but which, to more objective eyes, seem remote from what my paintings actually reveal. With these extremes in mind, my comments must then be measured to some extent against the work itself, and, if there seems some discrepancy, I believe that what the painting conveys should be regarded as nearer truth.

Among the beliefs that guide me are these: art requires order; the artist's work should reflect his uniqueness; the artist should know and respect the craft of painting; and a painting should be a rewarding visual experience for the viewer. I am aware that I prefer to work on absorbent paper, that I enjoy the immediacy of marks made with soft brushes and fluid paint, and that I often use complex color relationships.

My subject matter is nearly always lake-country landscape, but it is based on fundamental relationships and experiences rather than specific views.

Each painting is begun rapidly and intuitively, without preliminary studies, directly on rice paper. Then the relationships are compounded by the application of many overlays of thin casein paint. The work is continuously judged, and changed, until I feel that a precise unity of all its parts has been achieved.

How my work may or may not fit into current art style at any time is of little importance to me. It seems enough to do whatever I can, as well as I can, and to concentrate on the things which have meaning for me. Painting has meaning for me.

(Glen R. Bradshaw)

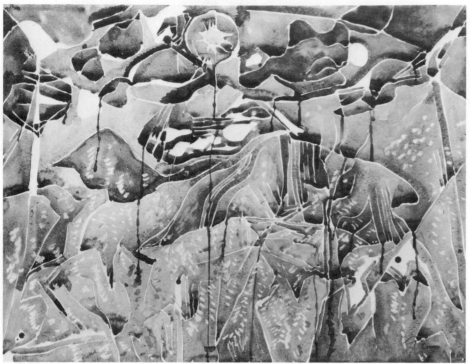

Red Horses by Harold M. Kramer (b. 1912). 1967. Latex wash on board. 18 x 22 inches.

Art is the act of creating an experience for both the viewer and the creating artist. The artist sees his meanings, his feeling-thinking, emerge from his work. This emergence from the canvas, paper, wax or clay is in accordance with the structuring he sets upon this art.

A major goal of the experimental artist is to select, invent or renovate a structuring that will house his idea-feelings. There are many, many structures in art and yet, in order to build them, he falls back on eight bricks — plastic or graphic means. These means are line, shape, form, color, value, pattern, texture, and sometimes movement. He may select two to eight of these bricks to build his creative structure, but in all cases he should be conscious of the restrictive and limiting nature of this art so as to expand it to his fullest use.

The mature artist can see-understand his work. His selection of structure, plastic means, and emotional idea gives him conviction and order. Without these, he tilts at windmills, deals with inconsistent emotions, and cancels out strength of meaning. The structural and graphic selections the artist makes do not confine his art but rather define and release it. The seeing-understanding of the wedding between his emotional ideas and his means is one of the purest profits in art. It is the meaning of the first line, when I said, "art is the act of creating an experience for both the viewer and the creative artist."

Art is not the act of locking nature into the canvas; this is merely depicting real estate. Art is man-made nature, and the understanding of the nature, its structure, plastic means, and energies wedded to an emotional idea.

(Harold M. Kramer)

White Line Landscape by Keith Crown (b. 1918). 1966. Watercolor. 22 x 30 inches.

The droplet of color running down the paper, the gathering of water and color in the valleys of warps, the confluence of saturated areas: these are natural, unforeseeable incidents of watercolor painting misjudged by some to be crude craftsmanship. To erase them would be to destroy the signs of adventure, to kill the painting.

One can discover only from a great deal of painting the delicate reactions of some colors placed in areas saturated by others, the sparkling whites of bare paper between areas of colors, the wild-fringed invasion of one color upon another when they are impinged, the power of scumbling and blotting. Without a subject, though, all of this is empty performance. The subject is all-important: it motivates the painting. Too bad it doesn't come in tubes — high-quality subject-motivation ground with the finest, most permanent ingredients — for the subject is so much more than a surface covered with bottles and apples, a landscape, a sailing vessel charging the waves. This subject-motivation is the personal observation, the poetry, the penetrating visual statement, the idea that pervades the picture, giving its appearance, its structure. Here one needs a certain kind of courage to ignore all that has gone before, that is so much surer of pleasing. With boldness reach into the painting with your brush to struggle with the unseen (the subject), and try to make it emerge into the visible.

(Keith Crown)

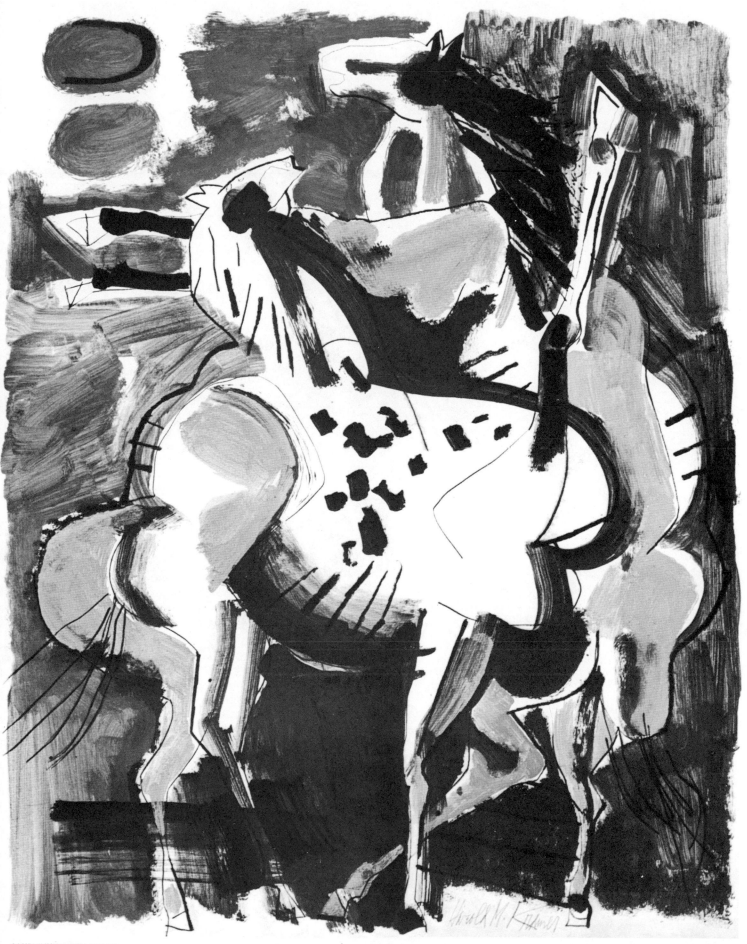

69

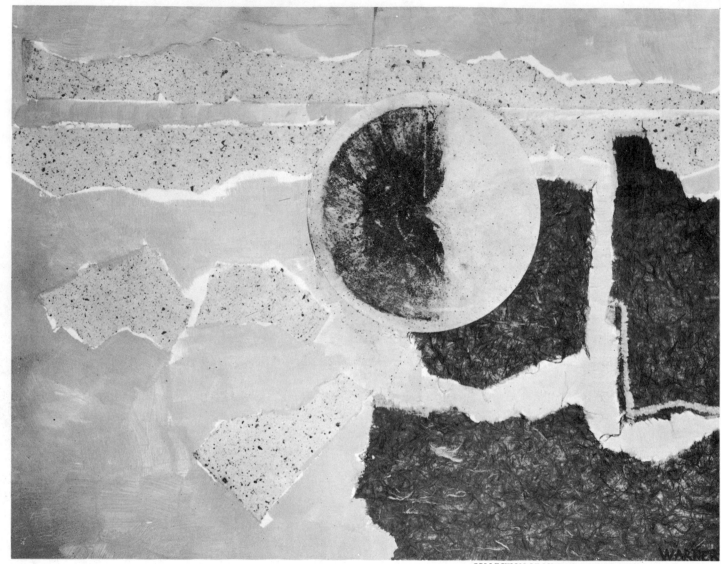

The Inward Sun by Elsa Warner (b. 1900). 1964. Acrylic wash and collage. 30 x 40 inches.

The immediacy of pleasure with the real, abstract moods of nature has been rewarding for me in the watercolor medium. The intuitive, spontaneous, imaginative, and automatic processes grow from the freedom of the activity of watercolor as it develops and shifts under the brush. This is an intimate and spiritual experience. The emerging images possess an emotional recall from many walks with nature in the cycles of her lights and seasons.

Abstract imagery, that which concentrates in itself the essential qualities of things, often reveals in depth their significance. My evolvement with inner and outer found images in collage activated the automatic juxtaposition of forms and colors. There is an intangible bond between the artist and his personal expression, and to these feelings I must add the joy of working in this infinitely challenging medium.

(Elsa Warner)

a message for Paul Klee

Message to Paul Klee by Olga Higgins. 1963. Watercolor and ink line.

The combination of watercolor, or casein, and working in line has long been a favorite approach of mine. Being an experimenter and innovator by nature has allowed me to move into many art fields and to employ media such as watercolor, Conté crayon, casein, gouache, collage, monotype, and oil. I am very prolific and work with great fervor, often producing a hundred paintings over a period of several months.

My most successful paintings occur when I am working on a specific series, sometimes concerned with subject but more often with media alone. When such a series is over, my evaluation of the work begins. Many times only a dozen may be saved, with the rest doomed to my "lemon bin"; but these discarded works may well supply me with collage material for future series.

The painting Message to Paul Klee *is a result of one such series that was devoted to line and watercolor wash.*

Today my greatest thrill as a painter springs from the memory of my long years as a commercial artist, which began at the age of 14. Having once experienced the pressures of deadlines, specifications, and a regimented life, I can now express myself with full freedom. Because of this, I feel a deepened sense of joy in my present creative endeavors.

(Olga Higgins)

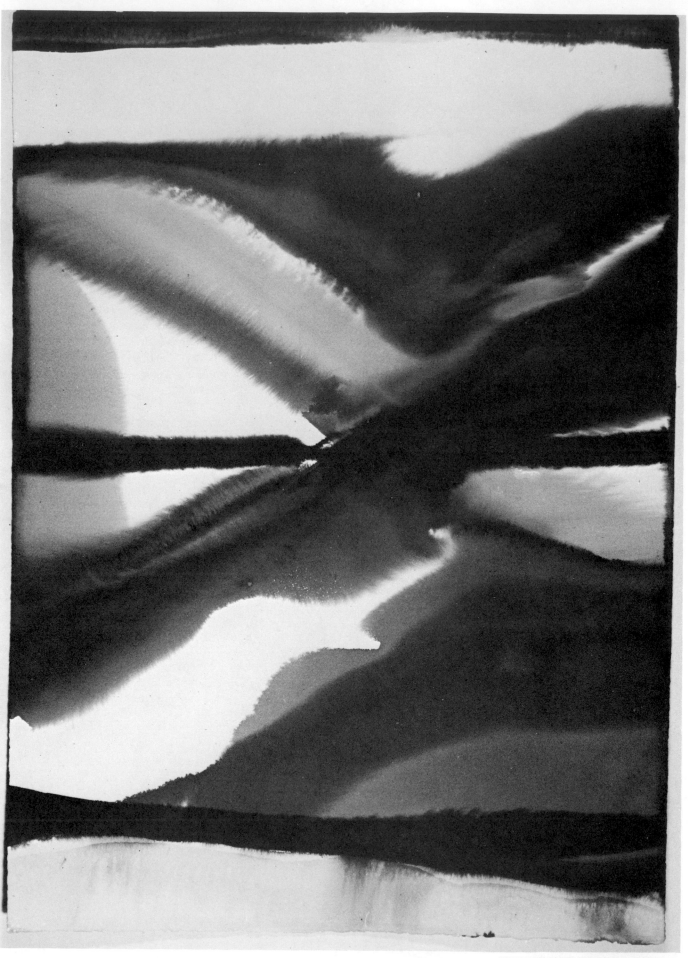

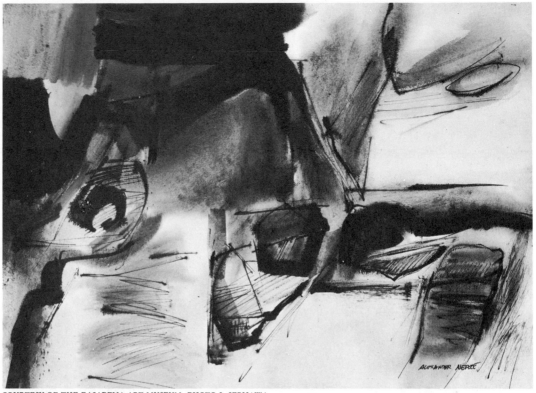

Phenomena Anatomy of a Cloud by Paul Jenkins (b. 1923). 1977. Watercolor on paper. 31 × 43 inches.

One doesn't simply view a Paul Jenkins painting—once you look at it you're trapped. Enormous washes rush one way or another, fluid and seemingly still feathering their edges or resolutely holding crisp. Movement, color, and scale; they are there to transport the viewer on an exciting voyage of discovery.

Jenkins's work seems effortless. How deceptive. *Phenomena Anatomy of a Cloud,* at 31 by 43 inches is virtually three times greater in area than the typical imperial-size watercolor paper; this in itself presents a challenge. Nevertheless, Jenkins's deep, rich color washes remain clear and vibrant, as he affords little credence to technical accomplishments. He is at ease with his work, absorbed by the statement and its destiny whether in sight or not, and the viewer is convinced.

Paul Jenkins's painting is seen here as a rightful part of the contemporary school. His personal commentary appears on page 112 alongside another of his stirring images in full color.

Utah Red Cliff by Alexander Nepote (b. 1913). 1957. Watercolor and collage on Masonite.

My reactions, which are embodied in my paintings, are the result of an intensive search: to see, as best I can, beyond the obvious to hidden deeper realities. I feel that man's existence in historical time is his greatest experience — his life. It is not my intention to describe a place but to suggest that the transitory things of nature are not the real reality. The ultimate reality is the never-ending process in which things come into being, exist, and pass away — the mystery of continuous change. This is a paradoxical situation, where the process which unfolds in historical time is the eternal, the absolute. To me, this constant transformation is best expressed by the illusion of deep space where relationships of light suggest the energy and movement in historical time, where mass and texture display the disruptions and marks of perpetual change. The esthetic fabric unites the seen and unseen, the known and felt, the specific and universal. In my paintings details of snow, cliffs, and crevices lead us to feel the spirit of massiveness, vastness or intimacy and to realize such experiences as aloneness, ambiguity, and mystery.

The technical process echoes the ultimate content. Torn pieces of thin black and white etching papers are glued to Masonite and painted as they are placed into position. There they are subjected to continuous modification — scrubbed, rubbed, pulled off, cut out, and new pieces added. The textured pieces (resulting from the tearing off process) are frequently reglued into the painting in different places, and repainted. This battle with materials continues until the work comes to life.

(Alexander Nepote)

73

THE DYNAMICS

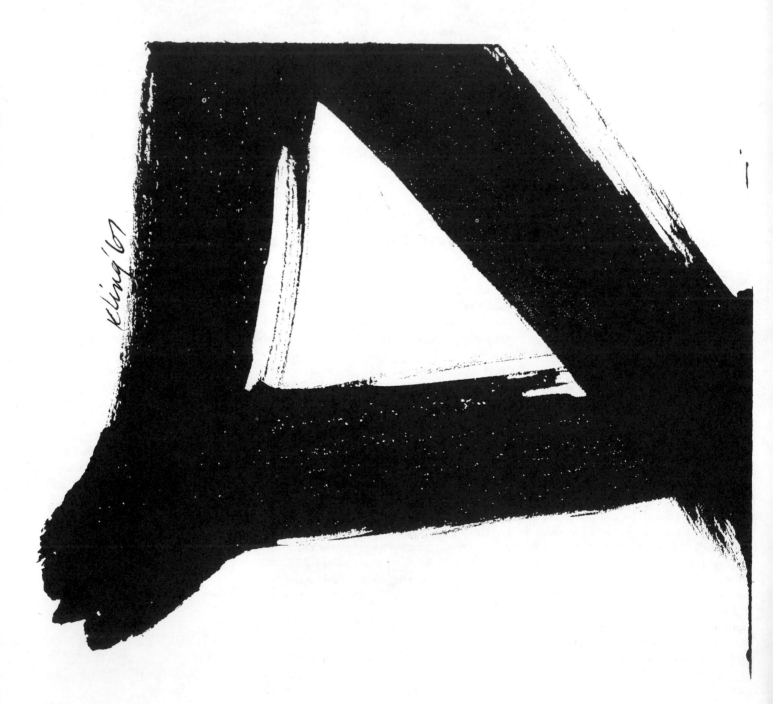

kling '67

OF THE MEDIUM

Dynamics: 1. The branch of mechanics that treats of the motion of bodies in space (kinematics) and the effects of forces in producing motion, and of the laws of the motion thus produced (kinetics): opposed to statics.

(Britannica World Language Dictionary)

The greatest concern, indeed the very crux of this entire volume, is contained in the deceptively routine area of dynamics. In no other area of art instruction has more misinformation been dispensed, with the result that it has served to inhibit rather than expand the artist's individual personality.

An over-concern with methodology is totally distracting when one is attempting to gain major goals involving content. Such things are attained through practice which builds experience, and technological solutions are then a wedding of common sense with that experience. It would be far more helpful to develop an understanding of the latitude that already exists and of the possibilities that beckon. The artist employing watercolor must be free to work as he sees fit: capriciously, meticulously, and, most important of all, independently! He cannot subscribe himself to a time element or a work pattern that is dictatorial. Popular formulae for "planning a watercolor" or "how to paint a tree" must be scuttled and relegated to that dismal level slightly above "painting by the numbers." Planning a painting is hardly the issue, for that is a most personal thing; but the true artist could never submit to another's method as a standard of procedure.

Nicolaides sums it up this way:

Do not try to learn a formula, but to become sensitive, to feel more deeply. Do not try to master a particular technique. Progress has been made by the people who refused to submit themselves to mediums. The rules of technique have been made by people who copied those who made the progress. You will paint well when you are able to forget that you are painting at all. When you are conscious of your medium, things become difficult, but when your interest is completely absorbed by the model — the idea — your materials become easier and easier to handle. Therefore, practice is the watchword.

Most artists recall nostalgically the use of the thumbnail or small preliminary sketch. In the early going, when sureness is a rare companion, such investigations are of reasonable value and comfort. Thumbnails in the hands of the mature artist may not only prove revealing, but worthy as individual efforts in themselves. As richly rewarding as they may be, it rarely follows that they

Brush Drawing (opposite) by Jack Kling (b. 1929). 1967. Ink on board. 4 x 4 inches.

would be copied verbatim; this would produce a mechanical, warmed-over kind of art. The feeble argument which suggests that if you cannot follow your plan then you are less the artist is pure nonsense and was a source of great irritation to me in my art-student days.

To elaborate further, let us assume that an artist begins a painting that will presumably occupy him for several hours, or several days. Why should he, then, proceed to devote the bulk of his time to the embellishment of a thought resolved at the outset, when possibly no later than an hour or two after getting underway a worthier goal may be suggested? Does he not know the meaning of flexibility, and of its richness of reward? Is it not a further possibility for him to approach a painting wherein a newer thought or an accident or turning may be seized upon; or could he not abandon the total concept and begin anew if a more enticing challenge offered itself? All of this is in direct conflict with the method plan, in which hours of routine busywork are devoted to the coloring-in of frozen diagrams.

Perhaps through the recital of personal experiences, a more forceful note may be struck in this forlorn area. As a student member of a class that worked exclusively in watercolor (on landscape locations), I was instructed to paint the sky first. Many times a sky was painted again and again until the proper result was achieved; after this initial victory, the rest of the painting could begin. Oddly enough, at a neighboring art school a class of similar nature was being advised to paint the sky last! Since skies were relatively simple things to paint, and could be adjusted to the rest of the painting with little effort, this bit of fatuousness was judged helpful. The pity of it all, at least to me, was that these dubious lessons were given in sincere fashion by hardworking teachers who were capable painters. The fear, in retrospect, is that damage was done to young artists who subscribed to such naiveté.

Watercolor was not, is not, and will never be a "class" on location or in the studio, working from the still life or the figure. It is a medium, as are oil, pen and ink, or acrylic. Class titles such as "watercolor landscape" and "watercolor figure painting" are meaningless, and invariably inhibit the student. Furthermore, an artist who works in watercolor is not a "watercolorist" but a painter who employs the watercolor medium for myriad reasons, perhaps too numerous to recite. Traditional definitions of just what a watercolor is are rather unfortunate in themselves. Each sincere attempt is either obscured by technicalities or diluted by an over-reverence of tradition.

After all, watercolor is nothing more than a paint whose pigment is finely ground and suspended in an aqueous solution of gum arabic, and it is miscible in water! The Europeans, in order to distinguish it from opaque paints, refer to it as *aquarelle.* Purists have traditionally frowned upon the introduction of anything foreign to the transparent colors, specifically, opaque white. It was generally conceded that a very white (a *cream* color was acceptable on rare occasions) hand-made rag paper was the most effective support to use. The only point of real significance in all of this concerns the permanency of the medium. For the purist of yesterday and today may not have produced any work of consequence, but it will certainly endure. To quote from the noted authority, Ralph Mayer: "When permanent colors are used on pure rag water-color paper and the picture is kept under the same normal conditions of preservation as are accorded other objects of art, the technique is as permanent as any other."

Working on a glittering white surface is fundamental to artists employing practically all media. In this way alone, a maximum brilliance is obtained from the translucent nature of watercolor. If the artist selects another support, or a toned ground, he does so with the complete knowledge that he is abandoning luminosity to gain other qualities. He knows that when he gravitates from the pure white ground, he loses the high rate of reflected light that plays off of it and back through the films of color. But by employing watercolor, the artist is granted the inestimable gift of being able to get where he is going quickly, often with effective conclusion. Accidents are omnipresent, and are conscripted to lead the way to newer discoveries. There is an excitement in the act of painting that is often inherited by the viewer. There is an air of expectancy and thrill that comes with each new juxtaposition of color, form or line. The very nature of the paint consistency, plus the design of the brush, invites the artist to continue painting with infrequent refills from his palette. The ease of mixing, especially in the subtle world of tertiary color, contributes to the flow of uninterrupted spontaneity. Everything is directed toward and suited to the *alla prima* attitude, and all paths have been cleared for the inductive response. Still this has to be only one thought, one suggestion, albeit more sophisticated and intriguing to the contemporary painter.

The painter may change the support to cloth, add collage of white or color-fast papers; paint back over the collage, add ink, work with stick, twig or bamboo; use rubber cement as a frisket, or wax-resist, or invent his own approach. He may splash and splatter, or let the paint run; what does it matter if the floor is dirtied or his clothes are soiled? How does one think when such concerns are cluttering up the mind? Scrape the paint, scratch at it, scrub it away; ruin the surface and start again. Or sit quietly at a table and use rulers, T squares or any other mechanical device to gain the desired result. Break every rule, ignore all advice; but know it first! Only through long experience can one expect to grow, to understand and appreciate the singular beauty of watercolor. This medium is not simple to work with — but then, neither are the others; it is time that this be made abundantly clear. There is every good reason to believe that a great artist would be able to work in any medium, even one completely alien to his nature. Take from him all of his familiar and beloved materials, leave others in their place, and it will be a matter of time alone before great works will again pour from his studio. As an example, John Marin had great difficulty with his control of oil, particularly in the manipulation of the fluid calligraphy he excelled in; but, then, his watercolor paints were always near at hand. There are stories of the Mexican artist, Diego Rivera, who drew with shoe polish on newspaper all through the great depression of the thirties. At the expense of seeming redundant, it would be prudent if the aspiring artist learned to draw and compose; one could then assume that after these major victories, problems of materials and techniques would be easily conquered.

Because there has been so much said about how one should paint a watercolor, the following antidotal information has been included. The fullest control of a very fluid, water-miscible paint is maintained by varying the proportions of water and paint. For those encountering watercolor as an initial experience, it seems furtive, elusive, and downright unruly. Apprehensions soon vanish, however, after competence and confidence are gained, mainly through practice. When the artist works a relatively dry brush into a wet surface, he maintains a

firm control of his stroke, as is virtually the case in all liquid media. A dry brush applied to a dry surface or a wet-into-wet approach affords still other possibilities, and in this light the aspiring artist makes progress. We could discuss scraping, scratching, splattering or splashing in detail, but this would be antithetic to our premise. In addition to the obligation of the individual's personal experimentation with the medium, there are the works of thousands of other artists to be studied carefully and used as a fount of information if not inspiration. The paintings reproduced in this section alone provide a good beginning. One may quickly note the value of a wet or dry calligraphy, or the use of a stick to apply paint or a hard-edge instrument to scrape it away. There is little advantage to be gained in suggesting one kind of tool or another, since we could compile a list that would fill volumes, and they would all make a different mark. Splattering and dripping paint need to be done, more than to be described. The very heart of this adventure is imbedded within the hide of discovery, and is highly personal.

Painting is not without its amusing experiences; and those who are either blindly or platonically devoted to this medium in particular make bountiful contributions. For one thing, there is a breed of *artists* who take enormous pride in being able to produce a very narrow line or minute shape with their largest brush. They will use the same brush so exclusively that all of their results are similar. It has never occurred to them that they might well use a smaller brush for smaller strokes, and the larger brush for massive areas. There are those who will not put paint on their palettes; frugality is part of their composure, and their work shows it. A stumbling mass of insipid, unchromatic brush-stroking appears worn and faded at best. Another manifestation of frugality is seen when a large mass is to be painted, and only a minimum paint mixture is prepared. While this is common to most neophytes in all media, it is devastating in watercolor, since it is time-consuming to duplicate color mixtures in general, and time is often a vital factor.

The paintings that have been carefully selected for reproduction in this section possess a strict, singular purpose. They are not intended to entertain or amuse, but to be inquired into, dissected, and laid open. We want to know why and how the artist performed as he did, even when he may not be able to explain the nature of his automatic responses. The professional painter, along with experts in other fields of endeavor, creates in a relatively subconscious way. Excellent drivers, after arriving at their destinations, often forget the paths they took. If one were to ask a pianist, a surgeon, and a golfer precisely how they achieve their high level of performance, they would probably be quite unable to provide totally clear explanations.

The professional painter is well equipped, and he comes by this through experience. He has long since ceased to blame his equipment for his failures or inadequacies, although it would be well to keep at a safe distance when a defective paint or support has been unwittingly employed. He knows what to reach for and generally where it is; his instincts tell him these things while his mind is saturated with deeper concerns. And this applies to the action painter as well as the deliberate mechanic. We will look at the paintings contained in this section with this in mind, and try to get inside of the individual artist to determine why he resorted to a given approach. By the use of photo-enlargement, we will journey with the artist down a very private road. Here is a truly magical expe-

rience in any painter's medium, for all have their unique qualities that allure and, sometimes, seduce. Rather than be awe-struck or bewildered by these microscopic adventures (for such things are inordinately delightful), we will be engaged in a private autopsy of *why* and *how* an artist speaks.

One last word before turning to the paintings. Although they have been selected solely on the basis of their individual ability to project a clear message relative to the dynamics of watercolor, they are quite properly, in their own right, superb paintings by accomplished artists. These people have been most generous in allowing me the privilege of presenting their work in this manner. It would be safe to assume that they share with me the belief that watercolor is capable of inimitable expressiveness and unsurpassed beauty.

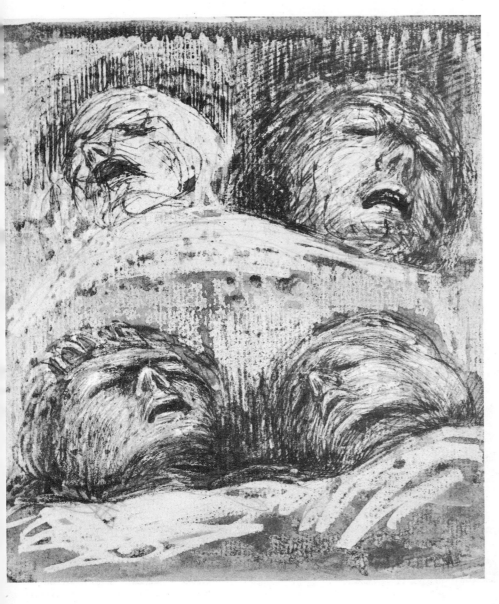

Page from Shelter Sketchbook by Henry Moore (b. 1898). 1941. Watercolor, ink gouache.

The pictorial essay of this section is mainly concerned with the exposition of the watercolor medium in all its forms, clarified by an accompanying enlarged detail of each work. However, with the paintings of Georgia O'Keeffe and Morris Graves it was not deemed necessary to include the detail, but rather to display the work as large as possible. Biographical data is kept to a minimum; the text is devoted to a clinical examination of the work itself.

Evening Star, III by Georgia O'Keeffe (b. 1887). 1917. Watercolor on paper. 9 x 11⅞ inches.

This startling painting by the pioneer contemporary American painter Georgia O'Keeffe is even more remarkable when one realizes that it was executed in 1917. The bold simplicity of its structure virtually overwhelms the viewer, and relates to the reductive thinking so prevalent today. Unlike the present school, the O'Keeffe statement does not deny textural concerns, but instead welcomes such events with open arms. All artists know that well-thinned or liquid wash will produce unpredictable results when applied to various surfaces. In *Evening Star, III* we see the result of this phenomenon and its magnificent contribution to the broad, linear forms.

Bird (opposite) by Morris Graves (b. 1910). 1957. *Sumi.* 34 x 22¾ inches.

In Morris Graves' handsome *Bird* we witness a similar happening. But, rather than imprison the textural experience within the stroke, Graves has pre-wet the surface in order to encourage a flowing out, so to speak. With but one purpose in mind, namely, that of exploring the dynamics of the medium, it would seem foolhardy to attempt this magnificent performance in any other way. It must also be noted that the elusiveness purposely sought out in painting *Bird* is made valid primarily through Graves' acute sensitivity and competent draftsmanship.

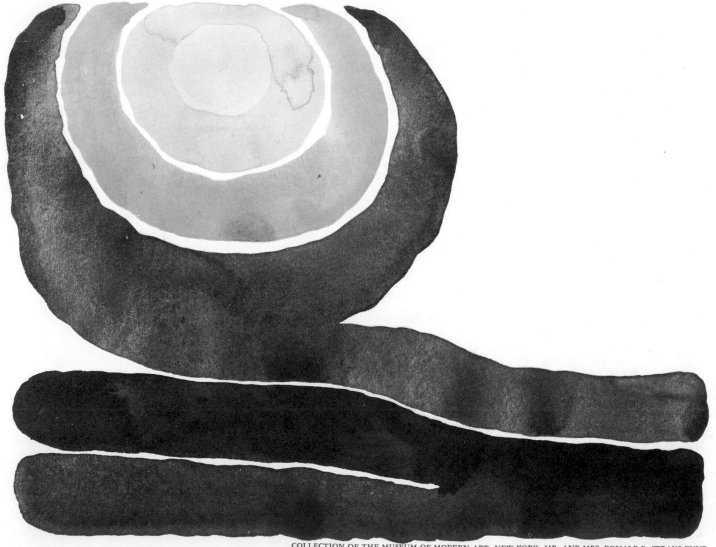

COLLECTION OF THE MUSEUM OF MODERN ART, NEW YORK. MR. AND MRS. DONALD B. STRAUS FUND.

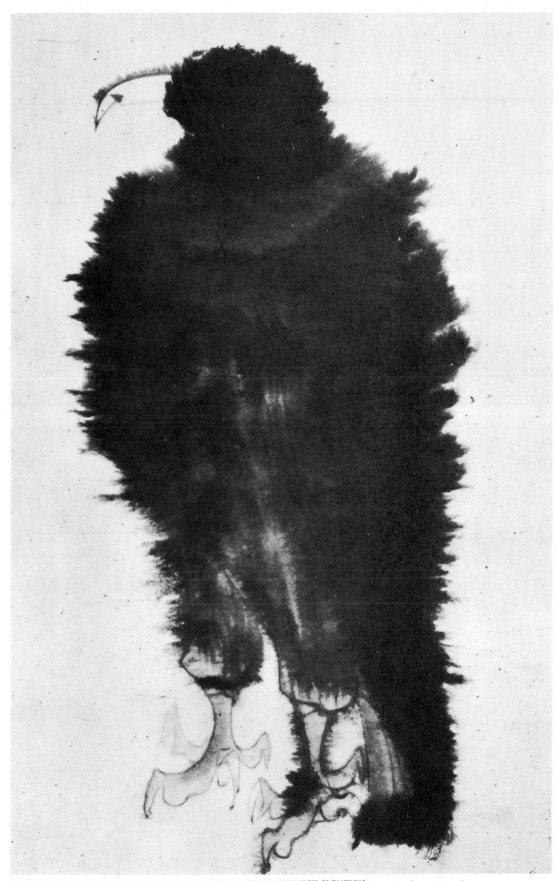

COLLECTION OF MR. AND MRS. JOHN D. ROCKEFELLER. PHOTO GEOFFREY CLEMENTS.

The Mirror by Edward Reep. 1956. Watercolor on paper. 20½ x 28½ inches.

The primary objective in painting *The Mirror* was to set down my reaction to the bright yet elusive light patterns before me, in addition to the intriguing, shapeless, nocturnal forms of lake and island. There is the recollection of seeking to build a structure from inside, or center-to-outside. The insistent chandelier-like image was omnipresent, and there was an attempt to present this thought as an unfolding, not too unlike a Mercator map projection.

The broad scraping away of wet paint that fills this work is the obvious purpose for its inclusion. Painting on a bitter cold night by a park lake forced this approach upon me, as the paint refused to dry. As each scraping seemed to illuminate a new area, entangled light patterns appeared to glow from within the painted surface. This is an example of how the content-goal may dominate and dictate method.

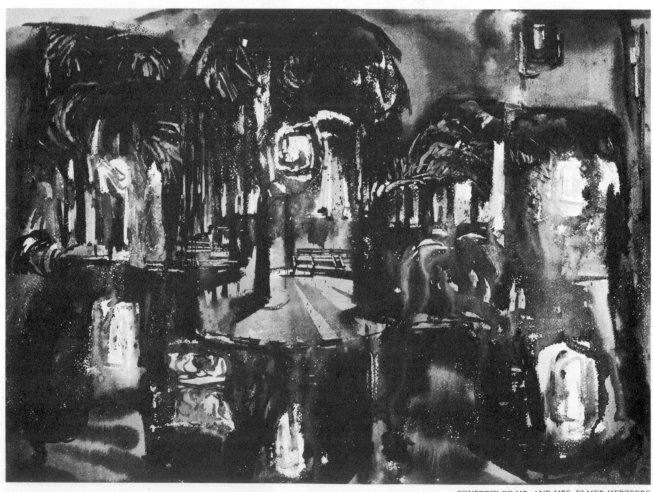

Ancient Grass by Meredith Olson (b. 1929). 1961. Watercolor on paper. 26 x 40 inches.

This splendid painting offers much when carefully examined. However, from Miss Olson's own words, we realize that she is not nearly as conscious of her method as of her philosophical needs. She states the following: "In this nocturnal scene, I try to impart the experience of seeing the burnished grasses of summer as a symbol of the continuity of life through time. *Ancient Grass* is not the grass of one season, but is as old as man himself."

At the time *Ancient Grass* was painted, Miss Olson was deeply involved in a series of works based upon this premise. Her dependence upon the repeated scratching away of paper and paint, which is so well revealed in the detail, is quite understandable. For how else could she capture the spirit of a nocturnal grass, when limited to an essentially *dark-over-light* paint? A change of medium would solve the problem, but could never present the personal, inimitable answer seen here. The beauty of *Ancient Grass* is a direct result of a relentless pressure brought to bear upon old limitations.

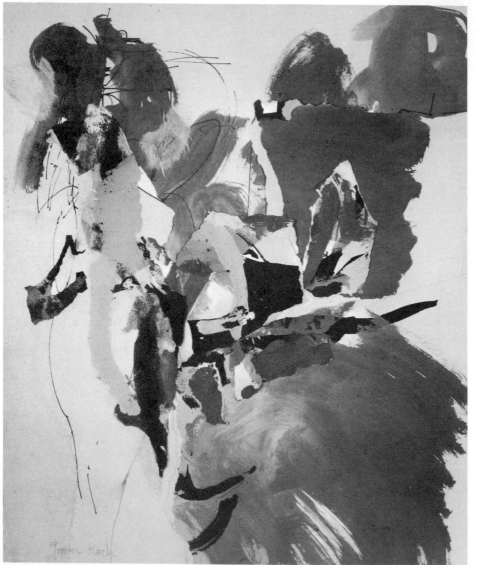

Grouping by Irene Koch (b. 1929). 1957. Watercolor collage on paper.

The sheer feminine gracefulness of Irene Koch's *Grouping* is largely the result of her management of tumbling pattern-forms, but it is further emphasized by her brilliant tonal scale. It ranges from glistening lights to velvet darks, each note clearly in tune. The detail peers into hidden recesses of quick line and spontaneous wash, displaying the artful manner in which complete and confident authority dominates her work.

Torn entries of other painted surfaces are so skillfully fused that one is hardly aware of their inclusion. The fortuitous rewards of this collage (technically, découpage) may be noted, as varied textures and movements are rudely imprisoned and placed into newer orbits. *Grouping* epitomizes a realm of eternal elegance.

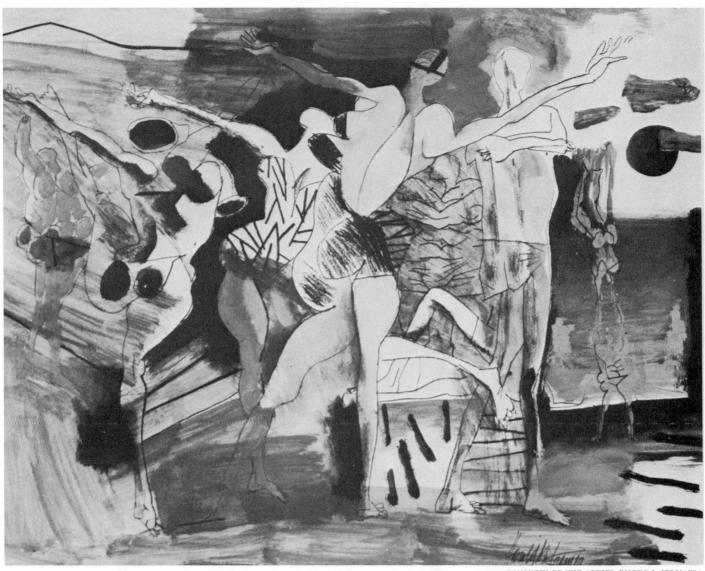

Beach by Harold Kramer (b. 1912). 1967. Latex wash on board. 17¼ x 22 inches.

The superb graphic controls and confident draftsmanship exhibited in this vibrant statement do much to simplify our earlier thesis regarding the importance of the artist's background or training. Certainly the method involved here is far from complex, and that is a great part of the painting's pristine beauty.

What dignifies Kramer's wash and line comes through years of creative explora-

tion. He exaggerates form and rearranges it into multiple station points, but above all he gives it further meaning through a personal symbology. His explicit line meanders about or it digs out an incisive shape; it may be wide or narrow, or autonomously awkward. There is a playing of all this against a pattern of striated wash, to the accompaniment of other inventive shape-symbols. The enlarged detail attests to this and more, especially with the discovery of both sharp and furry line. Rarely is the viewer presented with a more abundant world of pure visual delight than in this joyous painting.

1,000 Watercolor Touches by John W. McIvor (b. 1931). 1967. Watercolor on paper.

McIvor is neither a slave to tradition nor does he fret over the moral issue of eclecticism. The detail reveals all; the artist's brush moves confidently over the surface, dripping, scraping, scoring, yet always in touch with and seeking his goal. Imbedded in the larger and more obvious movements are countless smaller, startling thrustings, deepening dimension as well as bearing the sure mark of the draftsman.

It is important for me to work with materials which can be manipulated quickly and precisely. Not that I always work with a great rush, but when ideas do occur at a quickened meter, I demand a material which responds fast so the form can be built while it is still clear in my mind. With other media, I have experienced, at times, the painting seemingly dying in the process of being built; the work was lost in the gap between inception and realization — the "credibility gap."

(John W. McIvor)

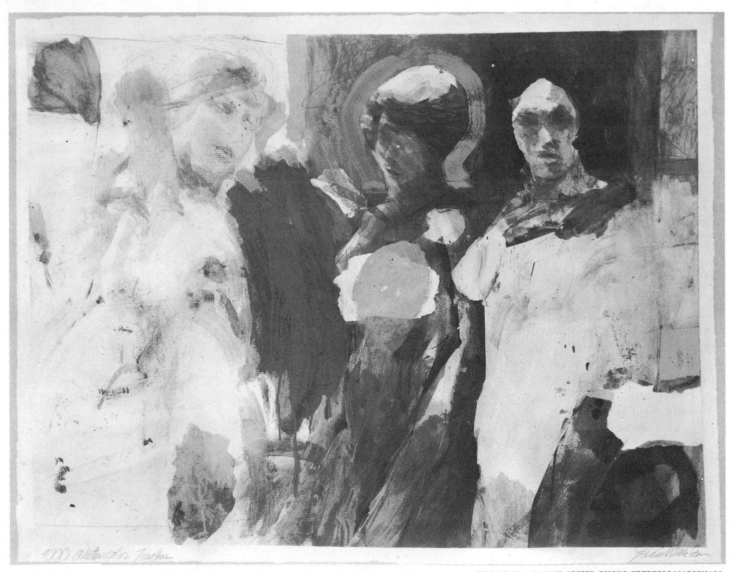

6 P.M. Glow, June by N. P. Brigante (b. 1895). 1965. Watercolor and ink on paper. 24 x 36 inches.

The singular beauty of Nick Brigante's space-world is breathtaking to behold. When seen magnified, it is overwhelming. *6 P.M. Glow, June* is only one of a long series that has intrigued not only Brigante, but his followers as well. There is a mastery of medium that can result only from long experience, and there is a wedding of performance with the philosophical directives of *Yang* and *Yin* that is equally impressive.

Brigante displays alternate patterns of wet line into wet and dry surface, and dry brush over wet and dry surface. He offers a multitude of textures that swarm through and about the painting, adding emphasis to his adroit use of scale and transposition. At first we are only witness to a ceaseless drama, but soon we are drawn introspectively into Brigante's world and become a part of it.

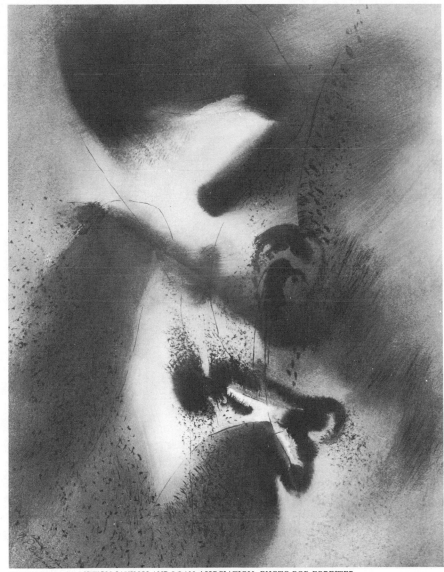

COLLECTION OF LYTTON SAVINGS AND LOAN ASSOCIATION. PHOTO BOB FORESTER.

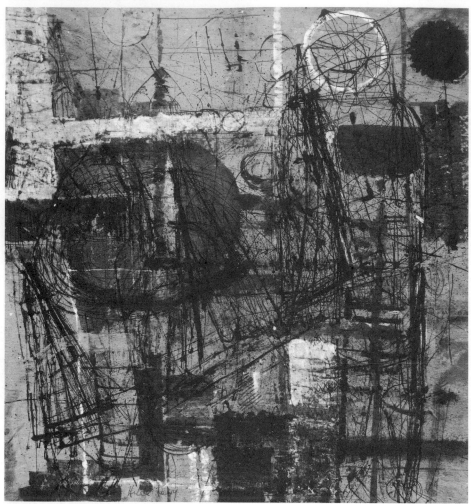

Formulations by Hilda Levy. 1954. Water-color and ink on "hospital paper." 19½ x 19½ inches.

This bounteous work by Hilda Levy lies a world apart from all others in this section. We are treated to the spectacle of a massive, yet calligraphic, unrest, all profoundly under the artist's control.

Essentially watercolor, ink line, and wash on a textured paper, Mrs. Levy's bold structure is the clue to the painting's success. She has manipulated a sensitive arrangement of textured shapes which ultimately plays against the complex linear patterns. In this way the monochromatic calligraphy stands forth or falls away at the artist's will. There is an imposing sense of scale and depth to be found in this work, and the enlarged detail offers a dramatic view of how this was achieved.

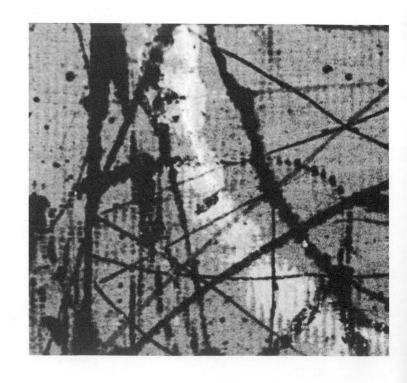

88

Demaphon #2 by Leonard Cutrow (b. 1911). 1963. Watercolor and ink on rice paper (mounted). 21¼ x 18¼ inches.

The exquisite management of the chiaroscuro in *Demaphon #2* is typical of Cutrow's dramatic *oeuvre*. There is resounding symphony heard here—one bursting with relentless fury that seems to engulf the viewer. Additionally, the detail reveals a particularly unique assortment of surface textures.

That so much power can be generated with watercolor wash, ink line, and rice paper seems astonishing at first, but we are soon provided with insights far removed from method and media. Massive washes sprawl over their more delicate counterparts, complex spatterings supply scale and vibration, and a broken, dotted line is omnipresent. Materials and artist are one, and there is little time for technical persuasion. What happens does so because of the careful preparation that has preceded this and countless other kindred efforts.

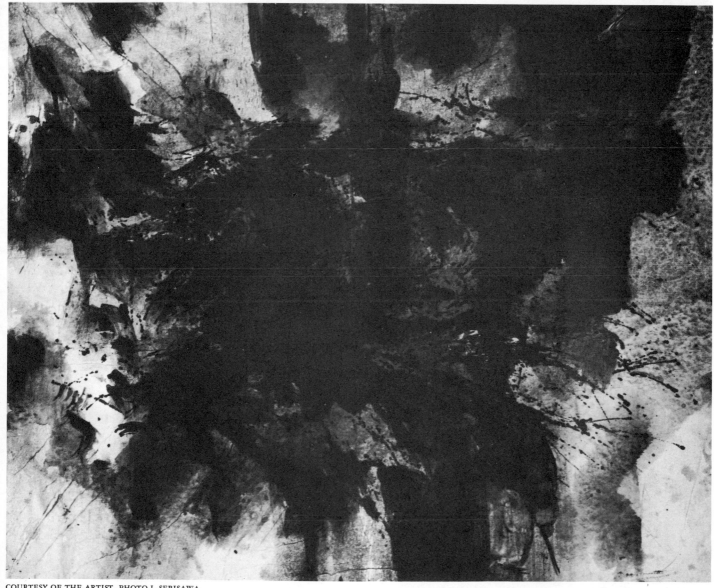

COURTESY OF THE ARTIST. PHOTO I. SERISAWA.

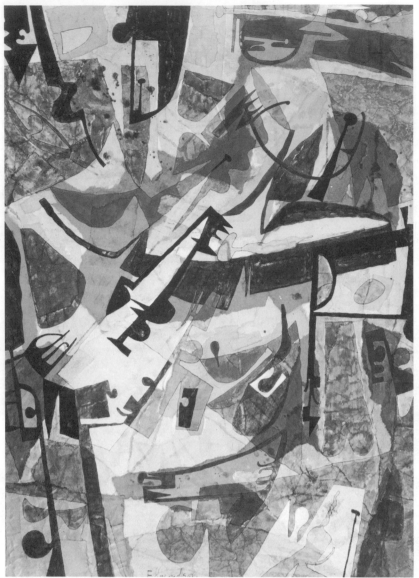

The Red Tear Drop by Leonard Edmondson (b. 1916). 1957. Watercolor collage on paper. 19½ x 28½ inches.

The patterned world of *The Red Tear Drop* is but one of a long series produced by Edmondson several years ago. It has lived in my memory, and was included in this section to display a rare use of the watercolor medium.

The patient attitude and obvious concern for a total synthesis is evident, but there is also a persistent, floating movement that denies complacency. There are echoes and dimensions that carry with them a myriad number of absorbing tactile sensations. This latter quality is most apparent in the enlarged detail, as is the painstaking care that went into its formulation. Edmondson relies heavily upon the transparent nature of watercolor to further enforce a sense of overlapping pattern, which in turn lends added emphasis to the painting's dimensional achievements.

South Side by Jerome Land (b. 1908). 1963. Watercolor and transparent plastic on black paper.

Perhaps the most eventful textural journey of this essay is found in the enterprising work of Jerome Land. Paint was initially applied to a wet, non-absorbent surface, to be eventually blotted with wrinkled, paint-saturated tissue. The support which Land employs is a transparent plastic material (polyethylene or cordite), which is mounted on black paper. He likens this to the effect of a large Kodachrome, except that a "black light" is utilized.

The resultant tonal qualities are de-pendent upon the support, as the transparent paint films that follow are affected by it. Land states that he finds in this method ". . . a great deal of flexibility in trying to attain a desired result. Shapes, textures, and tones can be richly realized to create moods of considerable depth and mystery."

There can be do doubting this comment by the artist. *South Side* is not only an impressive painting in its own right; it enhances our thesis by providing new and rewarding painting adventures. The enlarged detail is unbelievably generous in intimately exposing an all-too-often hidden fabric.

COLLECTION OF THE CALIFORNIA NATIONAL WATERCOLOR SOCIETY. PHOTO BOB FORESTER.

Allegory by Kenneth Callahan (b. 1906). Tempera. 24 x 32 inches.

WATER-SOLUBLE MEDIA

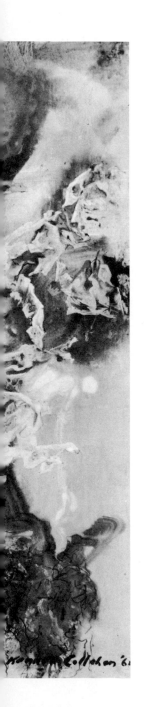

In our time art accepts no boundaries. Fashionable art movements often seem to be more the creation of critics than of artists, a somewhat frantic attempt to create some kind of order out of the exciting chaos of today's art scene. In technique, too, the artists have stepped across traditional boundaries with the coming of plastics, metals, and the multitude of new products. The situation is extremely confusing for a person inclined to divide works of art according to the media employed.

Should the new acrylic paints, with properties very different from those of oils, be classified as oils? In what category is a drawing filled with painting or a painting filled with drawing? At what precise point does a collage become an assemblage? These questions which have plagued many an art jury over the years have become virtually meaningless. An artist may choose to work in any medium in which his idea can successfully be carried out.

(Dr. Thomas W. Leavitt, Director, Santa Barbara Museum of Art)

While we are primarily concerned with painting in transparent watercolor, it must be noted that there are many other water-base paints manufactured for sale and privately compounded that are termed watercolor. One year, while I was preparing a lecture for the Los Angeles County Museum, it became necessary to survey the current exhibition which was to be the basis for my talk. Among the juried paintings selected for showing, which had been extracted from thousands of entries, were no less than fifteen categories of watercolors. Among them were: egg tempera on board, gouache on Masonite, casein on wallboard, tempera on Upson board, and watercolor on paper. Without any reference to surface or ground, there also appeared, listed thusly: watercolor, casein, collage-watercolor, watercolor-gouache, and tempera-wax. There were countless other combinations and definitions among the far more numerous rejections, all carefully noted by the individual artist.

Before going any further, let me make it abundantly clear that what will be presented here is not to be mistaken for a scientific treatise. Rather than lay down rules, explore chemistry in paint, or in other manner pose as an authority in so complex an area, my sole purpose is to present a very basic explanation of water-soluble paint to the reader. For if the artist is going to explore and expand

his dimensions as he goes, he must be aware of the physical properties of his paints and supports. In this manner he insures his work against deterioration or impermanency. But any deeper investigation additional to private experimentation should be undertaken by consulting reputable publications that deal exclusively with such things as materials and methods.

While it may seem perplexing to some that many of the aforementioned media appear very similar in character, there exist subtle differences in chemistry and manipulation that establish unique appeals to artists. For example, in addition to the broad definition of the traditional tempera medium, you will discover, when consulting a volume devoted exclusively to materials and methods, detailed treatises on such standard variations as egg tempera, gum tempera, soap tempera, and varnished and unvarnished tempera. Casein, gouache, and transparent watercolor will be looked at with the passionate dedication of the chemist, and the many glues and emulsions (wax, gum, natural, or synthetic) will be explained. Mixed techniques, along with the newly manufactured products in this as well as other areas, are presented with reliability, allowing the painter many options when formulating his own paint. Synthetic paints are elaborately described, the most popular being polymer tempera or acrylic. This astonishing paint is ground in water, mixes and thins with water, yet cannot be dissolved once it has dried thoroughly. The artist must gain complete understanding of the nature of synthetics, for while the polymer tempera colors are non-inflammable and non-toxic, this is not always so with other synthetics. We are not concerned with and therefore will not provide descriptions of paint that is not water-based, but it should be noted that acrylic-resin, ethyl-silicate, vinyl-acetate, and pyroxylin colors (lacquer) are also classified as synthetics.

Manufacturers are always alert to the needs of artists, often solving vexing problems for them. One example of this is to be found in the recent production of canvas primed with acrylic paint, the purpose being to accommodate both oil and water-base colors. While one may paint oil over a water-base paint, it is not advisable to apply water-base paint over oil.

GOUACHE

The most intimate relative of the transparent watercolor family is gouache. Artists and technicians alike have never been able to agree upon a single or precise definition of this elusive medium, but my description would read as follows: "A paint that produces delicate, luminous, high-key, and semi-transparent qualities." But let me hasten to add that gouache colors are essentially opaque, and only in the manipulation of overlapping brush strokes and washes does the semi-transparent quality delightfully appear. As in most media, however, the artist will dilute or thin his color to gain transparency, whether by accident or intent. All this seems more than proper to me, since painters employing gouache are predominately concerned with *alla-prima* qualities couched in a soft and reflective world.

Although gouache colors are manufactured and offered on the retail market, one must be extremely careful to select only those brands guaranteed to be permanent. Watercolors, watercolor inks, designers' colors, and gouache have been manufactured for use in the commercial advertising-illustration fields as well as for the easel painter. Some of these colors are exceptionally brilliant in hue, hence extremely inviting to use, but since there is little need for permanency in

the commercial world, they are all too often *fugitive* or impermanent. My own attempts with gouache (that is, my version of gouache) have been executed with the addition of a good opaque white mixed into transparent watercolor; some artists gain an even more delicate result with the use of the less opaque Chinese white.

Concerning the working surface for gouache colors, there is one major difference that distinguishes them from the white-ground support desired for transparent watercolor. It is generally agreed that with an essentially opaque paint such as gouache there is little need for the refraction of light off the ground and through the color. Therefore, toned grounds are generally preferred, although there is no real objection to white or other high-key supports. The primary purpose of the toned ground is to enhance lighter masses and calligraphy. The supports usually preferred are cardboard, paper, cloth, and a multitude of specially prepared surfaces designed to attain highly personal goals. Cheap cardboards are often of such subtle and neutral nature that they have been widely used for gouache grounds. They are additionally attractive to painters since they require little or no preparation.

TEMPERA

The broad category of tempera must of necessity be broken down into some simplified form or we could easily devote a full section to it. This medium has enormous range, being involved with both oil and water-base colors. In the latter vein we will cover tempera, casein tempera, tempera-wax (or gum), and egg tempera only, as these are the most popular and widely used. When one considers that tempera colors may be formulated with either casein, gum, oil, wax, or egg, plus combinations of these elements, it becomes clear that there is a delightful experience awaiting the artist.

Tempera colors are classified as emulsions, which means that they are a mixture of oil, fat, resin or wax with water. The emulsion provides a heavier and more opaque base than found in transparent watercolor. When combined with a more coarsely ground pigment, tempera becomes very opaque in nature. At times you may note the classification of *oil-tempera* used, which indicates that an oily or fatty emulsion was present. If, however, you eliminate the fatty content and mix tempera with glue only, the result may now be termed *distemper*. In any event, tempera colors are noted for their resplendently luminous and sparkling qualities. They are most successfully applied to a rigid support that has been coated with gesso, which is a chalk or whiting mixed with glue, gelatin or casein. Tempera is virtually insoluble in water when dry and may be overpainted without great fear of moving the undercolor. Supports most commonly used are wood, untempered Masonite, and wallboards composed of various materials and structures. Although the common casein wall paint that has become so widely accepted in recent years may be used with success when preparing any of these panels, gesso remains unexcelled as a ground. Perhaps this is because it may be shaped or textured during application.

CASEIN TEMPERA

Apart from the popular acrylic colors, which are relatively new, casein tempera has enjoyed by far the widest use of all the opaque watercolors. This is mainly the result of its markedly simple formulation, plus the fact that nearly all well-

known paint manufacturers offer it in virtually every hue and in convenient tubes. It was once very difficult to tube and keep casein tempera in working condition, but new discoveries and materials have conquered these problems. Enigmatically, casein colors have not received the stamp of full approval by all of the leading authorities; yet none of my own work in this area (some of it dating back twenty-five years) has seemed to discolor, fade or deteriorate.

Casein is extracted from skim milk which has been allowed to sour. The resultant fresh white curd is used as a binder or glue, and it is extremely effective, owning superior adhesive properties. Among the attractive advantages of casein is its ability to set up and remain impervious to water when dry. This enables the artist to rework an area without fear of lifting the undercolor. It also permits effective glazing and increases the painting's resistance to damage from moisture. Casein white, a most brilliant and effective color possessing enormous hiding power, has been largely responsible for the advances made with the underpainting white (controlled or quick-drying white) of the oil palette.

WAX AND GUM TEMPERA

The most brilliant color of all may well be found in paintings employing wax emulsions. Tempera wax will as a rule be formulated with a clean, white beeswax, but it is not to be confused with wax-encaustic or *hot wax*. The use of a wax emulsion provides the final work with excellent protection against moisture deterioration. As noted earlier, wax-encaustic was utilized by the Romans of ancient times for identical purposes. Various lusters may be obtained in lieu of varnishing by rubbing over the finished work with a soft cloth; but one must gain a working knowledge of this procedure through personal experimentation. Gum temperas are confected with emulsions consisting largely of either gum arabic, cherry gum, or gum Senegal. Their chief advantage is that they are extremely compatible both in mixing and formulation. Artists have been known to use gum arabic since earliest times, and have been well aware of its vital function as an adhesive in the transparent watercolor recipe. But the gum-tempera colors, while permanent, will pick up easily when painted over, and at best must be classified as the least effective paint in the tempera family.

EGG TEMPERA

Tempera formulated with the emulsion of egg probably constitutes the earliest known water-soluble medium we will discuss. We know that it has been used effectively since at least 400 A.D. Most of us associate egg tempera with the Renaissance, when it attained enormous popularity, particularly among Italian artists, or with the illuminators of the Middle Ages, who employed egg tempera with incredible beauty and purpose in their religious documents. Usually prepared with the yolk of egg (egg yolk contains its own natural oil), it may also be compounded with both yolk and white, or with the white only. Present-day artists often support the natural egg emulsion with equal measures of various oils and varnishes in order to fortify their colors, yet water always remains the dilutant when working.

Applied to the hard panels generally used with the other tempera paints noted, egg tempera is virtually insoluble when dry and is claimed to be tougher than oil paint. Being a most demanding medium and requiring extreme care and patience, it is not suited for the *alla prima* technique. Because of this limitation,

very few of today's painters work with it. Those who do gravitate to this age-old medium find the luminosity and brilliance of color to be irresistible. It would seem ill-advised for those new to painting to become deeply involved with the intricacies of egg tempera, particularly until much further along with their careers.

POSTER COLORS

In my estimation, poster colors are the poorest of the water-base paints. They are essentially *glue* colors, coarsely ground and therefore very opaque, but their main disadvantage is that the undercolor will pick up very easily and alter any overpainting. This bleeding is disturbing to the artist, especially when he attemps to change a hue. Poster colors are very susceptible to damage by the slightest moisture exposure, and will crack or chip if applied too thickly. These colors are quite properly suited to classroom and commercial purposes.

SYNTHETIC PAINTS

The synthetics or plastics are considered by many artists to be the paints of the future, and there is no question that they have been gaining popularity with artists throughout the world. These versatile colors were born in the chemist's laboratory and are likely to prove the most durable of all paints. Synthetics are highly sophisticated colors that are marketed under myriad titles and trade names, but all are very similar in manipulation and character. While no one paint can ever completely supplant another with respect to behavior or result, the range of the synthetics knows no boundaries; for example, they may be applied equally well in delicate wash or heavy impasto. Obviously such combinations of diverse qualities lead to scintillating and inimitable results.

The completed statement in synthetic will more often than not resemble an oil painting. The quickness of drying plus the infinite ease with which corrections or changes may be made remain the primary reasons for the growing popularity of the synthetics. Still there are numerous other advantages, such as the development of a very effective modeling paste. This material is essentially a combination of polymer emulsion and marble dust and may be applied to the support or mixed into the color. It has excellent adhering ability and may be shaped, carved or chiseled, thus affording the painter exceptional latitude in the area of surface relief.

Additionally, synthetics are available in extremely brilliant hues, and have proved to be tough, durable, and permanent. When they were first marketed there was some complaint about their consistency or workability, but this has been corrected.

The bulk of manufactured synthetic paint to be found on the shelves of artists' supply houses are commonly referred to as acrylics. Most labels carry three words, *acrylic polymer emulsion*, are sold under various trade names, and are non-toxic. Polymer medium may be used for mixing, glazing, and even fixing collage. It is also used to prepare a highly sophisticated tempera paint. The ease with which the artist may prepare his own tempera to fit his own needs is unbelievable: one need only grind dry pigment in a minimum amount of water and add the polymer medium.

Synthetics, as well as all modern plastic materials, are created through the process of polymerization. To fully describe this complex process would be too

digressive for our purpose, but if you will visualize molecules fused or joined to form larger groups (through catalytic action), you will have witnessed polymerization. Or another way fully to appreciate the phenomenal nature of this new and exciting paint would be to apply a layer over a slightly oily surface and then peel it off when dry. It will have fused itself into a powerful thickness of color, very tough yet highly flexible. When applied properly to clean, non-oily surfaces that have been suitably prepared, acrylic will adhere with tenacity to wood, canvas (primed or not), metal, Masonite, hardboard, paperboard, paper, and even masonry.

Curiously enough, with all of the qualities listed above, many artists react unfavorably to the speed with which acrylics dry. They find that there is not time enough to *work* the paint. So manufacturers, always alert to artists' reactions, have been quick to respond. They have come up with a preparation to retard drying which is nothing more than a traditional glycerin-based recipe used in watercolor for many years. It is altogether possible that the synthetics will in time become the most universally accepted paint in the history of art.

The pictorial statement to follow will include some of the media discussed above, plus other inventive combinations. The attempt here will be to examine retrospectively the event of the painting. With the aid of enlarged sections, you will be able to determine differences that would otherwise be impossible to observe — differences in both artistic temperament and method. You may furthermore detect the artist's enthusiasm and his affection for his work as he senses it growing to completion. While all such thoughts are nothing more than imaginary visions woven with an occasional educated guess, they do prove illuminating and rewarding.

Most artists care little for this kind of autopsy, yet we are inquisitive and eager to learn. It is in this spirit alone that the essay is offered. It is hoped that through patient examination of each painting, new avenues of personal exploration will await the viewer.

Desert Landscape by Clinton Adams (b. 1918). 1960. Polymer tempera, collage on paper. 30 x 22 inches.

Discriminating selection has always been a characteristic of Clinton Adams' work. Here we find a notable example of his care, restraint, and ultimate victory in reducing desert elements to their simplest terminology.

When first viewing *Desert Landscape,* we see merely flattened shapes, floating, superimposed, and butting against one another. Massive earth-layers play against a distant sky, and we feel the eerie tranquility of the Western desert. But like the desert itself, this painting offers much more to the patient observer, as one suspects after careful examination of the underground labyrinth.

Through the magic of enlargement all suspicions are confirmed. Patterns, textures, and movements of unusual complexion hint of deeper life. Clinton Adams truly develops an unparalleled synthesis of media and content in this exquisite painting.

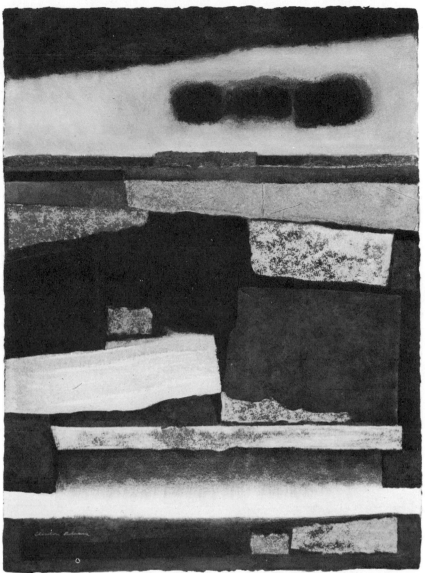

COURTESY OF THE PASADENA ART MUSEUM. PHOTO I. SERISAWA.

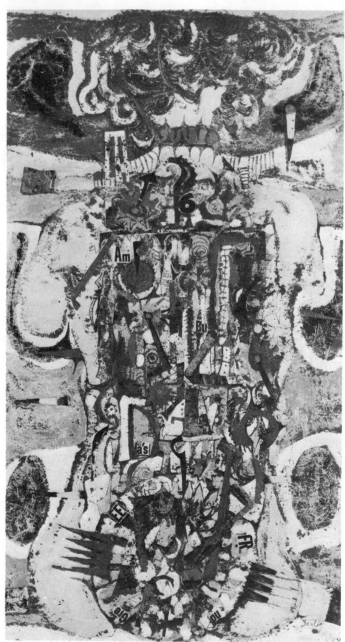

Automaton by Karl Zerbe (b. 1903). 1955. Gouache and collage on canvas. 48 x 24 inches.

No artist could better serve the purpose of this section than the deliberate experimentalist, Karl Zerbe. Widely acclaimed for his monumental achievements in encaustic, he shows here another facet of his *ouevre* with a most eventful combination of translucent gouache with collage.

Automaton is a powerful statement which presents man's inner self as a microcosm of our chaotic world. Elaborately formed and infinitely complex, it demands more than one viewing. The collage includes mysterious numbers and letters. Undercolors peek through from beneath a resist-like layer; line darts about incisively. The impressive detail exposes a faceted understructure stuck together with a weblike mucilage, and the viewer is caught up in Zerbe's frightening self-examination.

100

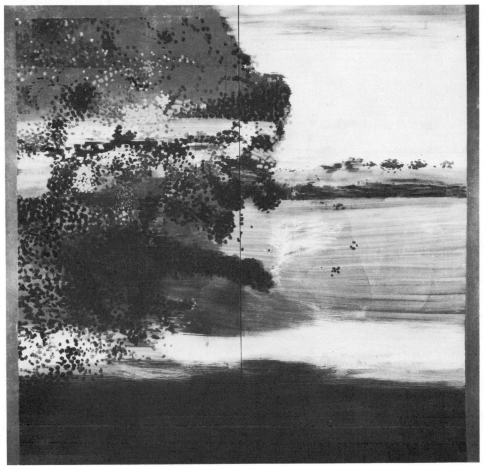

Country Landscape by Sam Amato (b. 1924). 1967. Acrylic. 96 x 96 inches.

My recent work has been directed to a wide range of pictorial experiments — most of them dealing with African landscape with or without animals as subject matter. I've been leaning-out my paint (acrylic), until it almost resembles watercolor, which I modulate by the use of successive wash-glazes and small marks. My drawing and feeling for light have been directed increasingly toward photographic objectivity, although poetic motivations are my principal determinants in working through a painting.

Sam Amato's words sum up precisely how the artist becomes involved with considerations of media, subject, and poetry. His concern for light alone demands dramatic alterations of paint consistency. By thinning his paint he not only gains light effects through glazing, but also is able to manipulate his paint more quickly and give fuller attention to his poetic goals.

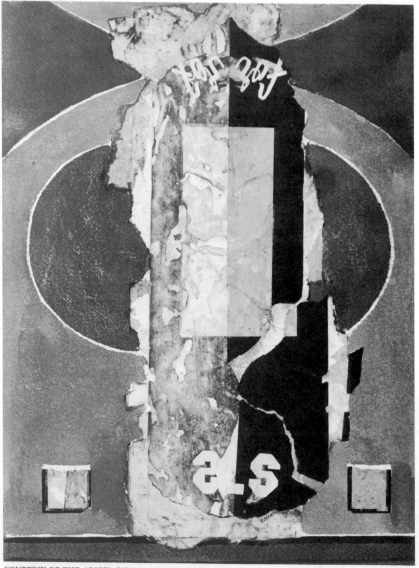

Untitled #1 by Gordon Wagner (b. 1915). 1966. Collage, mixed media. 22 x 30 inches.

One might easily read philosophical meanings into this provocative statement by Gordon Wagner, but our purpose is to examine the dynamics of the work. We look to its revelation of fragments and glimpses of the artist's own world, a world filled with vigorous contrasts of patterns, textures, shapes, and scale.

The detail further intrigues us not only with the physical dimension of collage, but an even more imposing illusion of varied elements floating through space. This invites one to return to the painting with more anticipation than before.

At work here is an elusive bilateral symmetry that is managed with extreme care. One may, through the persuasion of letters and words, sense a billboarded wall, but an infinite space takes bold issue with this interpretation.

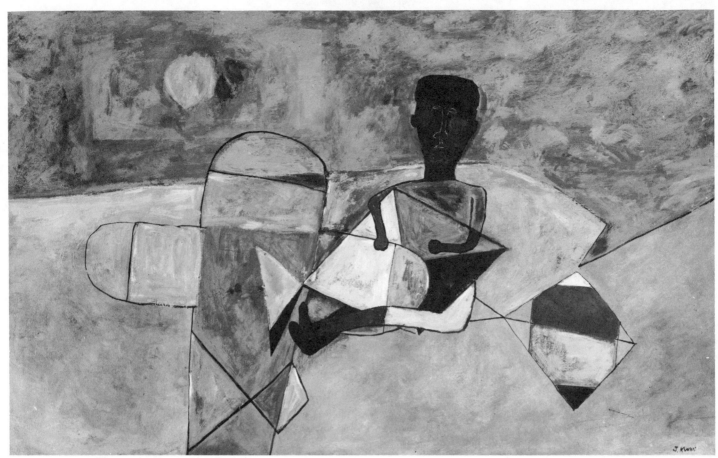

Boy with Kites by John Kwok (b. 1920). 1959. Casein. 19 x 28 inches.

John Kwok's paintings have been widely acclaimed for their incisive yet tender poetry. While his recent work has properly turned in new directions, *Boy with Kites* remains a characteristically compassionate statement, masterfully executed.

Casein paint, essentially translucent, may range from full transparency to opacity with ease. The very nature of the paint not only allows this, but offers its own dividends along the way. Kwok displays here a brilliant use of the inimitable qualities of casein. He feels no concern for the convention of *fat over lean,* or any other technical restriction. Underwashes are followed by countless overbrushings and still more washes, which now essentially become glazes: this provides the vibrant character of casein painting.

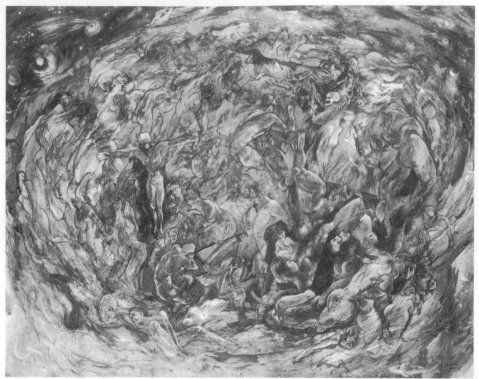

The Revolving World by Kenneth Calla-
han (b. 1906). 1962. Gouache on paper.
14⅛ x 18½ inches.

In this superb statement, as in Tobey's
The Drift of Summer (page C-3), we find
the *private journey* to be dominant. The
articulate use of gouache encourages a
remarkable calligraphy to coalesce with
the massive underlying washes. In this
way *The Revolving World* gains an enor-
mous sense of scale, yet it is a relatively
small painting.

Kenneth Callahan's use of watercolor
has been influenced by the Oriental, with-
out an attempt to adopt its methods. The
detail shows the extent to which Callahan
is at ease with all facets of his medium,
for the intricate and indescribable manip-
ulations so evident in the enlargement
properly play a supporting but minor role
in the total drama.

The theme is Christ's crucifixion as the
hub of a chaotic whirling of animals,
people, planets, etc. This painting is but
one of many works devoted to the role of
man in the cosmic scheme. One never
feels that he has absorbed all that exists
within the confines of Callahan's margins.

Nature's Abyss by Alexander Nepote (b. 1913). 1967. Watercolor, acrylic, and collage on Masonite.

No more unusual experimentation is shown on these pages than this painting by Alexander Nepote, for here is an artist who, in his own words, relies upon "99 percent straight transparent watercolor and a little acrylic." But this is only part of the story.

In the handsome *Nature's Abyss,* the artist's sense of the dramatic seizes and challenges the viewer, confronting him with the overpowering weight and dynamic energy of natural forces.

In surveying the detail it is difficult to believe that one is viewing a painting executed on a flat ground. The dimensional layers present their own peculiar surface variations and seem to be carved out in a more lithic or bas-relief manner.

COURTESY KRAMER GALLERY. PHOTO VIRGINIA MCINTIRE.

A CHRONOLOGY

COLLECTION OF MR. AND MRS. DONALD LENT. PHOTO I. SERISAWA.

The Bank. 1957. Watercolor and ink on cotton skrim cloth. 24 x 34 inches.

OF CHANGE

<div style="text-align: right">6</div>

In any endeavor there is nothing more constant than change. There is, in fact, definite cause for alarm when change is absent. My own work in watercolor is presented here solely to illustrate this firm belief. Furthermore, it is evident by what we have already seen in the earlier sections of this book that there appears to be infinitely more variation in the melange of other artists' work, but this is only superficially true. For while we may play a Klee against a Grosz, or a Cézanne against a Homer, and note remarkable differences, visualize a Klee against a Klee and there is another interaction altogether.

In most instances change takes place without our knowing it; consciously forcing or seeking change carries no guarantee that it will happen. What remains clearly needful to me is the attempt to move (hopefully) forward. It is unlikely that a sensitive artist could assign such welcome movement to his own efforts, and this will not be the case here. The changes noted have more to do with philosophical attitudes, emotional or intuitive perception and, enigmatically enough, structuring that appears pragmatic in retrospect. But there will be no doubt as to motivation, and the message will be clear. It would be far less revealing to depend upon art critics, historians or any other second-hand source for this information.

The work appearing in this section has been updated to cover a span of thirty-four years from 1946 until 1980. In the early going, my efforts were virtually confined to the watercolor medium; only upon occasion did I turn to either lithography or very elaborate oil paintings. From 1958 until approximately 1970, the reverse has been true: the bulk of my work was in oil or acrylic, with only infrequent sojourns to watercolor. During the 1970s, I began to produce works in series, roughly seven to twenty in number, and alternating rather consistently among oils, acrylics, oil pastel drawings, pen and inks, and watercolors. All throughout this period, whenever possible, I continued to work from the figure at least one night per week.

Most artists struggle to maintain a high level of quality, perhaps not in what they attempt or when they attempt it, but in what they will ultimately let out of

their studios. In the exploration of new directions (which is another manifestation of change), it should be noted that for each promising gain there may also be a loss of ground. A frustrating yet natural phenomenon occurs when one produces work well ahead of oneself, at any given time. These and other factors contribute to the dilemma of the serious painter, and all this without a thought given to the concerns of critical acceptance. It would amaze the general public to discover how many paintings artists labor over diligently, to ultimately detest and destroy. Ivan Albright once confessed that he didn't really enjoy painting very much. He said, "I go at it the hard way, with my eyes wide open. But I do like getting the results I want. I'd rather paint one good picture than a hundred bad ones. Anybody can paint bad ones, including me."

To get away from oneself, to stand off and recognize weaknesses and to be able to do something about them—that is important! For example, several years ago it became necessary for me to abandon all painting and draw for a solid year. Prior to that, my lack of knowledge and experience in three-dimensional form had gnawed away at me from within, the result being that for a full year my efforts were confined to sculpture. While the results were not always satisfying, the experience was invaluable.

Rarely, despite beckoning nostalgia, does one peer into the frozen past with a sense of great expectation. It is impossible for me to look back without seeing flaws, omissions, and futility. Rules and regulations based mainly upon craft or technique saturated my mind and limited my vision. Needless to say, this hapless condition did not appear so at the time, for even in ignorance there is unlimited joy. How does one know when training, environment, and exposure are narrow and confined? The teachings of the modern schools were not only ignored, but for the main unknown by my teachers. The Bauhaus was either pure fiction or merely tolerated. Expression outside of my little world was an impossibility, and what made matters worse was my inability to recognize this fact.

After two years of army service, my career took a sudden turn. Commissioned as an artist-correspondent under the auspices of the War Department, I came into contact with men such as Reginald Marsh, Mitchell Siporin, and a host of other renowned artists. Being with these men and seeing what they did and how they thought was a revelation. My own inadequacies came into focus with embarrassing regularity. Until then, drawing meant copying what was before me, and composition meant little more than arrangement. What a shock to find that other artists cared little for or completely ignored what seemed so sacred to me. And what pure joy to be released from the world of modeling to gain form or from the sole reliance of the "s" shape movement of the Renaissance.

Here and there was a breakthrough or an overcoming of the deep-seated concerns of ineptness. Color was always a love of mine, and while there had been severe and restrictive rules laid before me during my art-school tenure, it seemed far simpler to dispense with these than the others. There is no doubt that the war-artist experiences changed my entire perspective, philosophically as well as artistically. For while most of my work was of a documentary nature, something of deeper import was being included. Being awarded a Guggenheim Fellowship on the basis of paintings executed during the Italian Campaign was a thrilling experience. However, upon my return to America, with confidence and eagerness to get to work on proposed projects, further frustrations appeared. Grandiose ideas vanished one by one, as it was impossible to set down that which lived in

my heart and mind. The war had sickened me, the futility of it was omnipresent, and once again my work appeared inadequate. Turning to numerous preliminary sketches, and in many instances full-scale black and white drawings, was my salvation. Each of these elaborate drawings took several days to complete. If the human figure were to appear, separate drawings would be made to further assure a result.

When the war experiences began to fade, there were other excitements to be found in both new and neglected areas, such as reading and studying in the worlds away from art. Teaching anatomy became a form of self-abuse that seemed imperative to me; after two years of it, condyles and tendons appeared everywhere, and that was enough. The most intelligent move at that time was to quit teaching at the school that was perpetuating beliefs that no longer held any meaning for me. Soon after, my teaching career resumed at the Chouinard Art Institute, and has continued to this day.

At Chouinard it became my great privilege to work with men of exceptional abilities, not only as artists but as master teachers: men such as Donald Graham, Herbert Jepson, William Moore, Watson Cross, and Harold Kramer, to name but a few. It is surprising how much one can absorb by simply working along-side fine teachers, especially when the core of instruction is built of creativity and not methodology. Concurrently, in 1950, it was my added pleasure to work with an artist of rare and separate nature. This was E. J. Bisttram, whose work was largely based upon the lessons of Dynamic Symmetry. An abstract painter of unusual quality, Bisttram proved to be a warm friend and an unwitting teacher. With Bisttram came my first real appreciation of picture structure, largely through the fascinating study of Hambidge's essays on Dynamic Symmetry. For some time after that, most of my work was based upon the rigid precepts of this doctrine.

Coming to the School of Art at East Carolina University as artist-in-residence in 1970 proved to be an enlightening experience. The change from a fast-paced, noisy, jam-packed western metropolis to the serenity of a rural, southern university town was overwhelming. The days grew longer; I worked without interruption and my production increased. A school of art with growing pains was searching for help in its quest for excellence. It proved a joy to work with a faculty that was on the move, primarily with a host of creative, young teachers providing an ambiance of lively excitement.

To return to the work shown in this section, one may readily note that it cannot be labeled as experimental beyond a point, as this is not my wont. Whether or not subject matter is present in my efforts is no longer a concern. Today, a point of departure for painting may be little more than a desire to paint, an excuse to use a lot of yellow or possibly six different shades of black. Over a decade has passed since the first edition of *The Content of Watercolor* appeared on the market, and that fortunate circumstance has given me the opportunity to review and update the original text. In doing so, it has become apparent that certain attitudes of mine have either shifted one way or the other, or have been completely abandoned. It seems providential that my premise of change may now be proclaimed more vigorously than ever.

Artists young and old need to compare viewpoints and share experiences continually, which explains in part the traditional congregations of artists in the major urban areas of the world. However, this autobiographically flavored essay

is not to be construed as a blueprint for others; it merely serves as another basis for comparison, which I resorted to with some reluctance in order to amplify the pictorial document. If it underscores the need for continued search and inquiry, it will have served its purpose. Further, if such exposure of intimate concerns interlaced with frustration and desire are helpful to others in reassessing their work, there will be added merit to my thesis.

The form of tomorrow's painting is unpredictable. New discoveries, the exploration of outer space as well as the destiny of the human race will undoubtedly affect artists' work. *The only safe prediction is that there will be change.*

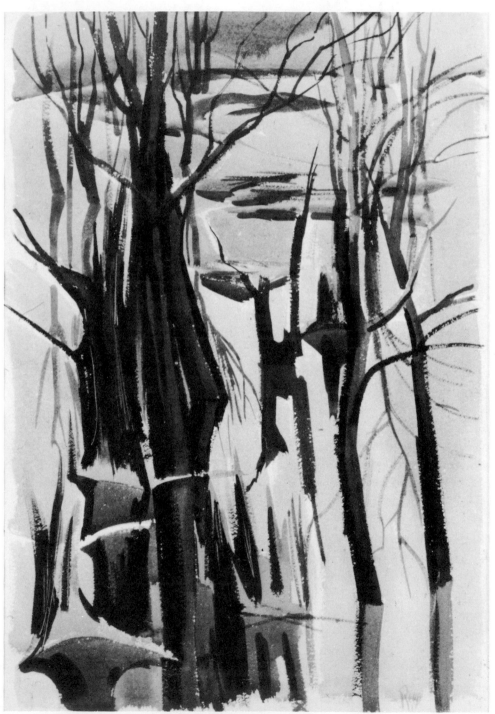

Swamp Note. 1950. Watercolor on paper. 15 x 21 inches.

Rebirth (opposite). 1954. Watercolor on paper. 19½ x 28 inches.

The paintings in this section were not created for this essay, but instead were selected painstakingly from work done over the years. It is far more meaningful to note change in this manner, even if a perfect chronology is not always present. Since valid change rarely follows a time schedule, I have determined that this is the most effective and fitting approach.

The two paintings facing one another here were executed fully five years apart. It is obvious that identical shapes appear in both works, although in *Rebirth* much has been added. The tranquil nature of the earlier work has given way to turbulence, gained mostly by a drier, spattered approach. In *Rebirth* there is a story of

But art—society will always provide room for painting—it is far too personal and separate to be replaced. Painting has a life of its own. It is an experience for others to experience: an event of the mind and soul. There is magic in both the doing and in the seeing—there is the moment and eternity. As Gautier wrote:

All passes. Art alone
Enduring stays to us:
The Bust outlasts the throne, —
The Coin, Tiberius.

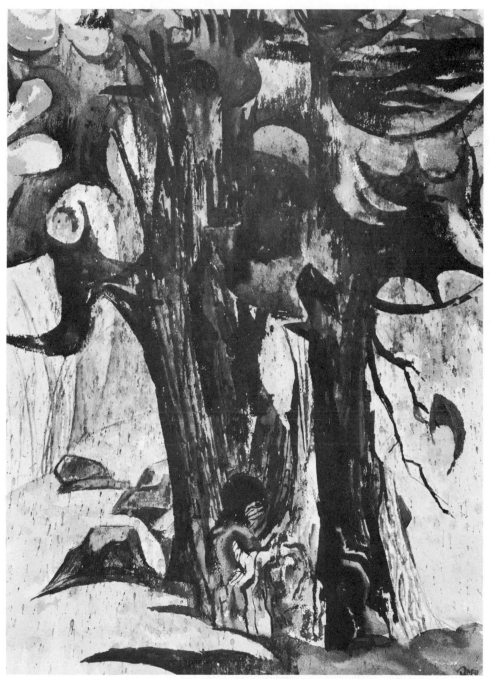

fury and devastation, along with the omnipotent regenerative force of nature. The splintered tree also offers refuge for two birds huddled together. In *Swamp Note* the brittle winter trees play against the early-morning light patterns and their own reflections. All is peace and calm.

It would be convenient to state that these paintings differ because they seek separate esthetic goals, but this would be only partly true. At the time *Rebirth* was painted, I was largely involved with kinetics; that is to say, there was a constant searching for the *inner energy* of all things. It was my desire to express the condition of an internal life-force, and so a new examination of familiar subject matter took place. I even sought out things that would lend themselves to my goals, such as the shattered tree in *Rebirth*. One painting is not better or further advanced than the other, but each has its own message, and was investigative and fruitful when painted.

COLLECTION OF MR. AND MRS. RUBIN R. URETZKY. PHOTO DON GARBER.

111

COLOR INSERT

Some of the images presented in full color have been selected for their obviously significant color. They also verify pictorially the color premises offered in Chapter 2, "The Background of the Artist."

Other works shown in color are designed to enhance the various chapters from which they were drawn. In all instances, the section in which each painting was originally found has been noted in the text accompanying each work.

Our color section begins, appropriately, with the spectacular work of Paul Jenkins (opposite page). Jenkins is a colorist in the finest sense of the word; of that there is little doubt. But he is much more. One of the most noted American painters working with watercolor, his personal commentary that follows reveals far more than author or critic.

Phenomena Appeal to the Sun by Paul Jenkins (b. 1923). 1979. Watercolor on paper. 31 × 43 inches.

"Watercolor is like entering into slow motion with a dam breaking from within. I don't go with the flow . . . I counter the flow, and this is where the tension evolves from. There is nothing preliminary about starting a watercolor. You don't ease into it like warm water from the Caribbean or dive head first into it like a spring-fed lake in Maine. It is blood pouring out of your fingers and running down your legs. It is a sensuous experience which entails a paradox: the purity of the medium with its strict limitations pulsate through a state of being. There is the sense of secretion . . . oils from the body . . . the fine granular pigments of the watercolor itself. And then there is the binder in the paper, which when moist, wet, or dry grasps the delicate substances of the pigment and makes them come to be or mean something.

"Watercolor is a form of breathing color, and to me has the sensation of an incantation. To what? I find out by seeing watercolor collide with the world of phenomena which is involved with the capture of ever-changing reality. I am drawn to ever-changing realities not because they seem to be the evidence of a hazardous world, but because they draw me closer to the wonders. Marvels incite me not just to accept change but to induce it. A phenomenon which springs forth from the real, that which happens, is something we must continually strive to perceive.

"When I work on watercolor, I realize that it is surrounded by air much the same as a fish is surrounded by water, the moon with reflected light, or the sun with its own radiance. Watercolor insists that I take on a particular state of being.

"There are two kinds of light in painting which I move toward that become and relate to form. One is radiant, luminous light—that element which has its light from within, as in an orb. Luminous light comes from a central source or place and exists independently. The other is reflected light which appears as a mysterious substance on the surface. It is a light coming from the outside source which creates constant reflection. When these two kinds of light interpenetrate, I discover unique forms which have a psychic substance; forms which build, hold on to one another, become alive and certain. Like psychic substances, the color becomes what I call nonalternate color: color that cannot be any other color than what it is on the canvas. No other color can take its place. It becomes a constant—not entirely dependent upon the color next to it. I don't mind if it is an odd, strange color, an eyeball-taxing primary; even an indeterminant color, as long as it is a true color unto itself and not just some tone of another color to make the color next to it work. That is what I call "the cheating intervening space between the two colors, or the misuse of the intermediary color just to pull it together." Nor do I confuse this cheating with analagous colors—they are part of the whole of that single element.

"Color is a fact of science: it is not an abstraction in itself. Color is the hidden fact of your psyche and you make it real or not. You make it your own or not. No two people have the same fingerprints. No two people have the same primary colors even if they should come out of the same Winsor Newton tube. Color becomes the factual evidence of the individual which is not discovered through theory or found through osmosis.

"Watercolor has a sense of wonder, and when I look back I think that one of the reasons I was originally drawn to it was because it became an alchemist's task: refining until it takes on a psychic value which you cannot give a name to."

(Paul Jenkins)

112

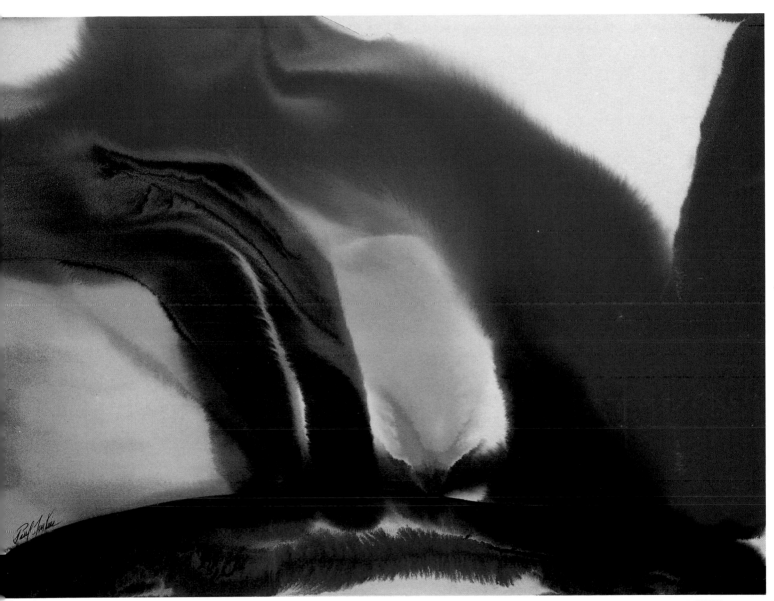

COLLECTION OF THE ARTIST.

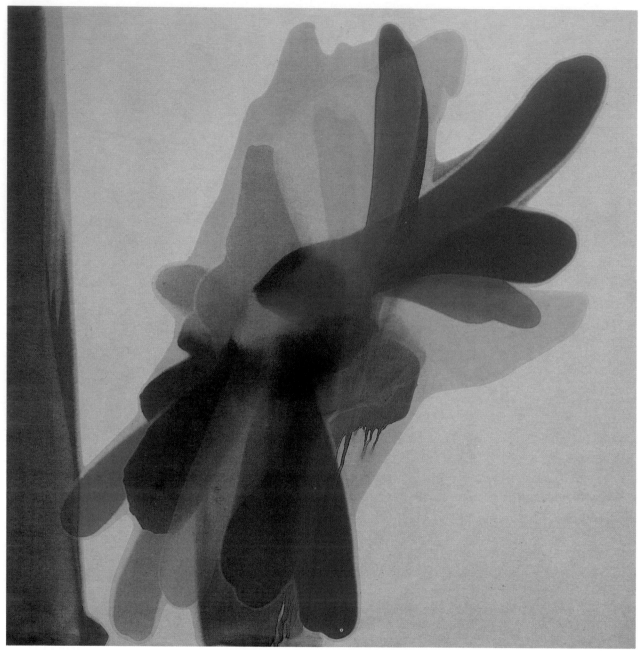

Winged Hue by Morris Louis (1912-1962). 1959. Acrylic resin paint on canvas (mixed media). 96 x 96 inches.

Nowhere in the world of contemporary painting do we find more staggering examples of the new plastic-base paint than in the *oeuvre* of Morris Louis. Louis not only employed a special version of Magna color (a paint miscible in water or turpentine), but added a great deal more of the original medium (acrylic resin) in order to thin his paint further. In this we discover a specific kinship between Louis and the Oriental masters. Louis, however, continues on to present a mammoth, introspective spectacle, and subject matter is non-existent. His paintings are often referred to as "veils," "drapes," or "florals," and *Winged Hue* is indeed well described by the last term.

While some artists, such as Tobey, reject intense color, and still others abandon line, Louis's work may be devoted to either or both at various times. The impression of a microcosmic world enlarged to extraordinary proportions overwhelms the viewer standing before a Louis painting. Never has the sheer beauty of transparent wash been so eloquently presented; apropos, the detail has been omitted in order to present *Winged Hue* as large as possible.

The Drift of Summer by Mark Tobey (b. 1890). 1942. Tempera. 28 × 22 inches.

Mark Tobey once stated, "My imagination, it would seem, has its own geography." In the magnificent *Drift of Summer* one is transported on an exclusive tour of that terrain. Originally a part of Chapter 5, "Related and Other Water-Soluble Media," Tobey's work is shown here in order to be seen in its distinctive color and detail.

Tobey has been referred to as a spiritualist, symbolist, and mystic. It is significant that work of such deeply philosophical nature is also technically flawless. Artist and medium are inexorably welded, thus eliminating mechanical procedures and allowing accident and discovery to follow. The detail reveals the striking patterns formed by multitudes of crossing lines that flood the surface. Because of the translucent quality of tempera, the work inherits soft, persuasive depth layers, which add to its intrigue. Tobey's work of this period has been called "white line" or "light line": however we choose to describe it, the fluidity of his brush is enchanting.

COLLECTION OF THE ARTIST. PHOTO ROBERT RASCH.

Homage to Gaudi–Jupiter Ammon by Edward Reep (b. 1918). 1977. Watercolor on gessoed paper. 20½ × 28½ inches.

"In tribute to the renowned architect Antonio Gaudi, the work above represents the signature piece of a series of ten. Serpentine benches from the Park Guell (an enormous housing development of Gaudi's) lead us to the central theme of the medallion of Jupiter Ammon. Below the medallion is Gaudi's signature. The border surrounding the painting is suggestive of Gaudi's use of mosaic patterns formed with ceramic tile. Borders appear in all of the images in the series, and for no other reason than the notion that I wanted to produce some paintings with borders. Oddly, Jupiter Ammon was completed at the end of the series and understandably contains more nostalgic reverence than the others."

(Edward Reep)

Fitting this work into the sequence of Chapter 6, "A Chronology of Change," attests to a continued interest in careful structuring combined with a livelier and more enterprising paint surface.

Paint by Paul Hartley (b. 1943). 1982. Mixed media on paper. 30 × 40 inches.

One of the more inventive artists working within today's expanded parameters of watercolor is Paul Hartley. On the page opposite, the image entitled *Paint* employs watercolor as a spontaneous, unruly base, paradoxically played within an all-over circular pattern. Color in chroma and tone abounds as tiny, circular mounds of polymer emulsion punctuate grid crossings. The viewer is prodded by word and symbol at every turn.

Finally, *Paint* culminates in a typical still life of artists' materials found on an elegant, *green brick* wall. Surprise, adventure, and enigma are characteristic of this superb artist's efforts. Planned as an integral part of *The Contemporary School*, *Paint* is seen here in full color along with the artist's commentary.

"I like experimenting with media, trying different combinations of materials and different methods of making marks. The hope is that nontraditional materials and mark characteristics will add visual variety and complexity and, if so, help in the struggle to make a painting with enough substance to be perceived as something beyond marks and pigment—a sort of reality on its own. This struggle to make a painting exist as a new and worthy reality is present whatever the media used and however abstract the image or nonsensical the subject matter. It is a perpetual which, if it is to be even partially solved, demands an attempt to understand how people look at things. My interest is in creating something, not representing the real world, but creating something with enough of nature's attributes, its visual complexity, to really involve a viewer in looking.

"When we look into the real world we are constantly distracted from one thing to another, from contrast to contrast. Confronted with incredible visual variety, our attention is moved and we change our focus from one potent aspect to the next. We are able to attentively observe only a miniscule portion of the visible particulars before us, but every blade of grass or loop in the carpet adds substance to our impressions. The immense variety of visual elements leaves no sense of chaos but all are related and made orderly by the rational efficiency of light and gravity. If these attributes of looking at the real could be transformed and ascribed to my paintings, the problem would be solved. Attempting the solution will keep me occupied."

(Paul Hartley)

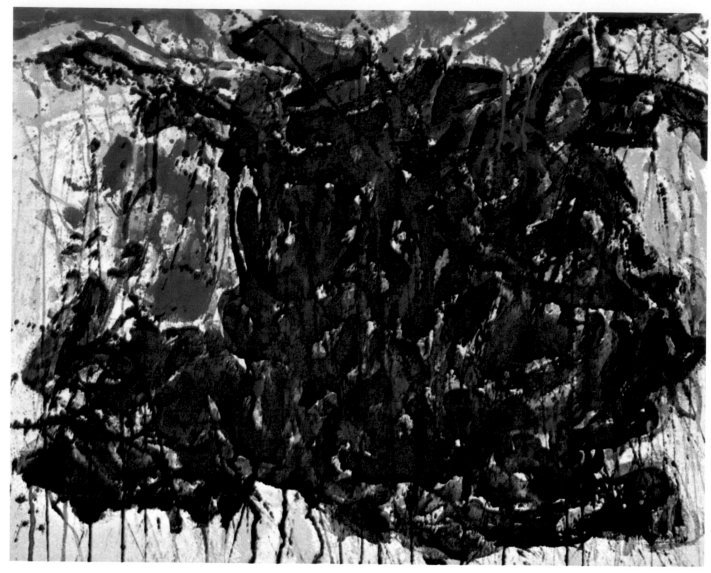

Untitled by Sam Francis (b. 1923). 1953. Watercolor on paper. 20¼ × 25⅝ inches.

This glowing statement by Sam Francis underscores the modest commentary on color found on page 44. However, none of the color images included herein has been selected because it is singularly extravagant, but of more import to present a cross-section of color ranging from chromatic to neutral or explosive to reserved; and in a truer sense, highly personal.

Sam Francis has long been recognized as one of the most dramatic of contemporary colorists. His work rings with vibrancy. His brush darts furiously over the surface, joins with splatters and drippings, and builds toward a thunderous crescendo. His control is so complete that the experience is relived with each viewing.

While Francis exploits the full color spectrum, it is rewarding to note how carefully he distributes his hues. At first glance, the viewer is aware of a large, essentially cool, blue mass moving against a red-orange space. Yet within the warmer and lighter spatial areas are countless minute cool accents which activate and provide fuller meaning. Sunken into the major blue mass are the most exquisite nuances of warm and cool greens, pinks, violets, and rich ultramarine blues, again completing the warm-cool balance so desirable in gaining color temperature.

Jardin Nacre by Jean Dubuffet (b. 1901). 1955. Collage with butterfly wings and watercolor. 8⅜ × 11⅝ inches.

Jean Dubuffet is represented here by an exquisite example of his work in watercolor with butterfly wings. When his good friend Pierre Bettencourt developed this approach, Dubuffet openly expressed his fascination with the method and produced many small paintings.

Jardin Nacre, originally used as part of the color essay in Chapter 2, "The Background of the Artist," remains a commendable foil to play against the Sam Francis opposite. Dubuffet's singular goal is bound up with the premise of a delicate, restrained, dominating light-warm color; yet we note that he feels compelled carefully to fit a few small, cool grays and blues into his scheme. *Jardin Nacre (Pearly Garden)* re-creates for the viewer the same magnetic powers that initially enthralled Dubuffet.

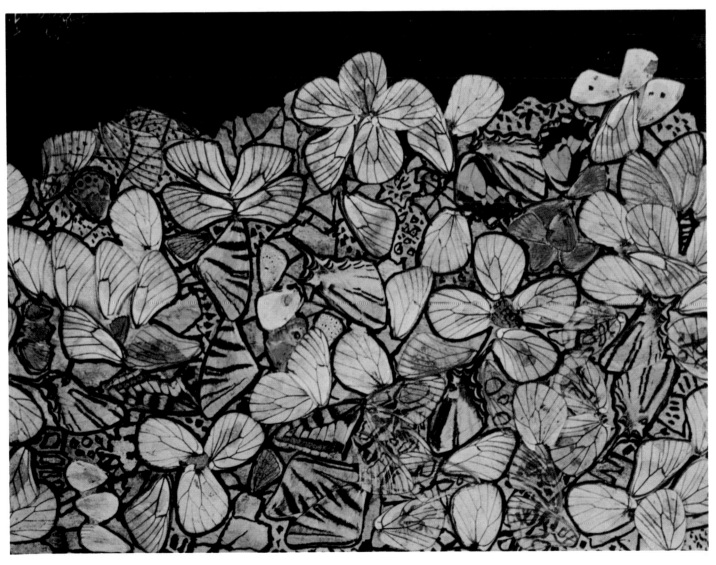

Illegal Flight over the Renaissance by Edward Reep (b. 1918). 1980. Mixed media. 21 × 24 inches.

"The alternate title for the painting below is The Archangel Raphael and the United States Naval Air Force. *I was admonished by a distressed viewer to include the word* naval *into the title, which had been carelessly omitted at first. All this is indicative of the lighthearted attitude I maintained throughout the work. Surely, I reasoned, there isn't a soul living or dead that witnessed the Archangel Raphael airborne—yet see how famous he is. Meanwhile, our friend the*

anonymous naval pilot is cruising right along—smack over the Renaissance, and vying for attention with our archangel.

(Edward Reep)

Once again a combining of gessoed and raw paper surfaces provide countless variations for the subsequent washes of color. Much *lifting* of paint is in evidence, as are both opaque and semi-opaque accents.

Along with the paintings *Cycle* and *Homage to Gaudi–Jupiter Ammon* (see last two pages of color section), these images cap the chronology presented in Chapter 6.

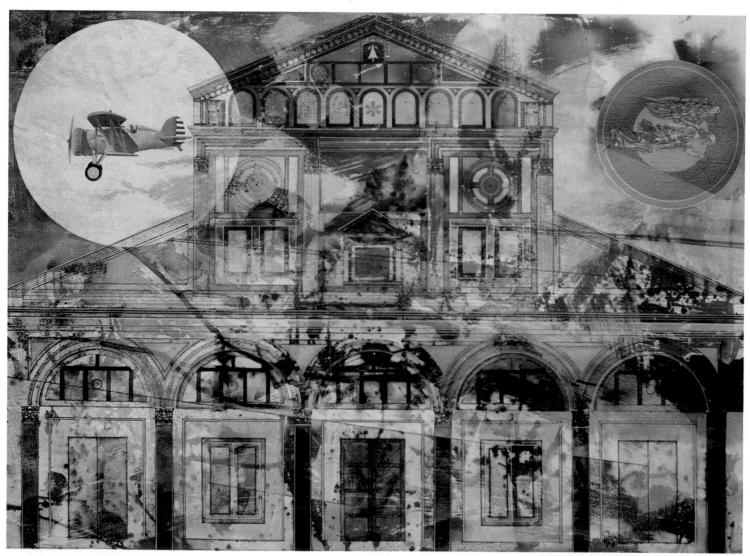

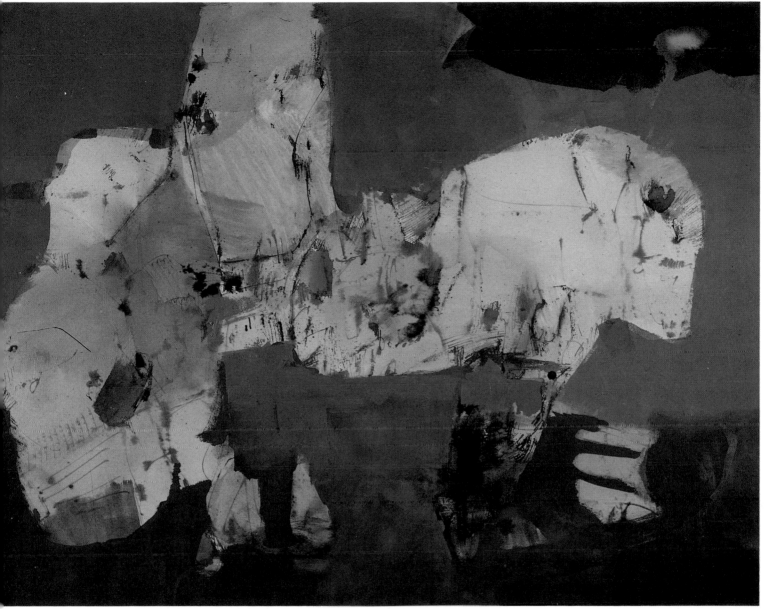

A by John Altoon (1925-1969). 1956. Gouache on board. 29¾ by 40 inches.

There are no rules, nor is there need for any, to explain this exquisite work by John Altoon. Here we find the same considerations of surface and plane, dark and light, and form and space that appear in the preceding paintings in this book. However, there is no trace of subject, apart from insinuations, and the painting continually serves as a springboard for the individual imagination and occult appetite.

Always a brilliant craftsman, Altoon offers an intriguing tactile experience in his painting. Enormous, monolithic masses seem to float weightlessly in space, suggesting form through essentially flattened shapes. The painting is not a depiction of some object or person, but the beginning of a new and private point of departure for each viewer.

Untitled by Clarence Morgan (b. 1950). 1982. Mixed media on watercolor paper. 6 × 8 inches.

This handsome statement attests to the mutual advantages in store when transparent watercolor is played against accents of collage, acrylic, and other opaque watercolor; as the artist explains, "a rough energy opposed to a more refined or traditional spontaneity."

Although deeply interested in iconography, the dynamic artist, Clarence Morgan, is not consciously attempting to reflect any particular symbology, culture, or ideology. Paint is used as the poet plays with words or as the musician is one with his instrument—the act is totally intuitive. Most noteworthy is the artist's control of the difficult realm of *dark, clear* color.

Small in size as a Klee, *Untitled* is potent in both color and structure.

Horizontal Still Life by Jo Rebert (b. 1915). Watercolor on paper. 27 × 40 inches.

Rarely are we treated to the sparkling beauty of the uncluttered transparent watercolor as with the work of Jo Rebert. While this sensitive colorist paints in many other media, *Horizontal Still Life* has been carefully selected for its mastery of the glazed wash. Removed from Chapter 4, "The Dynamics of the Medium," it is shown here with its detail in order to be fully enjoyed in color.

Jo Rebert is an exquisite composer, especially when involved with chromatic energy. Her work maintains a seemingly effortless structural dominance, while relying upon the accidental overlappings of washes to secure patterns in place and give a deeper dimension to her orchestration. In the artist's own words, "Watercolor lends itself to a rapid flow of ideas because it can be so rapidly and easily destroyed." This firm control over a spontaneous, transient surface is evident in both the painting and its detail.

COLLECTION OF THE ARTIST.

Untitled by Matsumi Kanemitsu (b. 1922). 1967. Ink wash on paper. 15 x 17½ inches.

By far the most reductive or minimal statement to be shown in this section is this painting by Matsumi Kanemitsu. It was produced as one of a series of experiments with ink and wash on paper, which was often cut apart and remounted on new surfaces. *Untitled,* however, is on a single surface, although the drifting patterns to the left suggest another material.

The enlarged detail readily demonstrates that there is more lurking within this simple yet powerful statement than first meets the eye. While a shimmering force appears half-coiled and ready to strike, we are allowed to examine its hide and anatomy. This method of ink and wash application, which is ultimately washed away, leaving only stained patterns on the paper's surface, is most effective, and the results are highly unpredictable. Kanemitsu readily confesses that he discovers as he goes, yet the viewer senses that he is in full control of his search.

COLLECTION OF EDWARD REEP.

Rancho de Taos and Mountains by Keith Crown (b. 1918). 1981. Watercolor on paper. 22 x 31 inches.

Few artists to my knowledge are as intimately involved with the medium of watercolor as is Keith Crown. You need only refer to his statement on page 68 in order to appreciate fully his reverence for watercolor and its inimitable qualities—but not to the point where he is governed by methodology. The subject, so vital to Crown, only comes to fruition through the struggle to liberate the unseen.

In his dramatic painting to the left, daring color combines with the *controlled accidental* in a vivid interpretation of the New Mexico landscape.

Crown once wrote, "Everything is color. The slightest nuance has another precise meaning. Color is a language of the poet. Anything can be any color at any time depending on what color everything else is at the time."

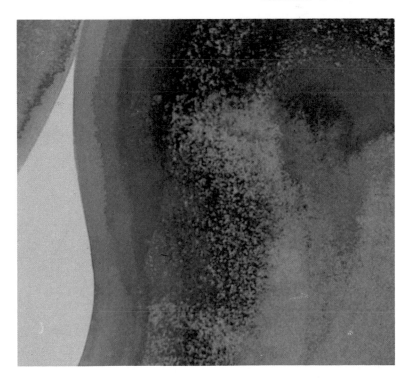

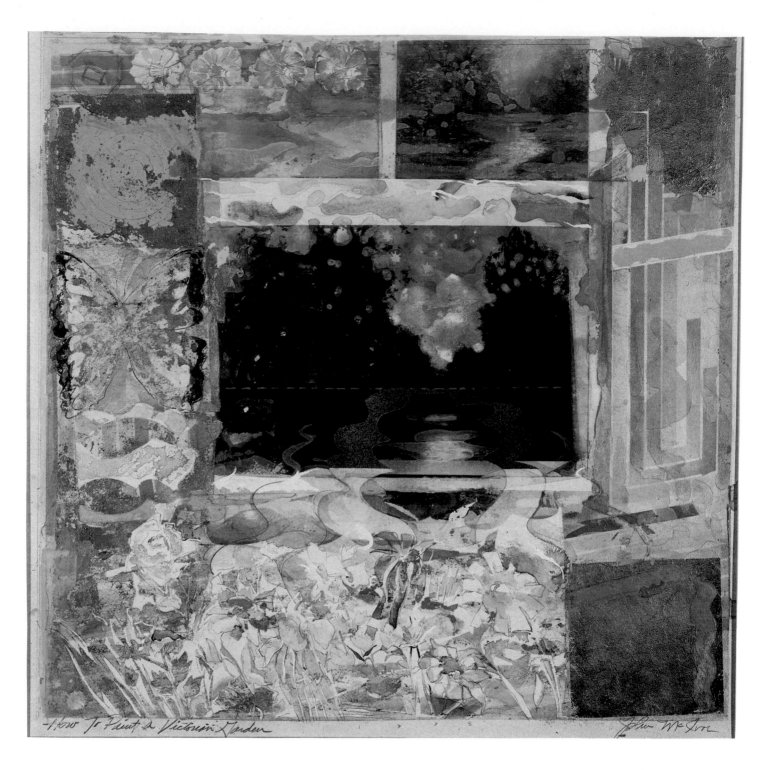

How to Paint a Victorian Garden by John McIvor (b. 1931). Watercolor. 30 x 30 inches.

The McIvor painting and personal statement, originally a part of Chapter 3, "The Contemporary School," appears here in order to be seen in full color.

"*I would like to tell you what I think watercolor is, except every time I nail an axiom in place it seems to rule out other things. What's worse, people armed with my own walls then fence me in and them out.*

"*I've taught some sixteen courses of watercolor, but on the other hand I'm not sure I ever taught anyone its essence successfully; I think they learned this themselves. I taught them to be sensitive to transparency, white space, drawing, and the other things—but these other things that make up a watercolor are all mediawide, and this is where the art lies. It seems obvious, then, that watercolor is very personal and not categorical.*

"*In 250 words I might sum up why watercolor for me isn't just a craft, but I couldn't in a thousand words define why it's an art. I guess, then, the cateogry is that craft is craft and art is art, and craft is of little comfort to me. When I'm fortunate, I sometimes can define the other with a painting.*"

(John W. McIvor)

Homage to Gaudi–Casa Vicens by Edward Reep (b. 1918). 1977. Mixed media. 29 × 35 inches.

Long fascinated by the architecture of Antonio Gaudi, while visiting Barcelona, Spain during the summer of 1976, I enjoyed the rare opportunity to visit and view his efforts. Returning to America, I produced a series of paintings dedicated to this esteemed architect and his work. A master craftsman and innovative genius, Gaudi exploited color, form, and texture as no other architect in recorded history.

The unusual Casa Vicens, above, a summer house for the tile merchant Manuel Vicens, is used only as a point of departure for the painting. There has been no attempt to faithfully document the structure, but to capture the essence of the rare forms, patterns, and textures which abound. Note how the strong dark green and black border virtually becomes a part of the edifice as it invades the image. Resist effects over various tapes which have been left in the painting, plus the larger acrylic surfaces, are relied upon to rival the spirit of Gaudi's remarkable creation.

Pipe Dream by Edward Reep. 1967. Watercolor and ink on rice paper. 8½ x 12 inches.

Cycle by Edward Reep (b. 1918). 1980. Watercolor over gesso and paper. 21 × 29 inches.

"Having dealt with the landscape most of my career, Cycle *combines that experience and affinity with a recent interest in a stratified, mirrored or time-lapse circumstance, particularly in larger oils and acrylics.*

"The appearance of sun and moon, or two suns, or two moons—it is of little consequence—was a source of amusement to me. The work began with merely the horizontal divisions, followed by traced, major landscape forms; all that appears in the final statement was played by ear. The overall effect of a gradation ensued without a specific goal in sight. The real delight came when one sun (or moon) seemed to rise as the other appeared to set. Or was it the other way around?"

(Edward Reep)

A Pier Goes On and On. 1955. Water-color on paper. 21 x 29 inches.

These two pages are devoted to four picture structures that were employed for a number of reasons. For example, in *A Pier Goes On and On* I was involved with a very static horizontal and vertical motif of architectural form and space. The durable nature of such things, despite superficial decomposition, was of prime importance at the time.

In retrospect, it is all too evident that spattering paint was particularly fascinating to me then. In this statement the spatial apertures were covered over in order to preserve their clear, unmolested nature. It seems curious to me that there is a small painting of the large painting worked onto a wall near the left border — for what purpose I cannot recall. There is a finality about this painting and its structure which serves us well in a comparison with the three other works pictured here.

COLLECTION OF MR. AND MRS. NORMAN TOKAR. PHOTO DON GARBER.

Long Beach Pike. 1946. Watercolor on paper. 26 x 36 inches.

Painted immediately after World War II, *Long Beach Pike* was possibly my first effort in watercolor to successfully encompass distortion and animation. The joyous nature of all of my work at the time undoubtedly was a reaction to the preceding years of military service and to the paintings done then that spoke mainly of sadness and tragedy.

Long Beach Pike was initially painted on location, then done again, and much larger, in the studio. This second painting was carefully planned and completed in two or three days. It attempts to capture the colorful spirit of an amusement area as it might be seen through the eyes of children. The clouds form animal-like shapes and everything moves in tilted, muddled gaiety. There is a continuous writhing of colors, textures, and shapes which attempts to re-establish the cacophony of Pike sounds.

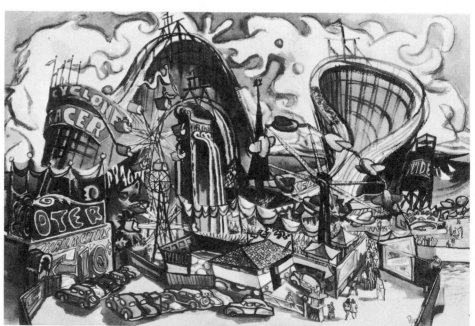

COLLECTION OF COLE OF CALIFORNIA.

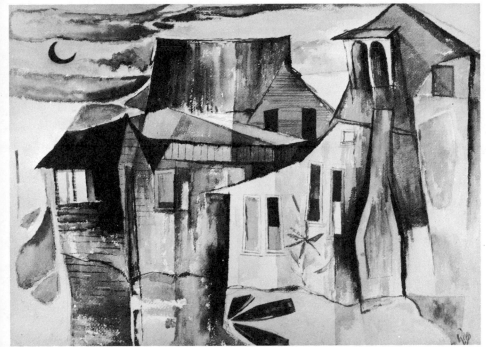

Moon Story. 1954. Watercolor on paper. 27½ x 19¾ inches.

Somewhat architectural, with patterns continuing on to move through one another, *Moon Story* reveals the functioning of floating forms. There is a definite attempt to isolate as many shapes as possible without letting them overlap. When this is not feasible, smaller floating patterns are placed within larger shapes.

Moon Story was painted when timelessness was all-consuming to me. The intention was to invite, suggest, and provoke individual excursions. The gentle yet persuasive lunar magnetism and its resultant chiaroscuro was a source of great intrigue to me. Although *Moon Story* has only a murmuring voice, it has long been a favorite of mine.

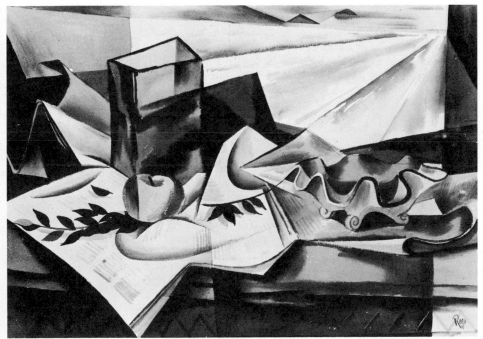

Still-Life with Apple #1. 1953. Watercolor on paper. 19¼ x 28½ inches.

This carefully planned work was painted soon after my friendship with E. J. Bisttram was formed. The lessons of Dynamic Symmetry that intrigued Bisttram were uppermost in my mind, and there was a concerted effort to develop structural authority in my work. Everything done at the time was ordered under the precise rules of root rectangles. In essence, these rectangular formats provide for proportionate orders of forms, shapes, angles, and thrusts.

In *Still-Life with Apple #1,* the opposing diagonals are quite obvious, but there is added interest contained in the transposition of dark and light. The immaculateness of the washes, as shown here, seemed vital at the time, but they ultimately displeased me and led to the spattering previously discussed.

115

Note. 1957. Watercolor and ink on cotton skrim cloth. 21½ x 34 inches.

Return to the Earth. 1953. Watercolor on paper. 19 x 28¼ inches.

Wind Bouquet (opposite). 1958. Watercolor and ink on cotton skrim cloth. 24½ x 34 inches.

The paintings *Note* and *Wind Bouquet* are drawn from a year-long period when all of my work was executed on a cotton skrim cloth backed with polyethylene. Given to me by a friend for experimental purposes, it provided an altogether new surface experience. The cloth was so widely woven that it proved to be semi-transparent, and practically invited collage to be placed under, or behind, the paint washes. When this was done, the warp and woof of the cloth fibers were accentuated, as if by dioramic means. The effect may be clearly seen in *The Bank,* shown on page 106.

With this work came a total abandonment of preparation for each painting; nor was any preliminary drawing done on the surface itself. In this spirit over 70 works were completed, but less than 30 were framed. My own desire was to capture an essence, spirit or condition, and consistent with this goal was the de-emphasis of subject. My thinking had now become less analytical and far more inductive.

Return to the Earth, completely out of chronological order, assumes a very important role when related to *Note,* shown just above it. It is an elaborate painting, and a most unusual watercolor, since it took over three days to complete. The striation of everything — earth, sky, architecture, and trees — was done in order to express a transitory step in the death of

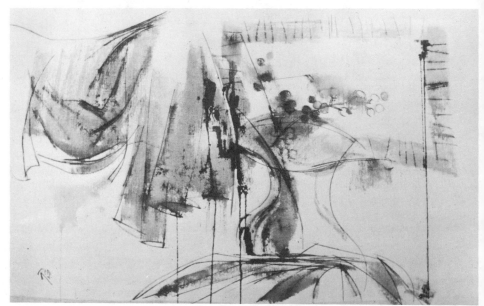

COLLECTION OF MR. AND MRS. EDWARD BROIDA.

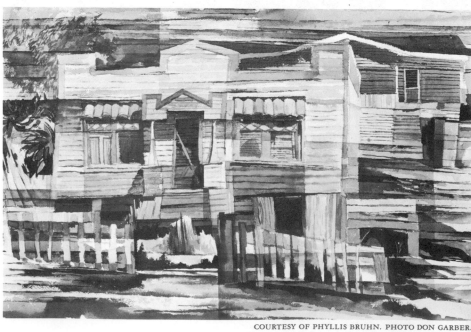

COURTESY OF PHYLLIS BRUHN. PHOTO DON GARBER.

a tiny settlement. These modest houses were put together with second-hand material, perspiration, and love, and they were doomed by the usurpation of a major-league ball park. Everything was headed back to whence it came.

Note was completed in little more than 45 minutes, yet it remains one of the most successful of the cloth watercolors. Its content-goal is distinct from that of *Return to the Earth*; consequently, it was executed in a different manner. But what of the time element — 45 minutes and three days! Prolific painters, writers, and composers often crank out work accord-ing to a time schedule, but its quality is highly debatable. It is here that I take issue with the automatic methods that produce inferior results.

One further point concerning change, or new events, is shown by the paint-runs in all three of these paintings. This innovation was a brisk step away from the earlier work, which was complete and immaculate. But the condition of the moment, and how to get the viewer to participate in the excitement felt in the very act of painting, were what I now considered vital.

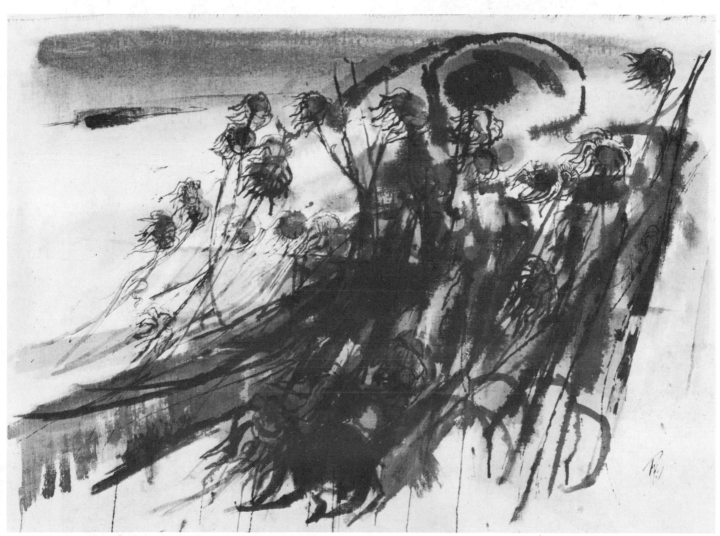

COLLECTION OF KATHERINE PAGE PORTER. PHOTO I. SERISAWA.

Day in Echo Park. 1954. Watercolor on paper. 19 x 28½ inches.

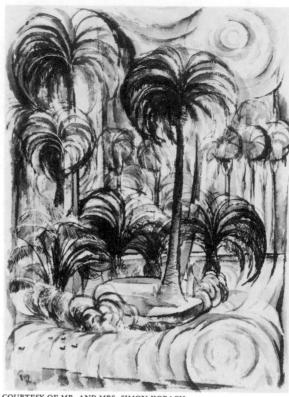

Mountain. 1949. Watercolor on paper. 27½ x 20 inches.

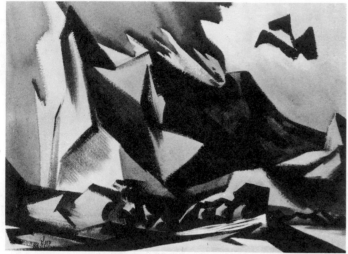

COLLECTION OF WESTSIDE JEWISH COMMUNITY CENTER.

COURTESY OF MR. AND MRS. SIMON KORACH.

The Beach. 1950. Watercolor on paper. 21 x 30 inches.

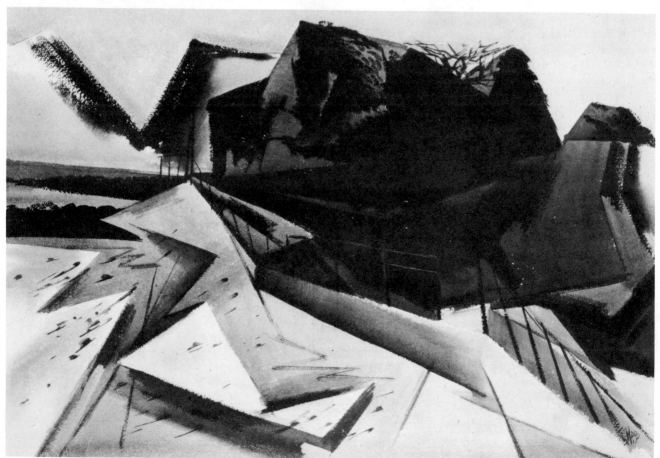

COLLECTION OF THE ARTIST.

Crystalware in Pink. 1954. Watercolor on paper. 20 x 28½ inches.

Crystalware in Brown. 1954. Watercolor on paper. 18½ x 28 inches.

Of the paintings on the opposite page, *Mountain* and *The Beach* represent a continuing interest in the dynamic structure already discussed. The resolute diagonals still remain, but there is a definite lessening of complete dependence upon them, and slight texturing has been added. *Day in Echo Park* completely abandons the angular format, although the circular patterns that appear did not constitute a trend. These patterns are peculiar to this painting alone, and spring from the spheroidal sun, the flora and their reflections. The lessons of Dynamic Symmetry had been effective, so much so that now there seemed to be an overemphasis given to structural order.

The two *Crystalware* paintings are deeply significant for me. *Crystalware in Pink* was painted first, and, apart from the esthetic goals that were sought, is a small tribute to those craftsmen who do such exquisite things with glass. This seeming irrelevancy is mentioned because such extreme beauty in man-made things, as well as nature, is very often a source of inspiration to the painter. But of greater importance to this chronicle of change is the further relinquishing of the extremely tight controls that had dominated my work thus far.

By the time *Crystalware in Brown* was begun, there were more important things to consider; despite all of my previous efforts to extract newer and richer meanings, the similarity of my works was haunting me. Determined to continue in watercolor, I was bothered because 99 percent of watercolor was applied to a white surface; hence *all* applied color had to be *dark over light*. In *Crystalware in Brown* there was a bold attempt on my part to reverse this procedure and allow light forms to move out of a dark periphery. Inspired by this new (to me) development, I began to make more purposeful selection of subject and shape; and this painting in particular became the precursor of eventual liberation.

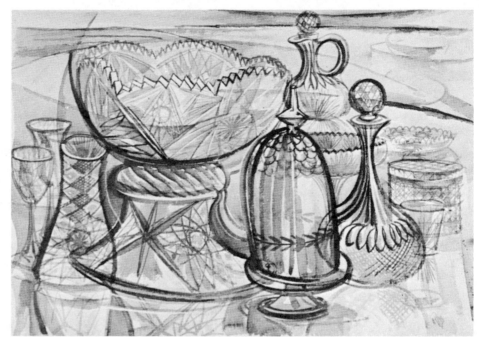

COLLECTION OF DR. AND MRS. DONALD HULL.

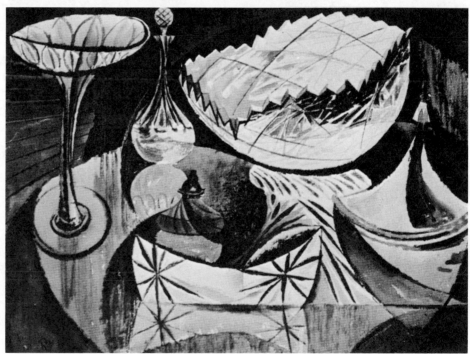

COLLECTION OF MR. JACK JEANS.

119

World in World. 1958. Watercolor on paper. 21 x 29 inches.

Although it appears to be completely out of step, *World in World* was actually painted a year after the far more spontaneous cloth series. This only underscores my contention that while an artist's methods and materials may change radically, his basic loves remain the same. Apropos, there can be no questioning my proclivity for detailed order, for here it is again!

However, there is now more being said through less, and there is added opportunity for the viewer to read other highly personal meanings into the work. *World in World* projects my reflection in the window of a building housing a beach carrousel. It nostalgically recalls early interests both of boyhood and of painting. The *range* of time has now invaded my thinking, a range that may be concerned with the past, present or future, the infinite or momentary.

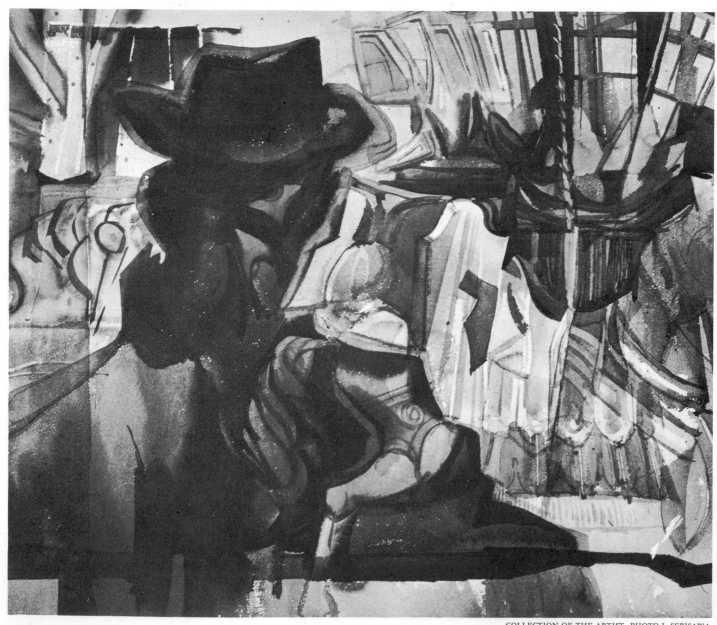

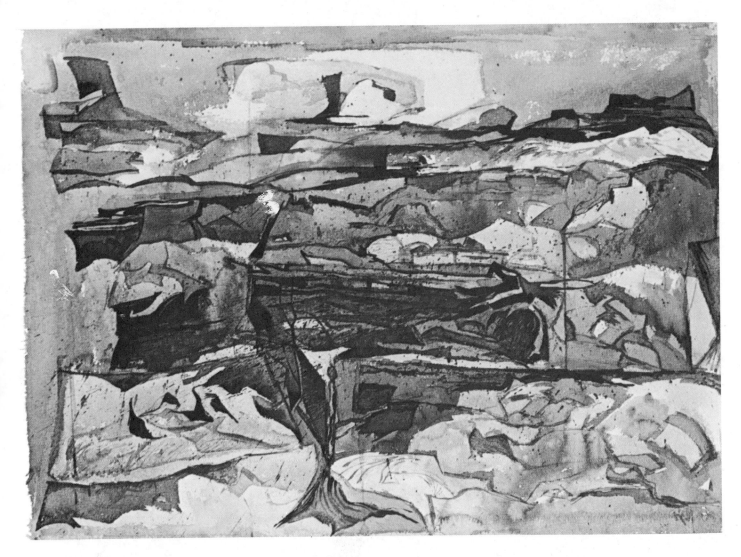

Stairway to Yesterday. 1957. Watercolor on paper. 21 x 29 inches.

Stairway to Yesterday is based upon the identical theme that prompted *Return to the Earth* (page 116), even though the structure is dissimilar. When old replaces new, and especially when homes are torn down, nostalgia pervades the atmosphere. In this painting we discover the lonely surviving portion of a home — a street-level concrete stairway — posed against a barren plateau where the house once stood.

Shoot First. 1967. Watercolor and ink on
rice paper. 16 x 12 inches.

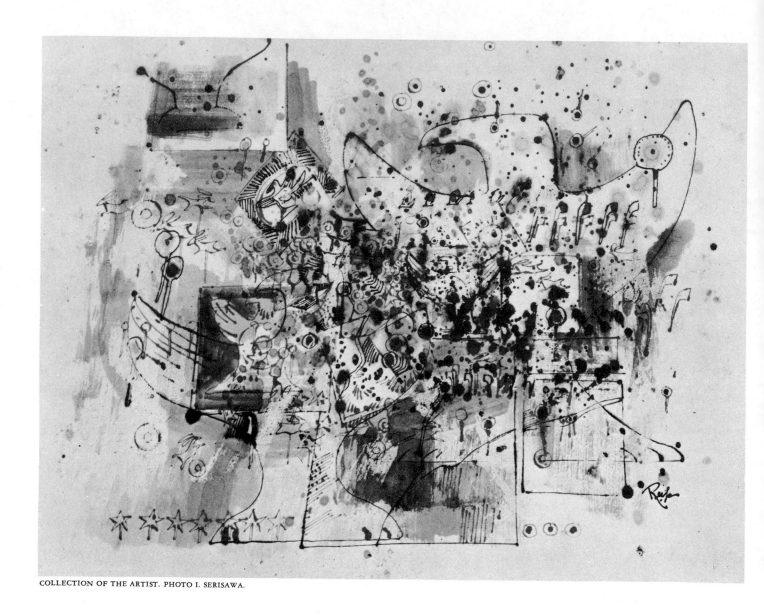

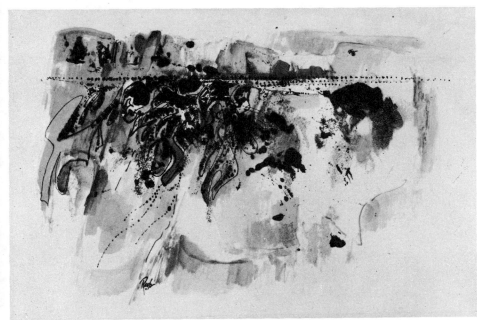

COLLECTION OF THE ARTIST. PHOTO I. SERISAWA.

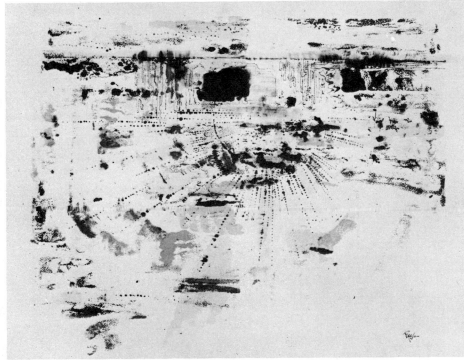

COLLECTION OF THE ARTIST. PHOTO I. SERISAWA.

Sun Horizon #1. 1967. Watercolor and ink on rice paper. 12 x 18 inches.

Sun Horizon #2. 1967. Watercolor and ink on rice paper. 18 x 24½ inches.

While definitely a technical part of this series, *Shoot First* is philosophically disparate. It is one of a group of small paintings that allude to our trigger-happy society. It was begun at a waterfront shooting gallery, where all comers are invited to take pot-shots at clay pipes, eagles, rabbits, deer, and various other targets.

The two *Sun* paintings on the left are largely the product of a very old device. In this instance, however, the approach was far from being predetermined, and was born of utter frustration. I was working on several layers of rice paper, and the washes and ink lines bled through to form strange new patterns on the paper underneath. Each time a painting was removed, there was the beginning of another waiting below. Soon, and especially when the first results were abortive, there was a sense of delightful anticipation in this act; needless to say, the second and third attempts were often superior to the original statement. The two paintings are offered mainly to give broader substance to the works on the preceding pages, for in final form, despite a different approach, they vary little in treatment.

If the viewer finds subject matter in the *Sun* paintings, it will have to be attributed to his personal responsiveness. Both works, along with the titles bestowed subsequently, are merely triggers to the event. While hardly innovational, it represents the beginning of a different approach for the artist — different technically and philosophically.

To present more elaborate descriptions of these paintings would only defeat our purpose. I have only attempted to explain something of the manner in which they were realized and how they relate to this chronology of change.

Circumstance. 1974. Watercolor on paper. 21½ × 29½ inches.

In the 1970s, working predominantly in my studio and rarely on landscape or other locations, "Circumstance" and a series of other similar works appeared. They represented an engagement with the image that allows one thing to suggest another, with little else in mind. Using transparent watercolor at the outset to develop some path or direction, the real excitement was eventually generated by the addition of countless varieties of semi-opaque and opaque accents. The work became a matter of juggling, emphasizing, denying, and refining one thing or another. Vibrancy and light, not merely light hues, but a sense of "luminosity" were major concerns.

While insect or animal forms may suggest themselves, the imagery has been drawn from fantasy.

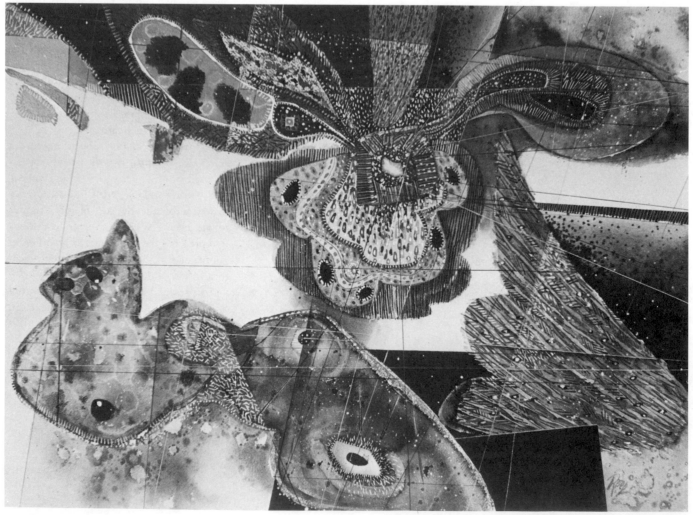

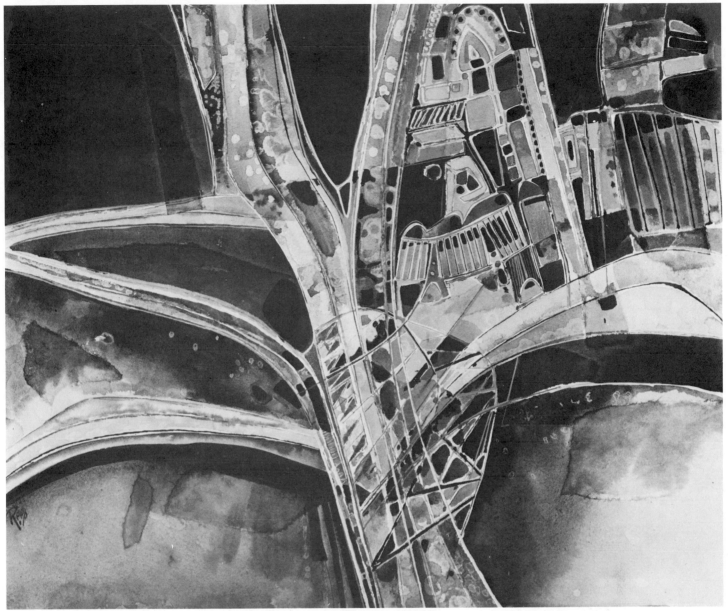

Three Rivers—Pittsburgh. 1974. Watercolor on paper. 21½ × 25 inches.

Dining high upon a hill overlooking the city of Pittsburgh, I was captivated by the panorama below. The painting above depicts my impression of the network of roads and rivers alive with lights. Automobiles seemed to leave trails of red and white as their tail lights and headlights snaked through the city, over and under bridges, and through and about clusters of buildings. The roadways were further accented by borders of flickering street lights that sliced apart the enormous and forbidding darkness. These massive unlit areas lent scale to the event.

From rapid sketches and color notes made that night on cocktail napkins, I returned home to begin work on recreating the experience. The image was so deeply etched upon my mind that to this day I retain a clear impression of the scene.

Rice papers were first glued to the watercolor paper to disturb the surface. Alcohol, dropped into wet watercolor washes, was employed to gain the effect of light paths and clusters. The approach seemed natural in every respect—the work went smoothly. The fly in the ointment was that despite enthusiasm, excitement, and inspiration all on my side, the painting of "Three Rivers—Pittsburgh" was my third attempt. The first two were failures.

125

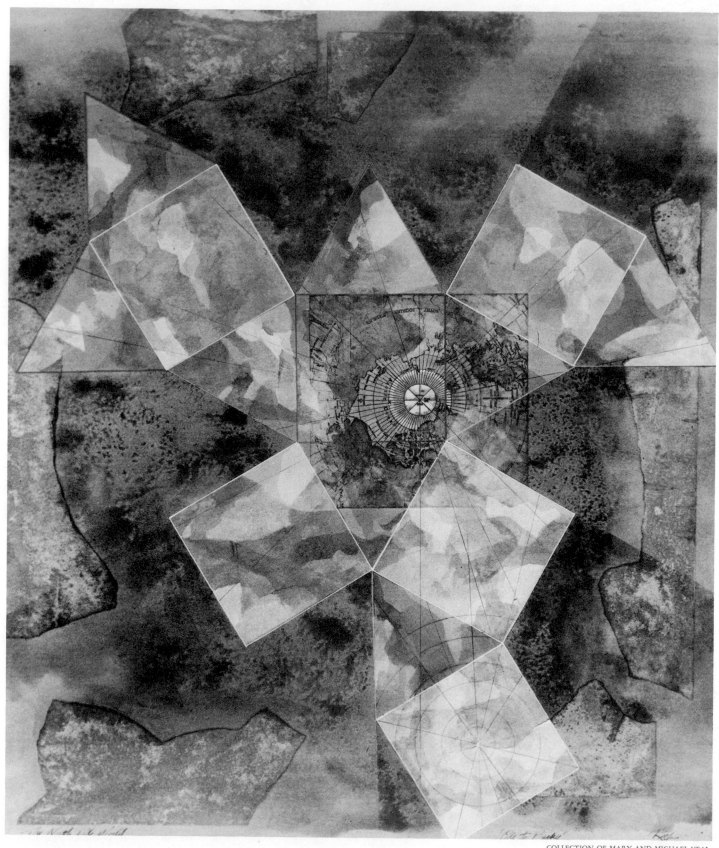

The North Pole World—Ode to Bucky #1.
1979. Mixed media. 30 × 34 inches.

In 1943, my interest in the work of Buckminster Fuller was born, notably his Dymaxion World. Clipping and saving the complete set of global maps from a national periodical, I became a student of his concepts. In 1978, while well into his eighties, Dr. Fuller visited our campus, and I was privileged to have dinner with him. So impressed was I with his energy, wit, and intellect that I produced a series of paintings based upon those magnificent maps.

The North Pole World is such a painting. The flattened map, with the North Pole section dominating (this square or segment has been glued in as collage), presents a scintillating geometric format. While liberties have been taken, the spirit retains the Fuller stamp.

The work was begun, sponged off to a tint, and painted once more in transparent watercolor. The surface is an all rag, neutral tone printmaker's paper. White tissue paper has been employed as part of the ground and for modifications not unlike glazing. Gouache, or semi-transparent touches, followed for careful definition.

I have attempted a brief documentation of technical and philosophical change, all expressed through a single medium. To my knowledge, none of the artists whose painting appears in this book works exclusively in watercolor. Obviously, far more variety would be seen if their oils, graphics, and drawings were included, and this is particularly true of my own work. The point to be stressed, however, is that change is necessary; the amount or degree of it is not what matters.

This section opened with the statement that there would be "cause for alarm" if no change were evident in one's efforts; thus, the pictures that followed were selected carefully, with that consideration uppermost in mind. To change only one's medium may prove rewarding but is not in itself enough. Merely moving from one medium to another cannot be equated with the vast new adventures awaiting the artist when his efforts reflect and harmonize with the inevitable physical, emotional, and intellectual transformations he experiences throughout his life. Picasso declared pointedly that the *search* means nothing in painting, and that *to find* is the thing. Perhaps it is true that young artists are constantly searching, and the finding follows. But whatever the nature of the change, there is no standing still!

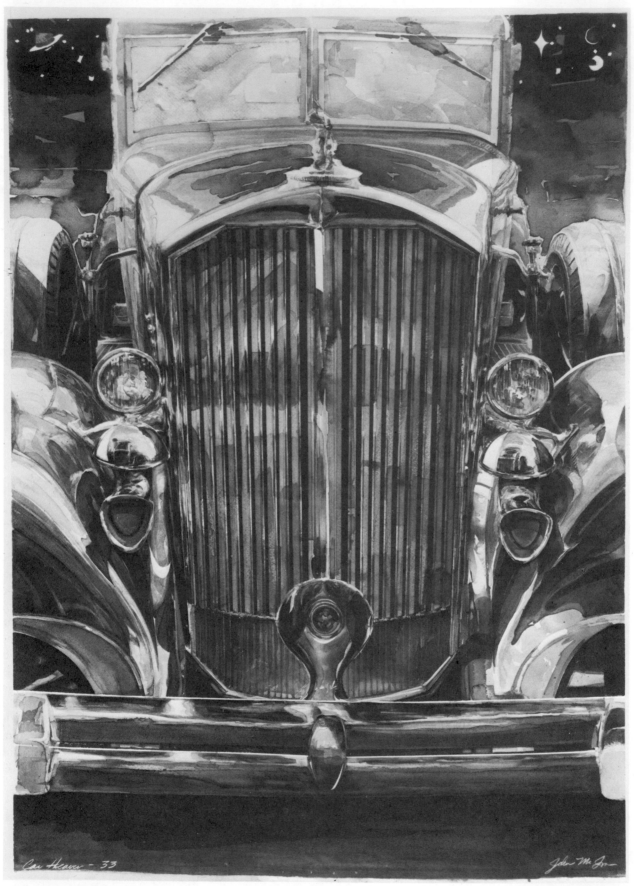

Car Heaven – 33

John McLam

THE CONTROL OF WATERCOLOR

Anyone can paint. With experience and practice, skills develop. How well one paints is another story; one that involves perception, feeling, sensitivity, and countless other things.

The control of the watercolor medium has more to do with common sense than following "professional" advice. Methods and approaches are a dime a dozen and leave wakes of frustration. I stongly suggest that if one is able to "color in" or apply a flat wash of watercolor over a six-inch square, half of the technical hurdles will have been surmounted. Vary the shape, use an assortment of brushes, experiment with various surfaces and with a little imagination you will be off to a resounding start.

When I entered art school it came as a wondrous discovery to find watercolor available in tubes that proved far more versatile than the scholastic, hard-pan colors I knew as a youngster. The rough surfaces of handmade, all-rag water-color papers were equally fascinating, offering a tough ground for attaining a host of effects. To this day I have not exhausted the multitude of directions available with so flexible a medium.

Car Heaven by John McIvor (b. 1931). 1982.
Watercolor. 36 × 48 inches.

During those early days I burned with a desire to produce works unlike those of my classmates and teachers, but seldom neared that goal. My environment and a woeful lack of art history, past and present, were to limit my offerings; diligence, desire, and a beginning mastery of technical skills kept me going. I learned quickly that my lack of draftsmanship and compositional awareness (picture structure) was apparent, and I would have to do something about it. Only an inordinate love for color and shape gave my work the appearance of being better than it was—or so it seemed to me. Very often this provided the encouragement so desperately needed.

Working alongside several well-known painters as a World War II artist-correspondent opened my eyes to new worlds of structure and draftsmanship. I remain grateful to those artists inexplicably under my supervision for their examples. In particular Mitchell Siporin and Rudolf C. Von Ripper awakened me to concepts and attitudes I had never explored. Siporin drew in his own inimitable manner, while Von Ripper was an extension of a consummate blending of Cézanne and Van Gogh. By contrast, I was still drawing and painting in the manner of my professors, which was limiting to say the least. I determined to develop a sense of *what* and *why* as opposed to *how*.

The foregoing is presented to establish clearly why the two ensuing chapters are designed for classroom text and course work as well as private study in a deceptively traditional fashion. Fundamentals must be absorbed and practiced in all endeavors. One cannot dispense with tradition without knowing what tradition is, or the past is repeated unwittingly. Without a working knowledge of fundamentals the artist is merely going through the motions and hardly seriously engaged in painting.

For those beginners who subscribe themselves to the lessons contained herein, I encourage you to periodically review the entire book to determine how other artists develop their personal styles. You will note that there is no single way to paint; each artist moves comfortably in challenging directions, often pressing the medium to unbelievable limits—and this is how it ought to be. My approach to learning is not the only way, and the lessons are subjected continually to alteration or refinement. I apologize to the many fine painters whose work could not be included in this volume, for with their images my premise would be further strengthened.

Before undertaking this work I asked myself a number of questions. How do we instruct the beginner—one who has never painted? How do we open up avenues of expression for those artists imprisoned by method or habit? How do we lay out the tools and materials available, and insist upon personal experimentation apart from proven results? How do those of us offering such advice in the arenas of study and exercise make certain that it is just that and nothing more?

The following text is submitted as my answers, and I wish to share them with you.

MATERIALS AND EQUIPMENT:
Paint

Any reputable brand of tubed watercolor is suitable and affords a high degree of permanency. When the word *artists* appears on a label it denotes the best of that manufacturer's line and differentiates it from the "student" or "scholastic" level. The latter paint does not contain enough pigment and will not allow you to gain rich, chromatic hues or clear color in the deeper ranges. I suggest the colors below as a starting palette. Note that black and white are not included at this juncture; later, when the command of these colors has been attained, I would add both black and white as well as any other color that has individuality and appeal.

> Alizarin Crimson
> Scarlet Lake (or a similar red-orange)
> Cadmium Orange
> Cadmium Yellow, Pale or Light
> Cobalt Blue
> Ultramarine Blue (optional)
> *Phthalocyanine Blue
> *Phthalocyanine Green
> Yellow Ochre
> Burnt Sienna
> Burnt Umber

Some of the better brands are Winsor Newton, Rowney, Rembrandt, Permanent Pigments, Bocour, and Grumbacher.

Papers or Support

I recommend the use of a 140-pound rough watercolor paper. Watercolor paper is graded by the weight of the ream—472, 480, or 500 sheets. Generally the lightest weight or thinnest paper is 70 or 72 pound (sometimes a 40-pound paper is available); paper also comes in 90 pound, 140 pound, 200 pound, 300 pound, and heavier. The heaviest papers are very thick and do not require stretching. The most popular size is called Imperial and is usually 22 × 30 inches. The best and most readily available brands are D'Arches and Strathmore; Cressbrook and Grumbacher brands are suitable, as are other all-rag papers

*Phthalocyanine may be found abbreviated as "Thalo" and as a rule carries the manufacturer's name before the hue (i.e., Winsor Green is Thalo Green)

made expressly for watercolor. In time you will select the paper most comfortable to you and your particular goal, in both weight and surface. As a rule, smoother surfaces are more difficult for the beginner to manage.

Brushes

The watercolor brush is unique, and the finest red sable brushes are very expensive. It is vital to secure only those brushes that permit full and easy manipulation, which always poses a problem for beginners. Several manufacturers have been producing excellent synthetic brushes designed for use in watercolor; in my view, the white nylon is the best. When you select a brush, dip it into water and snap it briskly to make certain it remains erect and retains its point. The ferrule or metal cylinder found on brushes carries two or three indented rings on it next to the wooden handle. Three rings once signified the top of the line. It is unwise to use a poor-quality brush such as the "camel hair" variety.

Most manufacturers produce a good red sable brush. Among the best are Winsor Newton, Grumbacher, Delta, Simmons, and ArtSign. You should have a small round sable (#2 or #3), a medium round sable (#8 or #9), and, if you can afford it, a large round sable (#12). Because the large sable is inordinately expensive, a one-inch *flat* sable brush will suffice. Some flat brushes are made exclusively for watercolor use and should be examined. Since the larger brushes are used primarily for washes or roughly laying in the painting, you may step down a notch or two in quality without sacrificing precise control.

I also recommend a large container for water. To eliminate frequent changing as the water dirties during painting, use at least a five-quart plastic pail or a two-pound coffee can. Glass containers are excellent but easily broken; they cannot take the abuse that a plastic or metal container can.

THE PALETTE FOR PAINTING

I recommend the white metal palette that folds when not in use. It contains small bins for holding the pigment plus several mixing areas that can be easily washed clean while painting—specifically, when a complete change of color is vital. The metal palette is unbreakable and very durable. Some of the larger white plastic palettes are acceptable; make certain that they contain enough bins for your color assortment and that they have ample mixing areas. Avoid the poorly designed circular palette as it woefully lacks the necessary areas for efficient mixing.

For work outdoors or away from your studio, an easel may prove advantageous, but it is not imperative. In or out of the studio, the working surface must be able to tilt one way or the other. In purchasing an easel be assured that it is steady, can be adjusted for height, and tilts backward and forward. If you prefer to stand before an easel with palette in hand, make certain that the palette you purchase contains a thumb hole for that purpose. In time you will discover which palette or easel is best for you.

The materials and equipment recommended are done so with an eye toward economy that allows full expression. There is no reason why all hues and shades cannot be achieved with the suggested color list. In time you will supplement both materials and equipment with those items peculiar to your goals—things you find most efficient and comfortable. Sponges, rags, bristle brushes, odd-shaped industrial brushes, bamboo and other sticks—the list is long and will be dealt with later in the text. What I have suggested will suffice at the outset.

PREPARING THE GROUND OR WORKING SURFACE

The best papers are handmade and comprised of 100 percent linen rag. They carry a watermark or embossment which indicates the preferred side on which to work. However, most fine papers may be painted upon either side with no apparent difficulty or noticeable difference in the finished painting.

A rough surface is most popular since it holds minute puddles of paint in its hollows or valleys. This allows a wash to remain "wetter" for longer periods, which in turn provides greater manipulation. The majority of artists stretch their paper over a hard surface such as 3/8 to 1/2 inch thick plywood. Some prefer not to stretch paper, while others work on sophisticated surfaces such as gessoed paper or cardboard. Masonite or other hardboards may be employed; again, coating with a white water-base paint enables the artist to gain full luminosity from the transparent pigment. By stretching a paper taut one commences with a perfectly flat surface which facilitates preliminary drawing or planning. This does not mean that when the paper is saturated while painting it will not buckle or swell; rather, as the paint dries the surface returns to its original flat state. In the advanced stages of painting, a stretched paper generally remains perfectly flat, allowing the artist maximum ease in controlling delicate or complex refinements. Finally, when the painting has been completed and is thoroughly dry, matting and framing is a simple matter with a perfectly flat image with which to work.

There are numerous ways to stretch a sheet of watercolor paper. Begin by wetting both sides of the paper with a sponge, working lightly over the surface to prevent disturbing or removing the sizing; or submerge the paper in a large sink or tub and let it remain there for two or three minutes. In soaking or wetting the paper you are allowing it to expand.

Working quickly but not in haste, lay out the wet paper over your board, flattening it out gently with your hands. If you experience difficulty as the paper refuses to flatten to your desire, pick it up and roll it one way and then the other, holding it in a fairly tight roll for several seconds. This eliminates buckling, especially at the edges. Using a staple gun loaded with quarter-inch staples, secure the paper to the board. Set the staples about one-half inch in from the edges, and space them approximately two to three inches apart for best results. Blot off the excess water with a clean dry rag or paper towel and allow to dry at room temperature. Faster drying takes place in direct sunlight or in front of a heater, but check the progress of drying; too much shrinkage can cause the paper to pull away from the staples.

Paper tape is also used for stretching. It is preferred because it does little damage to the board and the task of removing the staples is avoided. Gummed paper tape, sometimes called "water tape," may be troublesome at first. Using a good quality tape solves many problems, for it has superior adhesive ability. A medium-weight tape about two inches wide is recommended.

Wet your watercolor paper and spread it out over the board, as in the staple method. Secure the paper to the board by placing half of the tape's width on the board and half off the board. It is amusing how often this simple measure is abused, making the stretch a failure. When the four edges have been taped to the board, rub the tape firmly with a cloth or paper towel. This not only forces excess water from under the tape, but generates heat which temporarily helps set the bond. Allow to dry as with stapling.

Since most watercolor papers are approximately 22 × 30, it would be provident to work with a hardboard surface at least 24 × 34. This protects the edges and allows ample margin if taping. If a grain exists, as in plywood, it must run the length of the board, or the board will warp after the stretched paper dries.

For additional information on materials and equipment, see the Appendix on page 169.

THE WASH

The wash of watercolor is by far the most elusive lesson for the beginner to master, but with common sense and practice the task becomes routine. The above wash is about six inches square and was set down in a matter of seconds, or as quickly as you can brush back and forth across the surface with a fully loaded brush. By using no less than a one-inch flat or #12 round sable brush, or any other large brush that holds a great deal of paint to allow rapid covering, your chances of success are enhanced.

Mixing more than enough paint is necessary because dipping back into the water in order to extend the wash only weakens it. Attempting to remix the identical color and value can also prove disastrous; it is rarely achieved and the initial brushstrokes will probably have dried by the time you return to the painting. It is essential to gain this control or "feel" at the outset, for in short order all else falls into place.

With your paint mixed to the consistency of nonfat milk, practice the wash on wet and dry surfaces. By prewetting a surface with clear water the flat wash is somewhat more easily managed, but the increased water content dilutes the color slightly. If you prewet a surface, mix to a deeper or richer hue and you will probably arrive at the desired note. By *flooding* the area with water, one may virtually drop paint onto the wet surface and tilt the board back and forth, letting gravity spread out the wash evenly. With experience and by painting quickly with broad horizontal strokes, prewetting will prove unnecessary. When laying a wash on a dry surface, tilt the board slightly and work from the top downward. This method keeps the bottom edge of each brushstroke wetter and ready to accept the following band of overlapping color.

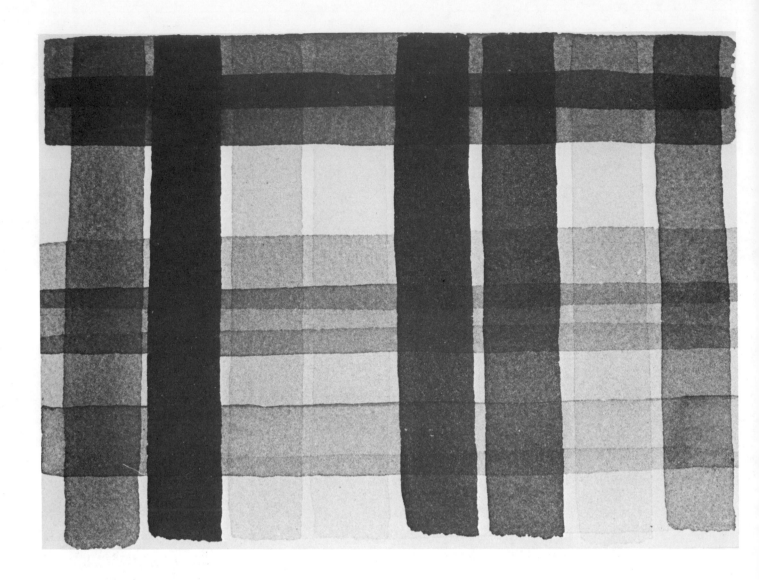

THE GLAZE

Glazing with watercolor means playing a transparent wash over a dry color in order to obtain the effect of a third hue. It is not unlike glazing with oil or acrylic paint, differing in that watercolor pigment contains gum arabic and is finely ground. Additionally, it requires no special additive to achieve the glaze. Before you glaze, make certain that the undercolor is completely dry. Apply a broad stroke of another color rapidly over the dry color. Do not work back over the surface. You will be delighted with the result. The eye reacts to this phenomenon by passing through the overwash and picking up the undercolor to arrive at a sparkling third hue. The effect is similar to varying hues in the warp and weft of fabric.

The rough paper also comes into play as further enhancement is gained with the gathering of tiny puddles of paint in the depressions of the paper. The puddles dry darker than the lighter hues left residing on the peaks. This is tantamount to what Josef Albers refers to as the film layer of color. It is best explained by comparing the dark brown-black color of a cupful of coffee to the sparkling amber hue of a teaspoonful of the same coffee.

If one primary color is painted over another, a secondary hue appears; for example, a yellow over a blue produces the effect of a green. If you wish to neutralize or tone down a color, play a complementary note over the area. And of extreme significance, not only will a glaze alter an individual color, but with one quick overwash an extremely detailed area comprised of myriad colors can change character in a split second.

THE GRADATION

If a gradation from tone to tint (dark to light) is sought, not only will practice be necessary, but ingenuity and resourcefulness must accompany the work. The panels above reveal gradations on rough watercolor paper, both executed rapidly.

To the left, very dark and middle values of the same color are prepared *before* wetting the surface with clear water. Then load one brush with the dark and another with the middle value, with a third brush readily available for adding clear water to the working surface. Always brushing horizontally in this exercise, apply the middle value to the central area of the panel. As you near the top, switch to the dark brushload and continue to the uppermost portion. Examine the lower section. If gravity has not done its work and

an acceptable blend is not evident, use the brush of clear water and work from the bottom upward to a midpoint. By maneuvering or tilting the surface in various directions you can encourage the paint to flow together. If you keep the paint surface wet, you will be able to work back into any portion of the gradation, modifying or accenting it. Near-perfect blends will soon be achieved.

The right panel illustrates a simple gradation where perfection was not the primary goal. In most creative painting the *effect* of a gradation is more important than technical excellence, and variations or imperfections are welcome in that they lend spirit and spontaneity to the image. In this gradation the area has first been *saturated* with water.

A very deep value is brushed across the upper section and allowed to flow or bleed downward. By tilting the work back and forth, you can control the flow to gain a desired effect. If a crisp accent of dark is required, turn the board around so that a second dark stroke can be applied to the edge of the dark portion, now at the bottom. In this fashion the dark accent remains at the edge and increases the crescendo effect. When you are satisfied with the result, lay the work flat and let dry.

Painters such as Keith Crown (see page 68) use an inexpensive, battery-operated hair dryer to push or blow the wash one way or the other. This device affords further manipulation with spectacular results.

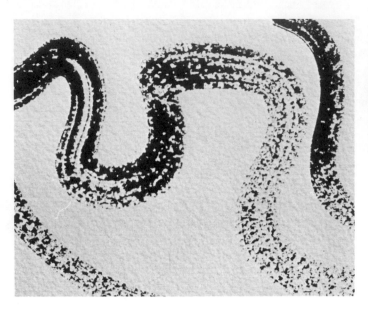

CONTROL

The word *control* is used to emphasize the need for the beginner to appreciate the dynamics of watercolor. The four examples on this page are all executed on rough watercolor paper and reveal the following:

The dry brush played over a dry surface
The wet brush played over a wet surface
The dry brush played over a wet wash of color
The wet brush, applied quickly with a single stroke, played over a color surface that has dried and been rewet with clear water

While these four examples are similar in spirit, there are subtle differences that are extremely important to single out. Left and above was done with a dry brush, which is simply a brush loaded with paint that is thick due to a minimum amount of water in the mix. When drawn across the rough surface, the brush catches the peaks of the paper and appears to skip along. Immediately to the right, for maximum comparison, a fully saturated or wet brushload is drawn over a very wet surface. A spreading or diffusion takes place immediately, which limits the artist's control of the mark. Below and left, the dry brush is played through the wet color wash, which allows the line to remain firm yet with an inviting softness. *This is perhaps the most important exercise on the page,* because when the dry brush or heavier paint is worked into a wet surface, unlimited possibilities abound in all areas of watercolor control.

Lastly, to the right, an area that was previously painted, hence thoroughly dry, is altered. The surface is quickly wetted with clear water and the full brushload is passed over it once only. When the painted area has been restored to its wet state it may be successfully painted into with either wet or dry brush. In all four examples an attempt has been made to approximate the identical path of the brushmark.

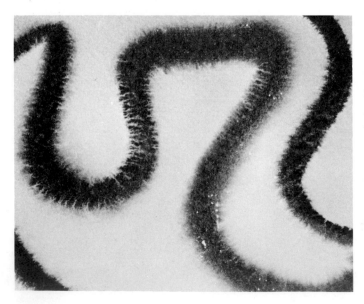 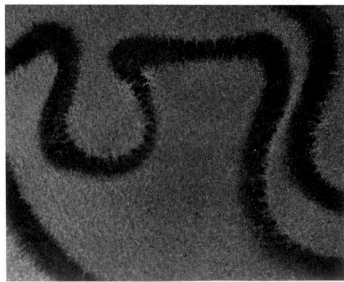

FURTHER CONTROL

Directing the brush to produce soft or crisp edges is largely a matter of prewetting the areas where you wish the paint to *feather* or run freely. The dotted lines in the diagrams indicate where the surface was prewet with clear water. At the right, a brushload of paint is merely worked into the center of a wet surface, allowing the color to feather out freely. This softness can be remarkably controlled with little practice. Keep the surface relatively flat to allow an equal dispersal of paint. How much or how thick the paint is worthy of note.

In the lower diagrams a very irregular, complex edge at some given point on the border of a wash or brushstroke is desired, while at the same time the opposite edge is to be feathered. At the top, after prewetting the area within the dotted lines, apply a bold stroke through the wet area while coming close to the irregular edge. Do not attempt to delineate or define it at this stage. Once satisfied that the feathering is taking place, return with a smaller brush loaded with the same color and define the irregular edge with care, as shown at the bottom. You will be pleased to discover that the latter, carefully articulated edge combines with the original swath of color imperceptibly. The result is full control along with clarity and spontaneity. This is often necessary when large washes abut complex borders.

THE DRY BRUSH

On page 138, the characteristics of dry brush on wet and dry surfaces are compared; in the example above, sable and bristle brushes reveal various dry brush effects. Press your loaded brush gently down on its heel, which allows the hair to fan or spread out. In this way, when the brush is lightly drawn over the surface the dry brush effect is achieved. Obviously the amount of paint in the brushload varies the result, as will the use of a frisket to block off the paint.

SCRAPING

By tilting a knife blade or similar instrument at a slight angle, you may scrape (literally pull) away wet paint to gain a lighter path or tint of color. Not only is this effective in first washes (at the left, above), but with an overwash or glaze (right). In the latter, the undercolor peers through. Remember when applying an overwash with subsequent scraping in mind to work rapidly and avoid repeated overbrushing. The more contrast in value and color, the more effective the scraping.

SCORING

By using a blunt instrument similar to a brush handle (which is always convenient), you can make a dark line in a wet wash by pressing the tool firmly and drawing across the surface. This is *scoring* the paper. It damages the sizing and tooth of the paper, allowing the paint to enter deeply into the surface rather than sit on it. The scored area or line darkens considerably in drying.

140

DROPPING PAINT

Dropping or squeezing out the pigment from a loaded brush onto a wet surface is unique: it can be controlled to a large degree and can result in varied patterns that are startling to behold. Load the brush and squeeze downward on the belly, directing the droplets where you wish. How full a brushload, how much you squeeze out, and from what height you drop the paint govern the character of the patterns. In the left portion paint is dropped from about four feet above the dry surface; to the right, paint is squeezed from the brush just slightly above the wet surface.

SPLATTERING

Similar to dropping in that the paint is directed onto the surface from above, splattering produces a finer pattern with added control. You may splatter at random throughout the life of the painting process with equal effectiveness on wet or dry surfaces. The work may be confined to selective areas by blocking off or covering portions of the painting. By tapping the ferrule of a loaded brush against an extended forefinger, you may control where and how dense the effect.

SPATTERING

At the far left, it is readily seen how spattering may resemble the ultrafine effect of the airbrush spray. Using a toothbrush fairly well saturated with paint, draw a dull knife under and against the bristles. When they snap back into place, the bristles will hurl tiny droplets of paint at the working surface. With a little practice you will be able to achieve sophisticated effects such as gradations. Experimentation will suggest how wet the toothbrush should be or how firmly to pull against it with the edge of the knife. It is always wise to practice away from the final work before commencing to spatter, especially after reloading the brush. At the immediate left is an example of working with friskets, both natural and man-made, to produce complex patterns or arrangements not easily attainable by other means. Spattering is also very effective as a corrective device.

141

RESIST

In painting, *resist* signifies alteration of the ground in order to prevent the paint from taking hold. In the example above and to the left, rubber cement has been applied to the surface. Because water does not adhere easily to the rubber cement, painting over it reveals the paths or marks of the cement. The upper portion of the example shows watercolor applied over a rubber cement pattern, with some of the dry paint still visible. The lower portion shows the rubber cement removed, leaving an immaculate pattern. When completely dry, rubber cement may be removed by lightly rubbing with fingertips or an eraser manufactured for that purpose. It is easily applied with brush or various sticks, or it may be dripped. Thin to a desired working consistency with rubber cement thinner, a petroleum distillate. All resist methods are effective over dry painted surfaces when glazing, which permits the undercolor to appear.

Above and right, the upper portion reveals the character of wax in resist. While not as controllable as other, more sophisticated resist measures, wax has a distinctive character. You can use a broad block of clear paraffin or a delicately pointed, opaque white crayon. Unusual striped effects may be produced by shaping or notching the paraffin. Because it is difficult to see where clear wax has been applied, many artists prefer the opaque crayon, notably when used over a color surface.

Shown immediately below the wax resist for maximum contrast is an example of a commercially marketed liquid frisket. It may be used as rubber cement or with a ruling pen, and allows precise control. The lower segment has been divided into two parts in order to show how the liquid frisket functions over virginal, white paper (left) and in glazing (right). After applying it, allow it to dry completely before painting. Liquid frisket is easily removed by light fingertip rubbing.

Salt

Most forms of salt, including common table salt, cause enticing starlike patterns when sprinkled into a wet wash of watercolor (below left). The salt crystals absorb the pigment, leaving light marks in their wake. When the paint and salt are dry, the salt may remain or be brushed off. Salt is also effective in glazes.

Denatured Alcohol

When denatured alcohol is dropped or brushed into a wet wash of watercolor, an astonishing effect occurs (below right). How large or minute the drop or brushstroke lends control to the event. The alcohol pushes the pigment away, leaving lighter, mottled patterns. When alcohol is used in the glaze, unbelievable colors and patterns appear.

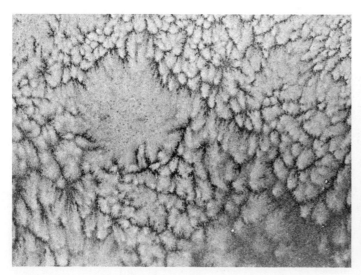

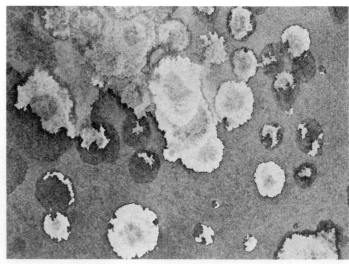

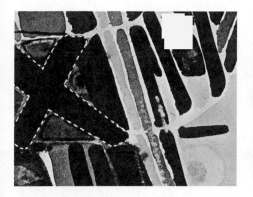

CORRECTIVE MEASURES

One of the prime reasons why watercolor was deemed so difficult to manage and earned the title "the medium of the masters" is the seeming impossibility of altering or replacing given areas of the work. It is a fact that many painters shun watercolor for this reason alone. There are, however, several ways to alter a color or part of the painting; they are simple to master and very useful.

Above left, the white dotted lines illustrate where a portion of the surface has been saturated with water prior to removing the pigment. By gently working a bristle brush back and forth over the wet area and blotting intermittently with a dry cloth or blotter, you can slowly lift the color, as shown in the central example. In this manner you are virtually able to return to the original white paper surface with little damage to the tooth of the paper. Dependent upon the staining power of the hue, this is a quick and effective way to remove the color. To the right, a change of color and pattern, remarkably lighter, has been inserted into the area where the paint was removed.

In the examples above, a more stringent and positive method has been used to completely change a section of the work by gluing in place a thin piece of white paper. To the left is the original surface; at the center, the paper glued in place; at the right, the restructured and repainted area. A good quality white paper suffices for this work. Those wishing to reproduce the original surface may use a lighter weight paper of the same brand and texture. Be certain to use a reliable adhesive, such as the popular white glues, to set the paper in place; avoid rubber cement.

Above, reading from left to right, are three examples of another approach to correction. Using an opaque white such as Designer's White or Casein White, paint out the undesired area. Spray the area lightly with a workable fixative and repaint with transparent watercolor.

REFINING

If one is not averse to using opaque water-color for emphasis or detailed correction, this is by far the most popular and readily available approach to delicate refinement and highlighting. Although the old school of purists would frown on this, there is no harm in any device or material of this sort if it enhances the painting. To the left, the original work; to the right, opaque paint is used to alter and/or highlight the image. A good casein, designer's, or acrylic white may be mixed with the transparent watercolor to good advantage. Chinese White, a semi-transparent pigment that is likened to gouache (see Appendix, page 171), provides only delicate alterations that permit the underpainting to peer through.

The example to the left above displays lines created by scratching down to the paper's surface with a sharply pointed instrument. A minute layer of paper is removed. This is very useful in accenting edges of shapes or gaining textures and patterns. By scratching against a ruler or template, surprising regimentation is possible.

To the right, a ruling pen is used to produce precise, linear marks. The pen may be adjusted to various widths, and it may be loaded with watercolor, ink, or opaque pigment. Pure watercolor in the ruling pen offers colorful results, but is always darker than the undercolor, whereas all values from tone to tint are attainable with opaque media. Unique patterns and textures are within easy reach with this versatile tool.

With the exercises completed, you may look forward with some measure of confidence to initial attempts at painting. I must emphasize that this preliminary work in no sense guarantees successful painting. Those who are seriously involved in learning to paint in watercolor, and who have applied themselves to the exercises contained in this chapter, will discover a sense of freedom in the work ahead. Further, they will be able to concentrate upon esthetic goals in the pursuit of individual expression.

The lessons have been restricted to manipulation; there has been no attempt to achieve one sort of image or another. The areas are identical to those offered in the initial phases of my university courses. The next chapter considers carefully various approaches to the final painting in watercolor; there also, no conscious demand is made to adhere to a specific way to paint. If you have been able to get started in a healthy direction—one that encompasses an open mind—my efforts will not have been in vain.

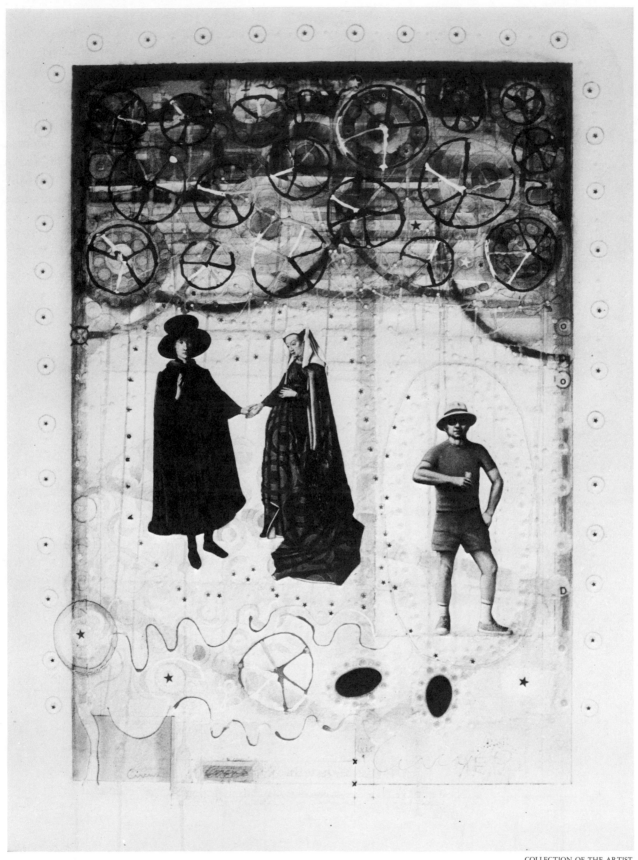

Arnolfini and Beerdrinker by Paul Hartley (b. 1943). 1982. Mixed media. 30 × 40 inches.

8

APPROACHING THE PAINTING

The use of aqueous paints on paper has increased to the point where they are now accepted as a major art medium; some of our most admired painters work exclusively with these materials.

—*Ralph Mayer,* The Artist's Handbook

In constructing the painting, the watercolor painter faces problems identical to those met by all artists working in any media—printmakers, draftsmen, or all who dare make pictures. Bearing this in mind, I have attempted to reduce the text to the significant, while placing goals within easy reach of beginners, those with limited experience, and those eager to break set patterns. Lincoln's words ring in my ears: "Forgive me for this long letter—if I had more time, it would be shorter." In that same spirit these lessons have been compacted, with the obvious and extraneous weeded out. Too many rules or rigid guidelines are as dangerous as overteaching.

In the work ahead, the traditional method is examined first, then carefully selected innovative areas explored. These exercises constitute a distillation of major thrusts in the world of contemporary painting and allow the student to form his or her own opinions. *They are not merely separate picture motifs or structures.* Each investigation relies upon a different state of mind or attitude, commencing with the initial brushstroke. The accidental is given license as the stage is set for search and discovery.

I have called for the enlistment of common sense in solving certain technical problems crucial to mastering fundamentals. If this has been done, you may look forward with confidence to approaching the final painting.

THE TRADITIONAL WATERCOLOR

The traditional approach to watercolor painting was universally subscribed to wherever classes or painting groups met. The traditional attitude was more or less imprisoned by the purist notion that dark marks are placed over a white paper support or over one another to achieve the glazed effect. The whites of the paper peer through and about the washes, creating abounding spontaneity. A singular result was expected and dutifully sought. If deviations to the rules and regulations occurred, they were probably due more to the inability of the student to master established procedures than to a desire to experiment.

In the two examples to the right, note how the sky is laid in at the outset of work. In a still life or figure painting this is tantamount to beginning with the background or field of color. In one sense this is a practical move, for the largest and lightest areas may easily establish a key or main thrust to a painting, and at the same time accommodates subsequent darker and more definitive painting. Further, if you are displeased with the sky, you might wash it away lightly and begin anew.

In an area no larger than six by eight inches, beginning with the sky, attempt the traditional approach by relying upon the control factors practiced in the preceding chapter. In so doing you will generate exciting, innovative marks that are attractive foils for subsequent subject matter. Prewet portions of the sky surface where you wish to encourage the paint to run freely; keep other areas dry where crisp accents are anticipated. The traditionalist deemed it advisable to leave the lower portion of the sky lighter than the top, envisioning a glowing horizon. Very rudimentary skills are needed to gain enticing effects, which explains why watercolors that are virtually 90 percent sky—dubbed "sky paintings"—were and remain popular.

Once the sky is reasonably dry, other forms may be posed before the convenient, glowing horizon. Naturally the ensuing work will be darker in spirit, as is everything when held against light; hence, when you add either organic, architectural, animal, or the earth forms used here, the result will be convincing. By continuing to paint the largest and lightest sections of the remaining subject matter, you can govern sizes and shapes prior to developing form and texture. Students were traditionally encouraged to build landscapes in the order of appearance of the parts; that is, first the sky or heavens, then the earth, then the flora or architecture and people. Obviously, windows followed walls and curtains arrived later still. They also cherished the early morning and late afternoon hours when the spectrum of color was alive and long dark shadows offered unlimited drama.

The exercise on the opposite page is offered for study. Do not feel confined to the landscape for subject; attempt a still life using the same approach. My purpose is to create a point of departure. The rewards will prove manifold as you gain a deeper and more reverent understanding of the traditional watercolor. For classic examples note the John Singer Sargent and Winslow Homer paintings on pages 30 and 31.

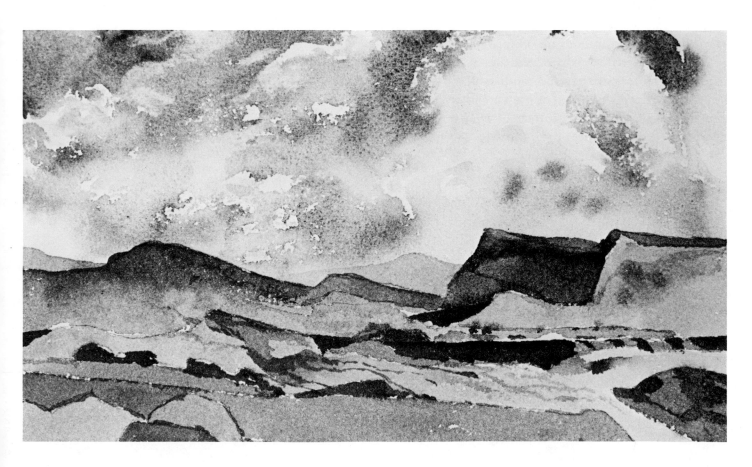

149

THE STATIC STRUCTURE

On the opposite page are two examples of an altogether different approach to painting in watercolor. At the top, vertical and horizontal brushstrokes are applied to a designated area about six by eight inches. The static or blocklike lay-in is very suggestive of architecture. In the bottom example, smaller shapes and lines suggesting form have been added, along with diagonal accents resembling buildings, windows, bridges, arches, roadways—and a city appears. Very little attention is given to control or other technical concerns; in so doing, numerous unusual, enticing accidental marks are inherited.

The demonstrations throughout this chapter are kindred to those presented in my classrooms. Each exercise is purposely limited to five or six minutes, for in this manner the student learns how quickly and effectively an emotional, expressive idea may be transmitted to picture form. The color is limited to four or five tints and tones of but two hues, plus a neutral gray. It soon becomes clear that by allowing one of the colors to dominate, the second lends support in a minor role, and the neutral gray assumes aspects of opposite hues.

While this exercise is not intended to do justice to the individual personality, surprisingly subjective results automatically surface. To carry the work further into valid attempts to paint necessitates clear visions or images in the painter's mind based upon personal encounters or research. In the words of renowned Constructivist artist Naum Gabo, artists hold the unknown in their vision, and the painted vision makes it known.

From another vantage point, the horizontal-vertical structure is suggestive, in a spiritual sense, of serenity, protectiveness, stolidity, and order. Antithetically, if strong diagonals are substituted for the prime motivation, turbulence, unrest, movement, activity, and force prevails. And as for color, the city may abound in a panache of color, light, and sound, or be cloaked in a misty fog. It may be envisioned in autumn or springtime, morning, noon, or night.

It does not require much imagination to alter either structure or color in order to arrive at separate images and conditions. Get moving in new and challenging directions, all well within your present ability and devoid of rigid guidelines or concern for the degree of abstract or realistic subject matter.

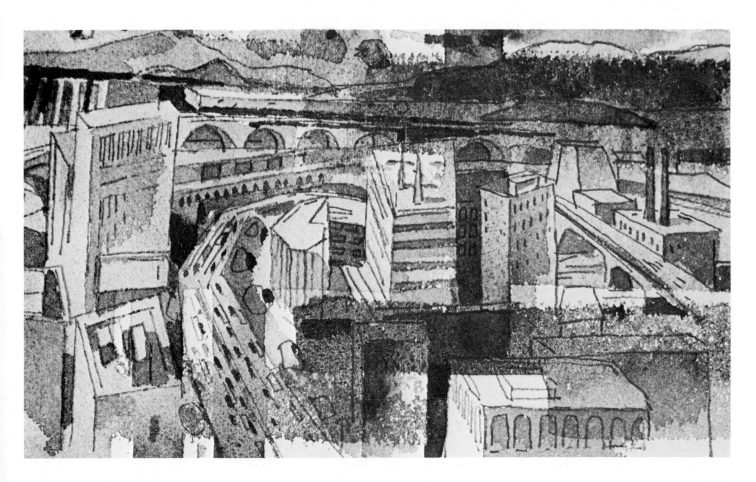

151

THE FREE EXERCISE

At the right is a most revealing and liberating example of another classroom exercise. The same size surface is fully covered with very small brushstrokes and washes of random hues, shapes, and sizes. To emphasize how *irrational* this preliminary lay-in can be, at times I close my eyes and dab away, only peeking for a split second from time to time to make certain that I am working somewhere within the boundaries of the work, or to reload the brush.

The top right example shows the work at the termination of the preliminary lay-in. The result, virtually formless, rarely lacks in verve and excitement. In truth it conjures up all sorts of fantasies not unlike Monet's distinguished lily pad series or any number of abstract-expressionist works.

The bottom example evidences a particular circumstance or place. Since you should work quickly, I have depicted the relatively simple forms of derelict lumber amidst weeds. To further strengthen the sheer delight of this premise and at the same time continue to devastate the rules of watercolor painting, select the subject matter you would like to see added to this rudderless beginning.

It is not hard to see how adaptable this approach is. It has been said that only the artist sees beauty in disaster—a shattered windshield, a crushed flower, a splintered board, or a torn garment. All of these and countless more summon forth unique tactile or textural experiences. The immense latitude made available by the personality of color and brushstroke places these goals within easy reach.

When initiating this exercise, try not to concern yourself with an idea or even subject matter. Select color combinations you find daring, innovative, even disturbing. If you wish, pre-wet portions of the working surface as I have done in the example, with no care for the painting to follow, which will add to the variations. After examining what you have done, work into the area with either pencil or smaller brushes in order to define some semblance of subject. You will become fascinated with the effortless manner in which the rough, uncontrolled marks support and enhance the statement.

LATITUDE

Watercolor as it relates to abstract or nonfigurative images is remarkably versatile. It is surprising to note how long it took artists devoted to watercolor to explore the worlds of abstract expression, despite the abundance of work by Paul Klee or, as a specific example, Georgia O'Keefe's *Evening Star III* (see page 80). When at last it was accepted that watercolors were not bound to the object, person, place, or style, they were eagerly sought out for inclusion in museum collections and welcomed into major exhibitions.

The examples on the opposite page are not to be executed in a specific manner. The premise is to investigate as many valid directions as practical to paint creatively in watercolor. The two statements have one thing in common—when begun, nothing was known or visible except in the mind's eye. The structures, while purposely similar, are not duplicates. They portray how different one may seem from the other with a minimum of time and effort.

Establish two areas roughly six inches square, and define in pencil abstract elements. Concern yourself with such things as shape, scale, tension, weight, contrast, and space. Arrive at compositions that are similar in spirit without worrying about duplication. Exploiting any of the control factors you now possess, set something down in one of the squares to *react to* or *work against.* Keep in mind that you will be using each step of the painting as a momentary point of departure, with little more than a notion in mind. When finished with the first exercise, go on to the second, trying to make it as different as possible from the first.

Understandably, watercolor does not lend itself easily to mammoth work, although frescoes, a form of watercolor into wet plaster are often very large. On the other hand, watercolor allows the painter to move quickly from idea to idea, especially during planning stages. But size in painting has very little to do with quality; many a smaller image offers more scale than an enormous counterpart.

Presumably devoid of philosophical beliefs, this nonfigurative excursion should prove immensely rewarding. The truly creative artist has an eager curiosity and is interested in all art forms or directions. He or she welcomes other artists' mysterious or innovative thinking as both inspirational and challenging.

155

THE IDENTITY FACTOR

Up to this point, work has been confined to the transparent pigment in order to emphasize the medium's basic characteristics, not the least of which is the opportunity for rapid identification or note-taking. This is the fifth and last of the explorations based upon painting with watercolor only, and sets the stage for the exciting mixed-media work to follow.

In order to underscore the practicality of the thesis of identification, the human form is enlisted for subject matter. The complexity of the figure and the difficulty in working from it has long been acknowledged, both in schools and in the professional art world. However, you may discover to your delight, in employing watercolor you will be able to *express* the figure equally as well as with oil, acrylic, or other seemingly more flexible media. In any instance the result is measured more by your knowledge of draftsmanship or creative interpretation than by the peculiar character of the medium. Using watercolor is an invitation to expression.

In an area about six inches square, delineate a clothed figure in pencil. Concentrate upon and emphasize the patterns you see. To be most effective include the smaller patterns found on textiles or jewelry—anything that can be easily reduced to an identifiable, flat color pattern. After denoting these patterns in line, record what you see by coloring in the shapes as innocently as a child using crayons. If your line is reactive to form (it has been explained that *line is that which encloses the form*) and if you are sensitive to gesture and placement, the result will prove astonishing.

In the examples shown—all selected from rapid classroom demonstrations—note that in the exuberance to delineate the face, a pencil mark has been used to either enclose the eye or mouth in order to create a shape. Other marks indicate fingers and folds; there should be no need to prevent this from happening. Upon occasion, after the short demonstration has been completed, it seems irresistible to add a touch of color between eyebrow and lid, or rouge the cheek a bit, as you may detect in the examples. The point of the lesson is to discover the strength and explore all possibilities of color pattern as *identity factors,* and to capitalize upon it as a point of departure for further work.

Your degree of keen observation will govern how successfully you have depicted a particular person in a particular place or setting, in an effective, convincing manner.

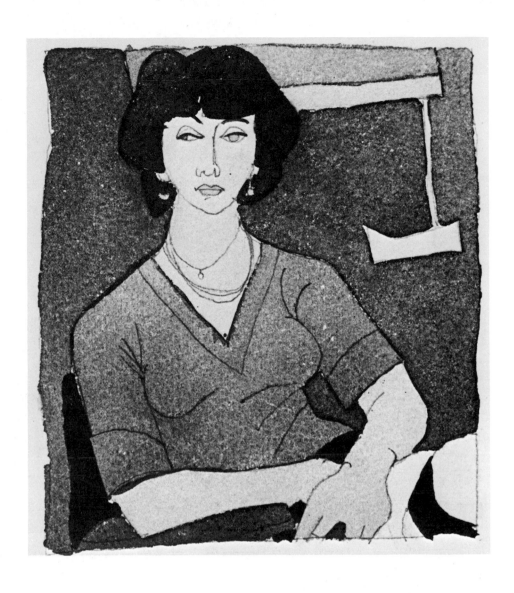

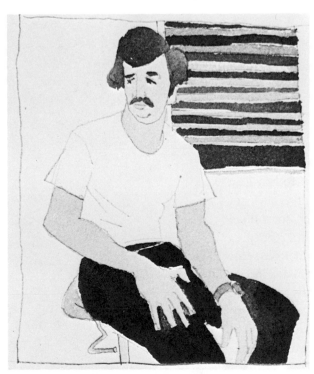

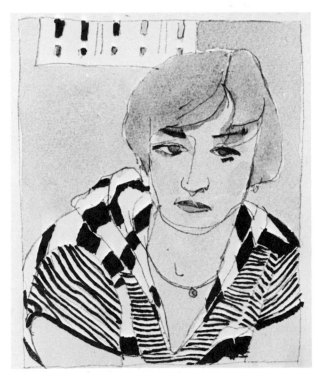

Roses are to Live By by Roxanne Reep (b. 1954). 1979. Mixed media. 30 × 40 inches.

MIXED MEDIA

In introducing this exercise to my students, it is my wont to incorporate into the painting's surface virtually everything possible. Students are asked to bring to class any material they deem suitable for the anticipated work, which is a way of building interest and arousing curiosity. Much attention is given to collage and frottage (rubbings); this allows for ease in developing rare, complex geometric patterns, textures, and relief surfaces. Rubbings taken from embossed book covers, caned chairs, cut glass and fire extinguishers serve as initial targets within easy reach; they offer unique letter forms, calligraphy, filagree, and countless other effects in dark on light or the reverse. Graph papers and other printed matter swell our reservoir; paper doilies, white tissue, and numerous weights and kinds of paper are welcomed. It requires little resourcefulness on the part of the student to uncover exciting material for the venture.

The prime concern is to expose the beginner to a myriad of experimentations destined to produce innovative and personal images. Fortuitously, in the not too distant past, a truly significant spin-off or dividend surfaced. When the mixed media demonstration was completed, with virtually no consideration given to composition, we decided as a group to cut up the work into random blocks about four inches square. In examining the result of this impetuous act, we found to our delight that the small images presented innumerable compositions of impressive nature. Due to the intricate character of the new materials we added into our work, these tiny *paintings* often possessed inordinate scale, a quality so often lacking in the beginner's efforts. We were thus able to envision transmitting this elusive quality to future work by imagining the miniature statements as larger, finished paintings.

There is a distinct difference in this random cutting of a large surface into smaller parts from the more conventional method of masking off or cropping selected portions of the work. In so doing the artist discriminates and controls the image, whereas by arbitrarily cutting the surface into small squares we are treated to unaccustomed relationships that exist outside of our known world.

Prior to painting, the ground is altered by applying various materials to it in anticipation of challenging prospects. My own efforts once reached the point where I tired of the conventional surface of manufactured watercolor papers and turned to the rice papers of the Orient. Painting on unstretched rice paper proved to be a joyous experience, but posed limitations due to its fragility. Returning to watercolor paper, I glued random bits of rice and white tissue paper to the surface to more or less break up the monotonous effect. Then gesso was added in similar manner to disturb the surface further. Gesso provided an additional advantage; its thickness made impasto effects readily available. Combing the wet gesso or pressing other materials into it formed highly individual relief patterns in which the ensuing watercolor would reside.

Apart from the delight of discovery—not the least exciting aspect in painting—the countless effects of mixed media involves the artist in a philosophical premise of some importance. The *skin of life,* our world, is not a watercolor wash. Nature provides us with abundant examples of its textured hide wherever we may gaze. We encounter the rough and smooth, clear and mottled, unordered and geometric, imperfect and scarred throughout each day. It matters little if our subject is the landscape, figure, still life, or fantasy—we must in some manner deal with the issue. When we succeed in having added textural or tactile sensations to our work, we will have provided for more vibrant and intimate adventures.

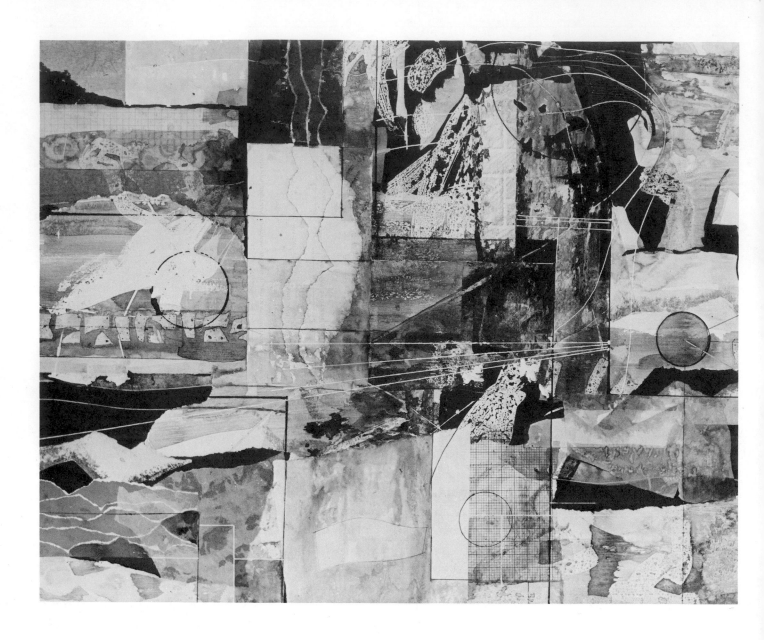

THE DEMONSTRATION OF MIXED MEDIA

The example shown above has been selected from a classroom demonstration of mixed media effects. It is executed on cardboard lightly coated with gesso, but the result is equally effective on any watercolor paper or illustration board. Consistent with the belief that lessons of this nature are more easily understood when pictorial and compositional considerations have been put aside, the working surface becomes a mere playground for experimentation.

On the opposite page are the many images that result from arbitrarily cutting up the demonstration into small squares. The viewer is treated to tantalizing pictorial possibilities, particularly when these small sections are imagined to be large paintings. This exploitation of scale and contrast is often a vital part of good painting. As the large work is reduced or cut into smaller sections, the elements of the original painting seem to expand. Through this intimate experience the student is able to visually comprehend the advantages of posing large, dark, clear passages against small, light, and very often intricate counterparts.

Do not duplicate the large experiment at this point. Complete the remaining lessons in this chapter and then return to this exercise. By then you will be better informed and more fully prepared to exact the maximum benefit from your own investigation. Do not attempt a finished painting; simply experiment, or the delightful event of cutting up the work will have been compromised.

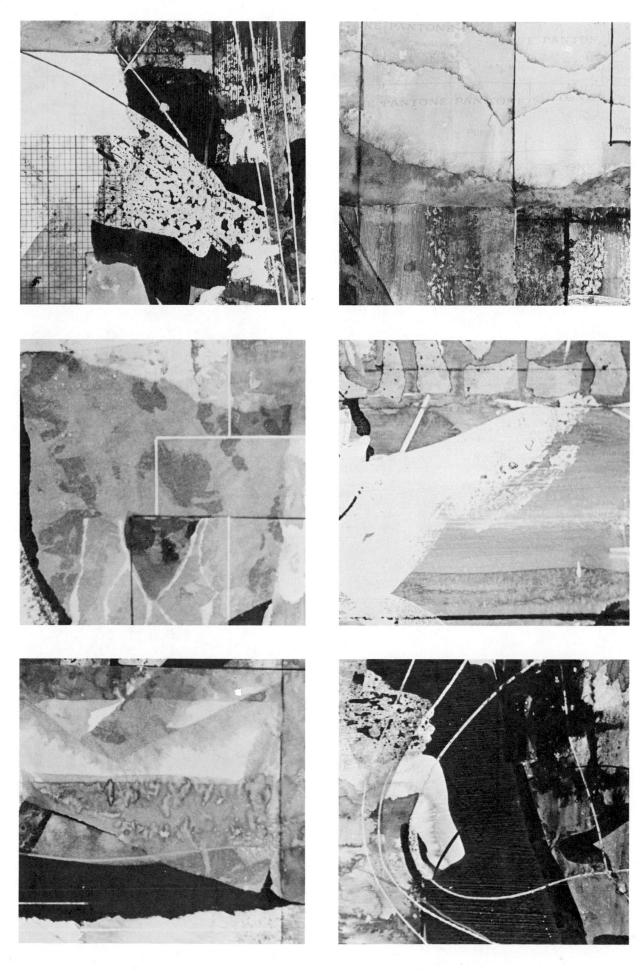

ALTERING THE GROUND OR SUPPORT

The first concern in using adventurous materials should be the ground or working surface. In changing the disposition of the ground before starting to paint, you can guide the subsequent work down chosen paths and still encourage accidental happenings. In the examples below, all that is required apart from the watercolor paper is a bristle brush of the kind ordinarily used in oil painting; a pocket comb, which may be broken to separate the coarse and fine teeth; and a small container of gesso.

Above and to the left, gesso has been applied by bristle brush to the traditional surface of a 140-pound rough watercolor paper. Immediately below, on a similar surface, *wet* gesso has been *combed* to create ridges. Because the gesso is white and would be difficult to identify on a white paper, a toned ground has been used solely for purposes of clarity.

Above and to the right, the textural excitement of the watercolor wash is evident as it settles into the valleys of both the brushed gesso and virginal watercolor paper. Immediately below a wash over the gesso reveals the bold, striated path caused by the combing process.

Rice papers and white tissue paper provide handsome, controllable, and simple means for further alteration of the working surface prior to getting into the painting.

Because they are white, these papers are virtually unnoticeable on the watercolor paper. In this instance, little more than a wider textural experience is sought.

The example at the left above shows tissue paper affixed to the surface with a reliable paper glue. To the right, a watercolor wash is played over the area.

At the left above, rice paper is glued to the rough watercolor support. Rice papers are available in various weights and textures, and for the most part are more opaque than tissue papers. At the right, the delicate qualities attainable when the overwash of water-color has been applied; most especially, at the torn edges of the rice paper. In working with all collage materials, particularly with the thinner tissue and rice papers, allowing the paper to wrinkle when gluing is a welcome option.

COLLAGE

Collage, the French term for the gluing of papers, fabrics, or cardboard onto the painting surface, remains a popular method of rapidly producing dramatic effects. While your sources of supply may seem unlimited, it is well to remember that few papers are fade-resistant and most will yellow if not made from 100 percent rag. For this reason many artists prefer to make their own papers, using both pigment and paper they know is permanent.

In the four examples below, flat color paper, graph paper, patterned fabric, and frottage (rubbing on paper), have been used.

In each exercise the material has been glued onto a rough watercolor paper, and is followed by an overwash of watercolor. The disparate personalities of the new materials can be compared to the traditional paper surface, now so familiar.

Flat color paper with wash overlay

Graph paper with wash overlay

Patterned fabric with wash overlay

Frottage with wash overlay

In the example above, the letter form is used in collage, but not necessarily to alter the ground. The painting is well under way at the time, which properly suggests that collage may be introduced to the work at any given stage. To the right above, white tissue paper is glued over the work to achieve a light, milky glazed quality due to the tissue's translucent nature. With this method the importance of color or shape can be regulated.

Printed matter, particularly the letter form, is inviting and widely used in collage work. It adds new dimensions by virtue of its appealing and recognizable forms; it conveys symbolic or mysterious messages. However, in employing wood-pulp papers used in printing periodicals and newspapers, you must make allowances for discoloration and deterioration. A good nonyellowing glue should be used, and the finished work should be coated with polymer medium or an acrylic varnish to help protect the work as well as enhance the surface.

A most important consideration in working with collage materials is the control of the edge. The material may be torn with care or abandon, cut with scissors or knife—each implement or method lends a different character to the edge. An added factor is the material's weight or quality. Should an image or color appear on one side only, tearing from the image side or the reverse will definitely vary the edge when glued down with one side or the other up.

Above, a variety of edges is attainable by cutting, tearing, burning, and fraying cloth. The supply of collage materials is endless, and with each distinctive paper or cloth a new edge is in store.

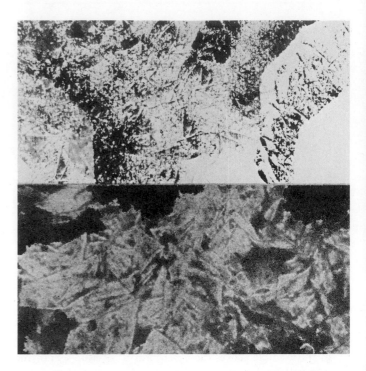

Wrinkled or crumpled paper offers intriguing collage effects. Above, in the top half of the example, paper has been crushed by hand, flattened out by hand and painted over with a wash of watercolor. The paper and puddles are allowed to dry *before* being glued to the surface of the painting. In the lower half, the paper has been crushed or crumpled and immediately glued to the work surface, then followed with an overwash of watercolor. Comparison attests to the disparate nature of very similar processes.

If crushed or wrinkled paper or cloth is used as a rubber stamp, surprisingly attractive yet flexible results are achieved. In the upper section of the example to the right and above, the material is crumpled by hand, pressed into a paint puddle on the palette and stamped onto the paint surface. These highly effective imprints can be further controlled by blocking out, or using friskets and stencils. Immediately below, a dry, absorbent material such as wrinkled cloth, paper, or sponge is pressed into the wet wash; the paint is lifted and the reverse effect of light patterns or imprints is gained.

Above and left, effective patterns of light may be attained by wetting and blotting a dry surface. When the dry surface of watercolor is wetted—in this exercise, by brush and clear water—the paint is being remoistened. By quickly blotting, you can lift the paint to gain a precise replica, lighter of course, of the wetted area. If you use a stiff brush and repeatedly wet and blot, you heighten the effect. Depending on the staining power of the paint, the stiffness of the brush, plus the number of times the process is repeated, a good control of this approach can be commanded.

The lifting process is magnified when the watercolor support has been gessoed. The pigment stains but does not penetrate the virtually impervious gesso; as a consequence, the paint is easily lifted by wetting and blotting. In the example to the right, light stained areas play against the original color with striking beauty.

166

A NOTE

Now that the exercises have been concluded, the following observations seem appropriate. The titles *teacher* and *student* are earned by diligent effort, an open mind and shared enthusiasm. As a teacher it is my responsibility to make certain that my students become *learners*. Teaching through enthusiasm alone results only in fatigue on the part of the teacher.

If the prospective painter wishes to *master* the watercolor medium, bitter disappointment will surely follow. When one direction or idea seems thoroughly investigated, another will beckon. Nearing death at the age of 89, Hokusai lamented that he was just learning to draw.

If through earnest application and experimentation with the preceding lessons you remain self-conscious or awkward in using watercolor, keep in mind that *practice,* in the words of Kimon Nicolaides, remains the watchword. Furthermore, as I have stated throughout, the lessons provide a basis for innovation and are intended solely to uncover paths designed for individual search.

It is clearly impossible to cover all materials and approaches to painting in watercolor. Hence if your curiosity leads to the inclusion of materials other than those recommended, it would be well to consider the factor of permanency. Some contemporary painters admittedly are not concerned with the permanency of their work, and that is their prerogative. For those who are, the following advice is offered. Black india inks are reasonably permanent, whereas color inks are not. The soluble dyes manufactured under various names are unreliable, as are the vast majority of felt-tip markers. Color papers, with few exceptions, will fade rapidly—especially pulp papers and color tissues. Some artists employing color papers feel that varnishing with polymers or other materials makes paper permanently light-proof, but there is no evidence to support that belief.

Framing under glass is recommended for all works on paper, especially for purposes of cleaning. If glass is unwanted it would be wise to varnish the surface with one of the synthetic materials, such as an acrylic spray coating. Exposure to direct sunlight should be avoided with paintings in *all* media.

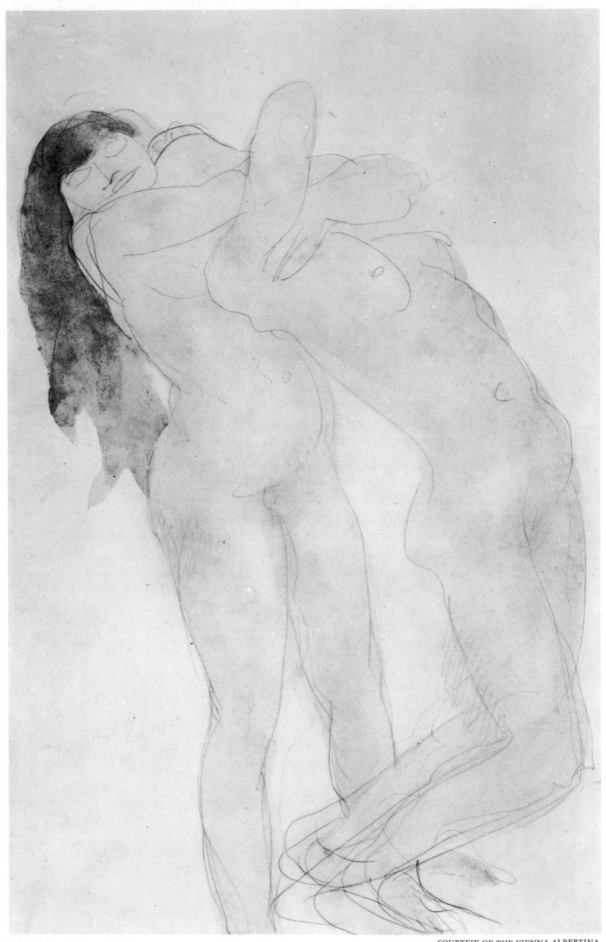

APPENDIX

Two Nude Females by Auguste Rodin. 1900-1905. Pencil and brown watercolor wash on light gray paper. 7¾ x 12 inches.

MATERIALS
AND
EQUIPMENT

Some of the following information will also be found in the two new sections, 7 and 8, which have been added to this book. This is necessary in order to allow maximum concentration on the part of the reader-student by eliminating distractions resulting from having to turn back and forth from one section to another for pertinent information. Keeping the Materials and Equipment section intact permits its usage as a speedy reference, one of the main purposes for which it was originally intended.

Although the best of materials and equipment cannot do the work for the artist, there are specific advantages inherent in manufactured products that are worthy of our attention. Here again it seems imperative to stress the fact that this knowledge is vital only in allowing the artist fulfillment in attaining esthetic or content goals. He must know what to expect of his materials in performance and durability, and he must also know what to seek out in brush, paint, and

support. Furthermore, such advice need in no way inhibit or restrict the artists' deep concern for expressive freedom; instead, proper materials assist sound craftsmanship and join to preserve the art legacy. It is deplorable that some contemporary painters seem contemptuous when the future of art is involved; yet these same artists are extremely dependent upon the heritage which has survived for centuries. Whether such attitudes spring from an anti-art doctrine or are simply the results of bitterness or haplessness is irrelevant. The fact remains that knowingly to produce faulty work is highly unethical. It is of little comfort that the business ethic in today's world condones the principle of built-in obsolescence.

There is intent upon my part to make this section as brief as possible, while still attempting to be thorough. The best explanation for this summary treatment is not the inability to provide the typical photographs and diagrams of artists' equipment, but instead to accord such concerns

only a properly proportioned emphasis. There is little question that *one afternoon* spent in any well-stocked art store would result in a more effective knowledge of materials than reading about or gazing at photographs of them. The subjective responses to touch, weight, size, color, and even aroma will play a role in this delightful affair. Should you be fortunate enough to find responsible, informed men working in your art-supply shop, you may rely upon their knowledge of materials and good advice in framing. How to present or frame work is not a subject consistent with the goals of this treatise, but one can hardly underestimate the ultimate importance of such things. Many distinguished artists are by their own admission highly incompetent in this area and depend entirely upon their framers. The common fault in framing is usually that of creating unnecessary interest in the frame itself, which in turn detracts from the painting. Or in simple language, too many paintings suffer from being overframed.

To return to the subject of materials — and on the lighter side — wherever or whenever artists congregate, animated discussions range from philosophical attitudes to a newly marketed paint. What is the nature of the paint, its consistency, its stubbornness or pliability, the drying factor, and with the newer products in particular, the omnipresent question of volatility and toxicity? The textures and aromas of artists' materials are unique and often delightful. My initial encounters with gum and kneaded erasers still remain in my memory. The thrill of my first decent

brush and the feel of it in my hands was eventful. The names of colors piqued my imagination. My first bicycle was repainted in Chinese vermilion. Van Dyke brown was never guaranteed to be permanent, and aureolin yellow twisted most young artists' tongues. Exotic travels were proposed by the use of Persian orange Pompeian red, French ultramarine blue — the list is endless. There was joy in opening a new can of paint, dipping into it for the first time or squeezing it on the mixing surface. My revered teacher used to state unequivocally, "If you enjoy squeezing toothpaste onto your toothbrush, you'll be a helluva painter." The dedicated artist at any stage of his career will have an inordinate curiosity about his materials and equipment. Furthermore, he will continue to read their every label and brochure completely and investigate every aspect of their composition and habits.

The following text has deep purpose or it would not have been included here. This rather obvious statement is set down to reinforce the belief that, as simple as they may appear, these suggestions have been painstakingly gone over again and again in order to eliminate the superfluous. If nothing more, you should be able to avoid questionable purchases and select materials directly helpful in attaining your goals. It should be kept in mind that in the purchase of artists' materials, as with virtually everything else in our society, the quality items are generally more expensive. Lastly, the ensuing text is devoted exclusively to the materials and equipment of the transparent watercolor medium, for

as you may have determined from reading the descriptions of related water-soluble media (Section 5), the identifying personality of watercolor lies largely in the transparent, translucent or glazed area.

PAINT

The finest transparent watercolors manufactured are not only prepared with the best pigment and binders obtainable, but are expertly formulated and ground. The most versatile of these paints are offered in *tube* containers and are of extremely heavy, syrup-like consistency akin to oil paint. While *cake* or *hard-pan* watercolors may be used successfully by competent painters, they are rarely preferred. The major objections are that they consume valuable time and effort to dilute or soften, and even then the resultant hues are often tinted substitutes of the desired depth or chroma. When the words *Artists Colors* appear on a paint container, this distinguishes the paint from that of the inferior quality of *Student* and *Scholastic* designation. The latter colors are extremely weak by comparison and contain excessive fillers and insufficient pigment. As noted with the pan watercolors, full saturation of color is virtually impossible to attain. Student colors are rarely if ever guaranteed to be permanent, and it would be foolhardy to bother with such inferior products.

BRUSHES

Superior watercolor brushes are made from the hair of the sable, and have been meticulously crafted through hand labor. The

hairs are shuffled to point inward so that the natural curvature of each individual hair is positioned to create a round, pointed brush. This is mandatory in order to insure that the brush reshape itself even after the most abusive treatment. The better sable brushes are usually set in seamless, nickled ferrules, with at least two or three rings encircling the ferrule. The experienced artist can run his fingers through a brush and immediately determine its quality. A standard test commonly employed at purchase is to dip the brush into water and shake it out vigorously. If the brush snaps back to an erect point it is probably of excellent quality, especially if it lives up to the other requirements of sable and ferrule.

The Japanese brushes we see now and then are delightful to look at and extremely reasonable in price. But it would be far better to leave them in the hands of the Japanese artist who is well aware of how they are to be used. There are times when experimentation with such things may produce stimulating effects, especially in the areas of spontaneous calligraphy and wash. The lamentable fact remains that many American artists haven't the vaguest notion of why the Japanese brush is constructed as it is, or what diligent exercise and training is needed before it may be used with meaning. Conversely the Japanese brush (*fude,* round, and *hake,* flat) is designed for use in a seated position and is to be held vertically; it becomes influential in the tradition and method of Japanese painting. Since the brush is made from the hair of deer, rabbit, badger, sheep, or other animals, it is relatively limp and uncontrollable in unschooled hands.

It is perplexing to note that elementary-school children often paint exquisitely with frightfully inexpensive, worn-out, and flimsy camel's hair brushes. Would they prosper more if finer equipment were available, or would this better remain a mystery? In any event, if the brush is doing what you want it to do, it is the right one; the foregoing comments to the contrary!

There are flat and round brushes in sable and bristle available to the artist in all forms and sizes. Brush catalogs are the most tantalizingly complex inventions known to artists, with a special brush manufactured for every known professional skill. It would be well to remember that in the selection of small brushes it is sensible to acquire the very best for better control, whereas one need not be quite so concerned with the quality level when purchasing larger sizes. The larger round sable brushes are terribly expensive; so much so that many artists resort to the use of the relatively inexpensive flat variety.

PALETTES

Any mixing surface or palette that is impervious to water is suitable for watercolor paint. A white metal surface is highly desirable because it is unbreakable and one may visualize color mixtures readily. If the mixing surface is porous, the liquid components of your paint will be absorbed into the palette and your color will be unfit for proper use. Since the vast majority of watercolor supports are white, one may readily appreciate the advantages of a white palette. If the palette has small bins around the mixing areas to house the squeezed-out paint, it will prove both useful and economical. Unlike oil or the newer acrylics, it is helpful to leave unused watercolor (even if hardened) in the palette bins. When fresh paint is squeezed over the older and relatively hard color the hardened color will soften in short order. Washing off the palette just prior to use serves the double purpose of cleaning the mixing areas and remoistening the hardened colors.

SUPPORTS

Watercolor paper is produced in various textures, weights or thicknesses, and dimensions. A 400-pound paper is far heavier and thicker than a 72-pound paper. All such papers are graded by the weight of the ream. The superior papers are handmade of linen rag, and have been sized with either a glue or gelatin substance. They are tough and durable, and will

withstand much abuse. The sizing procedure is designed to keep the applied paint predominantly on the surface, rather than allowing it to sink in as would be the tendency with unsized or blotter-type paper. Naturally, the resultant color is far more vibrant, and reworking the surface becomes a relatively simple procedure. Such reworking is virtually impossible on cheaper watercolor paper or substitutes.

When deviating from paper especially prepared for watercolor, it is necessary to seek out a support that will lend itself to a desired goal. Working on a stretched cotton cloth will prove a rewarding experience. Stimulating results stem from priming your own choice of paper with either a casein, acrylic, or gesso ground. Rice papers as well as any number of drawing papers or commercially prepared boards may be employed with good effect. For over a year my work was executed on a cotton skrim cloth which was originally manufactured to sack potatoes. This material was prepared with a polyethylene backing, which rendered it incapable of buckling or wrinkling when saturated.

The rougher-textured papers will remain damp longer than their smoother counterparts, since the numerous interstices retain pockets of water. When wetness is prolonged, more manipulation is possible, and for this reason the rougher papers are generally preferred. In addition, the rougher surface allows the artist to place the support in a more upright or vertical position, since the wet paint is held in the tiny depressions of the paper and will not run easily. Smoother paper produces other effects and is not as workable, but there remain valid reasons why artists wish to work with the smoother stock from time to time. Working on smoother papers discourages manipulation and in turn exposes the spectacle of brush calligraphy.

The extremely heavy papers of 400-pound weight are actually of board thickness. They do not require stretching as is recommended with the lighter weights from 140-pound on down. Watercolor blocks are offered as stretched paper, but

this is erroneous: they are simply glue-bound around the edges and will buckle severely when saturated. Almost all fine watercolor papers can be identified by their embossments or watermarks, which may indicate the preferred side, but most better papers are usable on both sides.

In stretching or preparing your support, the simplest method is to tape or staple the paper down onto a drawing board or a common plywood backing. By wetting both sides or soaking the paper in a tub of water for a minute or two, you allow the paper to expand, and while in this state of expansion, it should be secured to the board. When dry, the paper will have drawn taut through shrinkage and will have become an excellent painting support. Rolling the wet paper in your hands to form a cylinder just prior to spreading it out over the board, will aid in getting it down flat for securing the edges. Use only the gummed-paper tape for this purpose, as the cellulose and masking tapes are not suitable. Neither are any of the pressure-sensitive variety. If stapling, be certain to stay at least a half-inch away from the edges of the paper and keep the staples about two to three inches apart. There are numerous other ways to prepare the watercolor support, but they all serve the same purpose. Some prefer gluing down the edges, while others build complicated rigs that clasp the paper in the manner of embroidery hoops. But rather than dwell on this phase of preparation as a method, let me re-emphasize why such care is important.

Working on a prestretched taut surface virtually eliminates unmanageable buckling. What little swelling may occur (some is inevitable) quickly vanishes as the paper dries. It is difficult to work on anything but a flat surface in any medium, but this is especially so with watercolor. Not only does the artist have to contend with unwanted nuances of light and shadow that result from the uneven surface, but washes have a tendency to form undesirable pools of color in the troughs of the paper. The sooner one dispenses with the physical concerns in painting, the more intimately and vigorously may one then turn to content and meaning.

Some artists frown upon all such procedural advice, and while it is easy to agree with them in spirit, they make little sense. Technological awareness will often lead to a new environment of discovery, but only when it is not offered as a strict rule. It is always the result we are searching for. For example, by saturating a paper and spreading it out unstretched over any non-absorbent surface such as glass, a unique wet-into-wet result is achieved. Placing a blotter under the paper, whether stretched or not, will prolong the drying time of the paper and afford the painter wider manipulative power. Working at night or in a damp, humid climate will cause slower drying, while a hot, dry environment forces paint seemingly to dry upon contact with the paper. Lastly, by varying the weight of the paper, its surface, or composition, countless other qualities are within reach. Experience alone will make the foregoing meaningful and, more importantly, will ultimately beckon you down new avenues of investigation. It would seem to me that no serious painter at work with this elegant medium could afford not to explore its fullest range of dynamic potential.

EASELS

Whether one works in a studio or on location, there is one demand to be considered when acquiring an easel suitable for watercolor. Because of the elusiveness of the wash, it is often desirable to flatten the working surface to a more horizontal position. Therefore, it will prove helpful to employ an easel that not only adjusts vertically but will tilt back to adjust horizontally too. Watercolor easels are manufactured in various sizes and weights and are fabricated out of every known material. It is far more sensible to select a durable product that may be used indoors and out (therefore, too, it should be collapsible and transportable). The flimsy, light-weight items should be avoided. Any additional cost in purchasing a quality easel proves negligible in the long run, and will repeatedly spare your time and energy.

Watercolor is a medium which, by its nature, allows the artist to function day or night, in studio or on location, and during fair or foul weather. Because of the speed with which expression is gained (especially under adverse conditions), it is all the more important to be well prepared. This is evident in the note-taking area, where watercolor has long been relied upon as a means of gathering relatively complete information. Remember that Turner's sketches are now considered by many to be his major contribution and that Homer always rated his efforts in watercolor to be of greater importance than his oils.

Artists' supply houses offer such things as miniature palettes, collapsible water containers, and quaint brushes that break in half to fit the minute palette. Indeed, all of this equipment fits neatly into a shirt pocket. There was a time when this dilettantish material used to amuse me, but not for long. In years to follow, this miniature equipment was invaluable to me when, as an artist-correspondent during World War II, I was forced to work in tight quarters on assignment, backstage, etc. While my purposes then were mainly reference-oriented, and the results were of a very intimate nature, there is little doubt in my mind that this work could not have been produced in any other way.

May I repeat that whatever is offered here is only a suggestion based upon what we now know of contemporary materials and equipment. This has been drawn from personal experience and under no circumstances can be considered complete. It may be a starting point for many, as it has been for me. It may provide a reinforcement to promote confidence, sureness, and belief. It may, in the interim, save you time and expense, while sparing your energies as you struggle for expression.

BIBLIOGRAPHY

Albers, Joseph. *Interaction of Color*. New Haven: Yale University Press, 1963.

Arnheim, Rudolph. *Art and Visual Perception*. Berkeley: University of California Press, 1954.

Barr, Alfred H. Jr. (ed.). *Cubism and Abstract Art*. New York: The Museum of Modern Art, 1936.

————. *Fantastic Art Dada Surrealism*. New York: The Museum of Modern Art, 1936.

————. *Masters of Modern Art*. New York: The Museum of Modern Art, 1954.

Beazly, Sir John. *Masterpieces of Greek Drawing and Painting*. New York: Macmillan, 1955.

Butlin, Martin. *Turner Watercolours*. New York: Watson-Guptill, 1965.

Calderon, W. Frank. *Animal ·Painting and Anatomy*. Philadelphia: Lippincott (n.d.).

Cary, Joyce. *Art and Reality*. New York: Anchor Books, Doubleday, 1961.

Doerner, Max. *The Materials of the Artist*. (Rev. ed.). New York: Harcourt, Brace & World, 1949.

Gardner, Helen. *Art Through the Ages*. New York: Harcourt, Brace & World, 1959.

Goodrich, Lloyd. *Winslow Homer*. New York: Macmillan, 1944.

Graziosi, Paolo. *Palaeolithic Art*. New York: McGraw-Hill, 1960.

Grosz, George. *Ecce Homo*. Introduction by Henry Miller. New York: Grove Press, 1966.

Hambidge, Jay. *The Elements of Dynamic Symmetry*. New York: Dover, (n.d.).

Helm, MacKinley. *John Marin*. Boston: Pellegrini and Cudahay, 1948.

Heron, Patrick. *The Changing Forms of Art*. New York: The Noonday Press, 1958.

Itten, Johannes. *The Art of Color*. New York: Reinhold Book Corp., 1961.

Janson, H. W. *History of Art*. New York: Harry N. Abrams, 1962.

Jensen, Lawrence N. *Synthetic Painting Media*. Englewood Cliffs, New Jersey: Prentice-Hall, 1964.

Johnson, Una E. *Drawings of the Masters: 20th Century Drawings*. Parts I and II. New York: Shorewood Publishers, 1964.

Kandinsky, Wassily. *Concerning the Spiritual in Art & Painting in Particular*. New York: Wittenborn, 1964.

Kepes, Gyorgy. *Language of Vision*. Chicago: Theobald, 1945.

Klee, Paul. *Pedagogical Sketchbook*. New York: Frederick A. Praeger, 1953.

Lebrun, Rico. *Rico Lebrun Drawings*. Berkeley & Los Angeles: University of California Press, 1961.

Loran, Erle. *Cézanne's Composition* (3rd ed.). Berkeley: University of California Press, 1963.

Malraux, André. *The Voices of Silence*. New York: Doubleday, 1953.

Mayer, Ralph. *The Artist's Handbook*. (Rev. ed.). New York: The Viking Press, 1957.

Mekhitarian, Arpag. *Egyptian Painting*. Translated by Stuart Gilbert. New York: Skira, 1954.

Mitsch, Erwin. *Egon Schiele*. Salzburg: Verlag Galerie Welz, 1961.

Nicolaides, Kimon. *The Natural Way to Draw*. Boston: Houghton Mifflin, 1941.

Pallottino, Massimo. *Etruscan Painting*. New York: Skira, 1953.

Rasmusen, Henry. *Art Structure*. New York: McGraw-Hill, 1950.

Read, Herbert. *A Concise History of Modern Painting*. New York: Frederick A. Praeger, 1959.

Rewald, John. *The History of Impressionism*. (Rev. ed.). New York: The Museum of Modern Art, 1962.

Rhys, Hedley Howell. *Maurice Prendergast*. Cambridge: Harvard University Press, 1960.

Ritchie, Andrew C. *Charles Demuth*. New York: The Museum of Modern Art, 1950.

Sachs, Paul J. *Modern Prints and Drawings*. New York: Alfred A. Knopf, 1954.

Selz, Peter. *German Expressionist Painting*. Berkeley: University of California Press, 1957.

Shahn, Ben. *The Shape of Content*. New York: Vintage Books, 1960.

Sweeney, James Johnson. *Henry Moore*. New York: The Museum of Modern Art, 1947.

Taylor, Harold. *Art and the Intellect*. New York: The Museum of Modern Art, 1960.

Taylor, Joshua C. *Learning to Look*. Chicago: The University of Chicago Press, 1957.

Toda, Kenji. *Japanese Scroll Painting*. Chicago: The University of Chicago Press, 1935.

Yashiro, Yukio. *2,000 Years of Japanese Art*. New York: Harry N. Abrams, 1958.

INDEX